ALL ABOUT TECHNIQUES IN

acrylics

An indispensable manual for artists

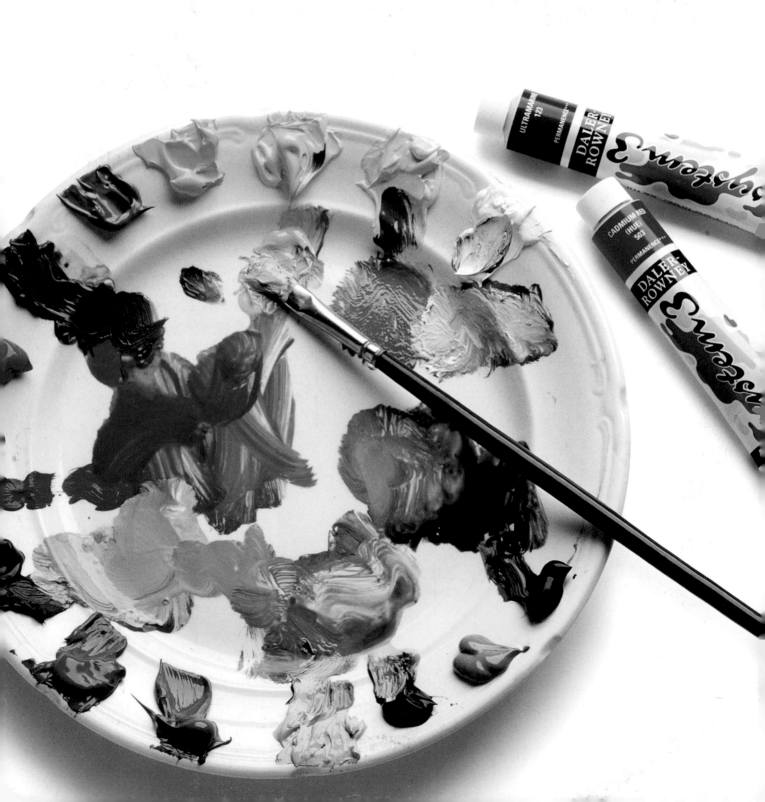

ALL ABOUT TECHNIQUES IN
acrylics

An indispensable manual for artists

Ⓟ Parramón

Contents

Although several decades have already passed since artists first experimented with acrylics, painters, both professional and amateur, still hesitate to use them today because they are synthetic plastic products. The truth is, however, that paint of any kind is one of the great contributions of science to art; therefore, it must be given fair credit.

The criticism stems from the lack of knowledge about the true possibilities of acrylic paints. Conservative artists, for instance, still consider them an imitation of oil paints and watercolors. Although the fact that acrylic paints can mimic other media is widely accepted, it is also true that they have a character of their own, which makes them one of the most versatile media.

The main characteristics that have made acrylic paints one of the best products are their plasticity and their solubility. On the one hand, their resinous composition provides the consistency, viscosity, and stability of the texture once the paint has dried. On the other hand, the total solubility of acrylics makes their removal easier when they are still wet.

Halfway between oils and watercolors, acrylic paints are suitable for painting in thick or thin layers, transparent or opaque. Their plasticity appears to have no limits, even when the artist is not completely proficient in the use of these paints and their advantages become inconveniences.

This is why in the following pages the reader will learn the techniques for using acrylic paints correctly. The different subjects are presented in a clear and concise manner, because the book is intended to offer a text that is educational for the amateur and at the same time useful for the artist who is already painting, so both can learn quickly and easily about the use of materials, the most interesting tips, and where and when to apply them.

The aim of this book is to put into the hands of the reader a useful and practical work that will lead to a progressive mastery of this painting technique based on a product of industrial origin.

The Arrival of Acrylic Paints

The first experimentation with semisynthetic paints took place in Italy during the Renaissance, when artists began mixing powdered pigment in their studios with a medium known as Fornis, which was obtained from a complex distillation process. The need for a paint with a short drying time and more flexibility than oils forced sixteenth- and seventeenth-century artists to use alkyd resins. This was already a totally synthetic medium that provided great elasticity to the surface of the painting. It was an ideal paint for working on canvas.

HISTORICAL BACKGROUND

The predecessors of acrylic paint can be found in the Renaissance, in the solvents called Fornis, obtained from the boiling of oil paints with resins—that is, from the union between oil and resin. This mixture gave the paint greater adherence and drying speed. Later, in the sixteenth and seventeenth centuries, a type of resin called an alkyd was produced. Alkyd resins were semisynthetic and made of natural oils and a totally synthetic resin that dried faster than oil paints, although not as fast as modern acrylics. A glaze of alkyd resin became insoluble and hard when dry, yet it remained flexible, which allowed the work to be stored in rolls without causing any damage to the layer of paint.

SYNTHETIC RESINS

Synthetic resins originated in Germany, where they were first used in the early part of the twentieth century. Synthetic cyclohexane resins were produced by chemical processes, clear as water, highly resistant to light, and completely neutral and resistant to acids, bleach, and other chemicals. Resin AW2 was one of the first synthetic paints used in Germany, but it was soon replaced by acetone resin N, which was superior in quality. In 1915, the first official patent was granted in that country for the production of synthetic acrylic materials, and that led to the manufacturing of new synthetic resins and Plexiglas, a product that plays an important role in artistic painting.

Artists in 16th- and 17th-century Italian studios experimented with the first semisynthetic resins by mixing them with oil paint.

The combination of pigments with synthetic resins originated in Germany. Initially, however, this mixture did not have a great impact on artists of that time.

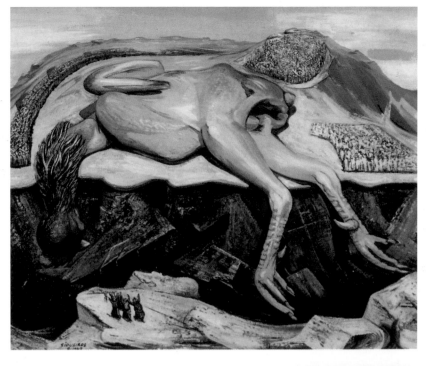

David Alfaro Siqueiros, Death and Funeral of Cain, 1947. Acrylic on wood. Museo de Arte Alvaro y Carmen T. de Carillo Gil (México, D.F., México).

MEXICAN MURAL PAINTING

During the 1920s, oblivious to the progress made in Germany in the area of synthetic resins, Mexican mural painters began to experiment with a new product that was resistant to weather and that allowed the painting of large murals on the outside walls of buildings and patios. This paint, in its experimental phase, had the material characteristics of watercolors and the opacity of oils, and it surpassed the drying time of both. The great artists of expressive Realism—the Mexican revolutionary painters

Clemente Orozco, Rivera, and Alfaro Siqueiros—made advances in this direction. The latter, Alfaro Siqueiros, made the most technical contributions.

COMMERCIALIZATION IN THE UNITED STATES

The Mexican discovery had a great impact many miles away, specifically in New York, where many paint manufacturers noticed that the products could be

used not only for murals but also on other types of supports. In the mid-1940s, after two decades perfecting them, the first acrylic paints could be purchased in specialized stores in the United States. Commercial paints were therefore incorporated into modern painting. With this introduction, their many technical advantages—such as drying speed, color stability, and affordability—put them in competition with other products.

Diego Rivera. Political View of the Mexican People, 1923. Fresco with nopal and synthetic resins. Building of the Secretaría de Educación Pública (México, D.F., México).

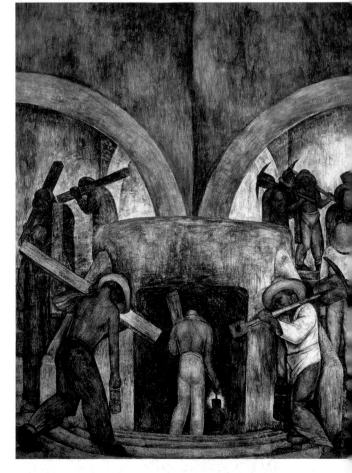

After the excellent results by Mexican mural painters, some American companies began to experiment with acrylic paints, and soon after they started manufacturing the product.

New Abstract Painting: Color and Materials

Around 1940, following the first avant-garde artists who developed new techniques and styles, some American painters began to use acrylic paints in their work. These new paints had great acceptance among the artists of the time and played an important role in the new painting styles in the United States after the war, comparable to the appearance of oil paints in Flanders.

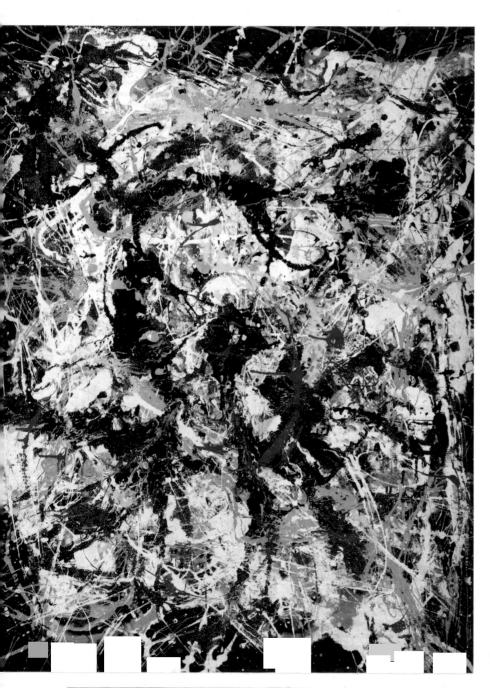

A NEW GENERATION

In the second half of the 1950s, water-based emulsions, as they are known today, made their appearance and became very popular among artists. Because of their affordability, thick consistency, and the fact that they could be purchased in large quantities, abstract artists such as Frank Stella, David Hockney, Richard Smith, Morris Louis, Willem de Kooning, Jackson Pollock, and Kenneth Noland used them for dripping and impastos and to produce large paintings, eliminating the long drying period, which was typical of oil painting.

Pollock and Alfaro Siqueiros, who worked together in New York in 1936, greatly influenced the popularity and expansion of acrylics among this generation of artists.

COLOR AND DRIPPING

Acrylic paints allowed more freedom, fluidity, and spontaneity in the work of these artists. Their consistency made it possible for abstract expressionist painters such as Jackson Pollock to work with thick impastos, often dripping the paint on the canvas directly from the tube, knowing that the paint would dry in a fraction of the time that oils would when used the same way. In their drip paintings and in those where there are large blocks of color, the effect of abstract lines and vibrant colors escapes any conventional art analysis. In these paintings, color is an important structural element, not only for modeling the form but also for understanding the nuances and interrelations that are used to create an artistic image.

LARGE FORMATS

Acrylic paints used in large formats produced striking works of art, which fluctuated between two-dimensional space and three-dimensional depth. In many instances, the large dimension of the work forced the artist to work on the floor or over a flat surface, which was more suitable for making washes and puddles, and afforded the artist greater control over the paint-dripping technique.

Jackson Pollock. Number 4, *1950. Oils, varnish, and synthetic resins. The Carnegie Museum of Art (Pittsburgh, USA).*

Morris Louis, KS I, 1959.
Acrylic on canvas.
Museum Folkwang
(Essen, Germany).

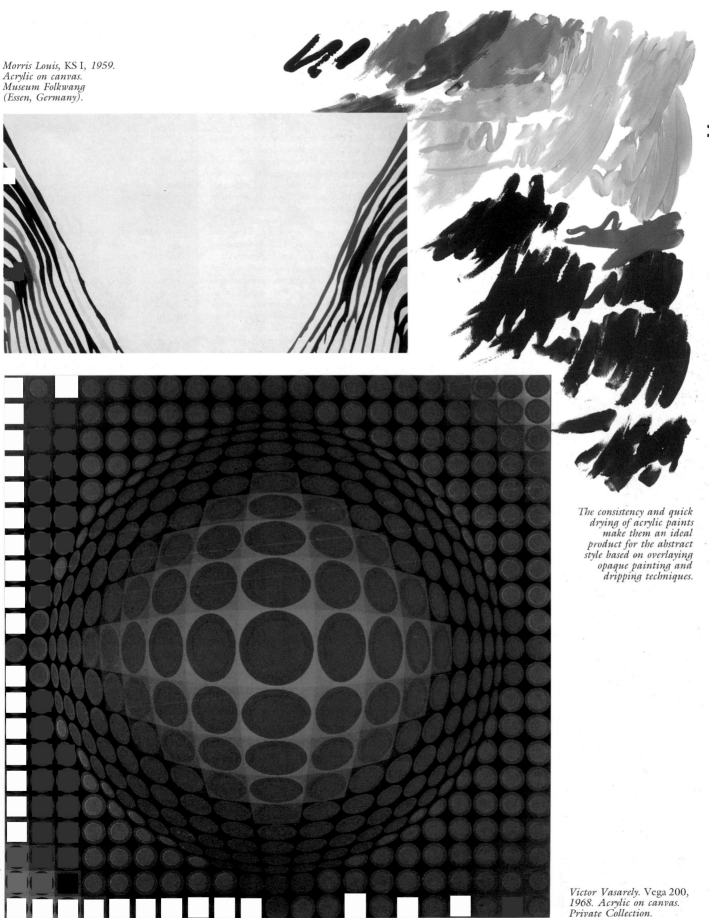

The consistency and quick
drying of acrylic paints
make them an ideal
product for the abstract
style based on overlaying
opaque painting and
dripping techniques.

Victor Vasarely. Vega 200,
1968. Acrylic on canvas.
Private Collection.

MATERIALS AND TOOLS

From Pop Art to Avant-Garde

During the 1970s and 1980s, different art movements used bright and pure colors in their paintings, thanks to the technical evolution of the new additives, which increased the range of effects and textures that could be created with acrylic paints.

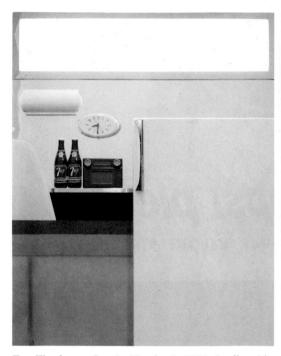

Tom Wesselmann, Interior Number 3, *1964. Acrylics with polished metal. Collection of Dr. Hubert Peters (Brussels, Belgium).*

POP ART

After acrylic paints were introduced into the art world, pop art and other similar styles made their appearance and adopted this kind of paint to vindicate serial reproduction and to elevate posters, comics, and objects from daily life to the status of art. This had an influence on mass production and, therefore, on ordinary objects and on the taste of the average person. Professional use of representational techniques and the popularization of acrylics inspired pop artists to mimic advertising billboards with their art. Their style is based on the personal selection of these motifs and on the generous and showy use of color (iridescent and fluorescent acrylic colors became popular in the 1960s).

In this sense, acrylic paints were appropriate for the representation of the images of this new artistic trend, which was known for its very defined outlines and its flat, very effective colors. Although pop art was a figurative type of expression, the style gave the elements an artful, almost unreal appearance.

COLORFUL AND IMPERSONAL

Pop artists used an opaque projector to create a pencil drawing of the picture. Then, they filled all the figures with flat layers of acrylic paint, producing very colorful and impersonal results that resembled publicity billboards and comics.

Nicholas Krushenick, Duckleswan, *1966. Acrylic paint on canvas. Stedelijk Museum (Amsterdam, Netherlands).*

During the 1960s, fluorescent and iridescent acrylic paints that were capable of producing new light effects on the surface of the painting were introduced to the market.

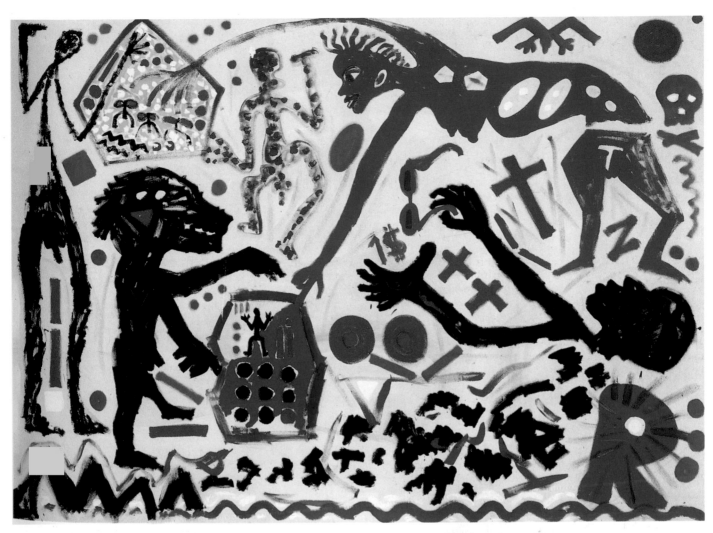

PAINTING IN THE EIGHTIES

The 1980s witnessed a rebirth of pseudofigurative painting tendencies in response to a more personal, public, and artistic identity. At that time a new generation of artists made their appearance, searching for new forms of expression that were deliberately subjective. They defended a return to expressionism, futurism, and symbolism, ignoring strict academic rules.

The varied and widespread use of acrylic paints in the last decades of the twentieth century clearly showed the great potential of this product, which, combined with thickeners and retardants, created the volume and color on the painting's surface. Avant-garde artists made huge paintings full of heavy symbols, lines, and colors. Thickening gels, modeling pastes, and collage materials became the new workhorses of acrylic painting.

A STEP FORWARD IN THE TECHNIQUE

In recent years, the introduction of various products in the market of plastic arts has encouraged artists to experiment with new methods. Acrylic paint is one of the new crafts that has found the most supporters. This is why manufacturers of acrylic paints continue to research their properties, giving them new technical finishes, great volume, soft consistencies, transparent or totally opaque colors, translucent varnishes, and a wide range of textures.

A. R. Penck. Event in New York 3, 1983. Acrylic paint on canvas. Galerie Michael Werner (Cologne, Germany).

Composition and Characteristics

Acrylic, or plastic, paints is a type of tempera paint. The only difference with the latter is that the glues or binders are plastic because they are acrylic, lithium-based, or vinyl polymers.

DRYING

Acrylic paint consists of a 100 percent pure pigment solution in acrylic resin suspended in water. As the water evaporates, the resin molecules and the pigment combine, resulting in a consistent paint that is very resistant when it dries. The quick drying time of acrylics is a double-edged sword: It is their most outstanding characteristic as well as their most inconvenient one. On the one hand, it allows paint to be overlayed without waiting for the layers to dry; on the other hand, it makes it difficult to spread the paint on the canvas or support and mix colors.

ADVANTAGES WITH RESPECT TO OILS

Acrylic paint has great covering power and offers several advantages with respect to oils: The paint dries quickly, so a new layer can be applied over the previous one almost immediately. Its high solubility allows the paint to be delivered with a brush, a spray, a roller, or an airbrush. Also, successive layers of color can be applied without a problem because the paint dries quickly and there is no risk of cracks forming on the surface.

AGING PROCESS

Acrylic paint is not affected by the chemical changes that other, more traditional types of paint may suffer with the passage of time. However, its recent introduction to the world of art has not allowed an understanding of its aging process, as in the case of traditional products.

Acrylic paint is a widely used medium among contemporary artists because it allows the creation of an endless array of effects on canvas.

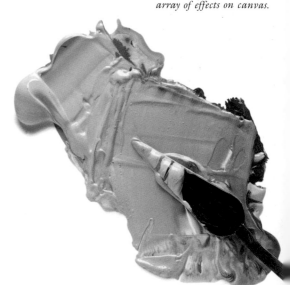

Acrylic paint is very creamy and can be diluted with water or used for texturing.

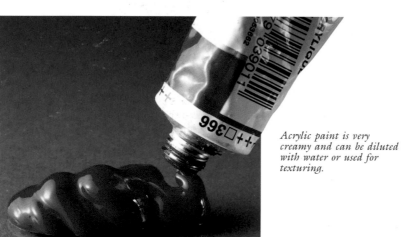

The main advantage of acrylic paint is that it dries very fast, therefore, it is important to work diligently.

VERSATILITY AND ELASTICITY

Acrylic paint can be used with the desired consistency to create impastos, textures, and so on. This versatility of application is an important characteristic. Another characteristic worth mentioning is elasticity: whereas oil paint hardens when it dries, acrylic becomes more flexible.

IMPERMEABILITY

Acrylic paint acquires the malleability and resistance of plastic when it dries. The resin in acrylics is impermeable, which means that a layer of paint can be applied over what has already been painted without muddying the colors of the mixture. This overlaying is possible because when the paint dries the polymer emulsions that bind the pigment form a very stable film.

Acrylic Paint and Its Properties

The properties that have made acrylic paint one of the best art media are its great plasticity and solubility in water. In other words, on the one hand its resinous component gives the paint consistency, viscosity, and textural stability when it dries; on the other hand, its solubility in water allows its quick elimination while still wet.

Acrylic paints have a high degree of pigmentation and can become very transparent when they are diluted with water.

TRANSPARENCY AND DENSITY

Acrylic resin can be used as varnish with similar characteristics to paint once it has been applied. It is easy to see that its great transparency as a varnish allows the pigment to be applied gradually, from thin layers of paint to the most complete opacity. However, as will be described later, complete transparency can be achieved by applying the paint not only in thin layers but also in thick, dense impastos.

MIMICKING OTHER MEDIA

One of the most attractive characteristics of acrylic paint is that it has a surprising ability to imitate the qualities of other media that are as diverse as oils and watercolors. Like oils, acrylic paint can be applied in a thick and pasty layer, either with a spatula or a brush. Diluted in water, the paint acts exactly like a watercolor. Opacity can also be achieved, as with any other media, by applying the paint in thick layers directly from the tube or mixed with a little bit of water.

DILUTING

Acrylic paints are diluted with water. However, to lighten a color it is normally preferable to use a part of the "medium," which basically means to prepare the color without the pigment. This procedure does not alter the consistency of the paint and only increases the transparency of the tone. If watercolors are limited in the number of washes they allow before they begin to mix and get muddied, acrylic paints do not have that limit because they do not change once they dry. Each layer of color is a separate entity from the rest, allowing the creation of complex and intricate effects without losing color brightness.

Water is indispensable for diluting paint and for cleaning.

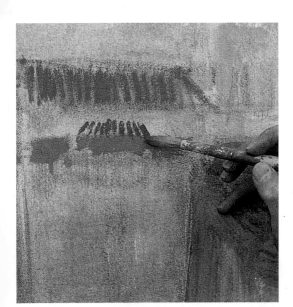

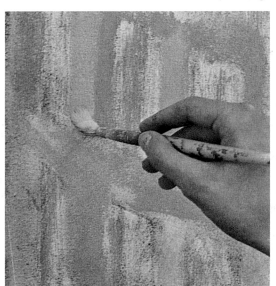

The properties of acrylics allow them to mimic the flow and consistency of other media, and they dry very quickly.

Commercial Packaging

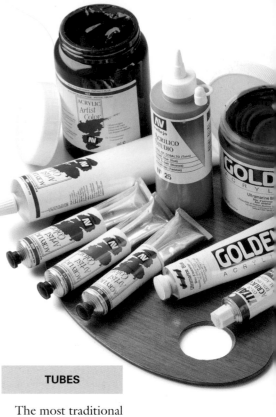

Acrylic paints offer significant technical advances that still have not reached an end, because more and more progress and improvements are being made in this field.

Bottles with spouts are very practical for the artist who uses large amounts of paint and who makes the mixtures on the palette, because the dropper can be used to measure the dose of paint needed.

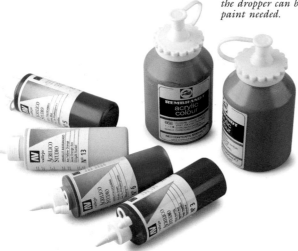

CHOOSING THE CONTAINER

Acrylic paints are available ready to use in different formats and presentations, so the artist can choose the most convenient one for his or her needs. It is important to know how to choose the most appropriate container because its use will in some way condition the work. Artists who like to work on minute, detailed paintings do not need to purchase big containers. On the other hand, artists who work on large formats should get larger containers.

TUBES

The most traditional package presentation for paints is a metal tube with a screw-on top. The contents are soft and creamy, very appropriate for the impasto technique. Acrylic paint in a tube allows the artist to control the amount delivered, keeping in mind of course the size of the work. This presentation is not practical for large formats because the paint runs out quickly. However, it is always a good idea to have a few tubes of special colors that are expensive and not frequently used.

BOTTLES

Different types and sizes of bottles are available, from those with a wide mouth (in various sizes), which allow the artist to get the paint with either a spatula or a brush, to the practical containers with conical spouts or small openings. The latter are ideal for any use because the paint does not dry, as is the case with other bottles that are left open accidentally.

MANUFACTURERS AND COLORS

The consistency of acrylic paints varies depending on the manufacturer: Some paints are quite thin and flow better, whereas others are thicker. Each brand name markets its products with a label listing the characteristics of the medium or varnish.

Modern acrylic emulsions are highly stable; they do not turn yellow or undergo chemical changes with the passage of time.

The color range of acrylic paints is somewhat more limited than oils or watercolors because some of the pigments do not mix well with the binder and tend to thicken. In these cases, manufacturers need to use alternative pigments, so a color like emerald green will use a substitute that produces similar results. Manufacturers try to introduce the most updated synthetic or inorganic pigments, discontinuing some of the more traditional colors.

There is a wide range of bottles and tubes to satisfy every need.

The contents of the wider bottles are similar to the narrower ones, and although some brands come with a measuring device, the main advantage of the wide mouth is that a larger amount can be scooped at once.

acrylic paints are manufactured with an alkaline resin, which gives them a strong dying power. Their consistency makes them suitable for working with a reed pen and also with a dip pen.

IRIDESCENT COLORS

Iridescent, or pearlized, paints are available in orange, red, blue, green, violet, and gold colors, and are very durable. They are manufactured from mica flakes and titanium, and their shiny surface changes depending on the way the light hits them or on the angle from which they are viewed. These paints can be used by themselves or combined with regular acrylics to produce luminous textures.

PVA PAINTS

There are also other commercial paints available that, instead of being manufactured with an acrylic medium, are produced with PVA (a type or resin that contains polyvinyl acetate). This type of paint, although similar to acrylic paint, tends to be cheaper and produce a color surface that is more vulnerable to the passage of time, but there are some good brands available.

Paint in bottles is thinner and more fluid and dissolves easily in water, making this an ideal format for glazing that mimics watercolors. After the paint dries, it forms a fine film that is slightly more matte than the paint in tubes.

LIQUID ACRYLICS

The containers for acrylics in liquid form resemble the bottles of India ink and come with a dropper. These

Iridescent paints add interesting luminous effects to the surface of the painting. They can be used by themselves or mixed with other acrylic paints.

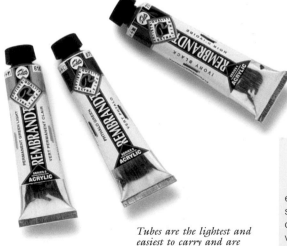

Tubes are the lightest and easiest to carry and are available in various sizes.

A VERSATILE MATERIAL

Acrylic paints are very versatile: They can be used either for large paintings or for small ones; they are suitable for indoors or outdoors, as well as for walls, canvas, and paper; and they can even be combined with other painting and drawing media.

Colors in Acrylic Paints

With acrylic paints being a relatively new medium, manufacturers have been able to incorporate the best and newest pigments along with the more traditional ones. This way, the acrylic medium offers the possibility of painting with opaque colors as well as with subtle transparencies, without losing any of the properties of color.

LUMINOSITY

Acrylic paints are very luminous. They have a component made of a transparent polymer resin, so when they dry the pigment that is found in the mixture receives the light in all its intensity and reflects it. The luminosity of acrylic paints allows the creation of a range of colors as wide as that of any other art media. The popularity and expansion of acrylics was greatly influenced by

Jackson Pollock and Alfaro Siqueiros, who worked together in New York in 1936 and revealed the possibilities of the medium to their contemporaries.

RESISTANCE TO LIGHT

One of the problems common to some art media is that the color tends to fade with time from exposure to light, although other media, such as oils and acrylics, are resistant to color deterioration. In the

case of acrylics, its very composition serves as protection to the pigment.

DRY PAINT

Unlike oil paints, whose color tends to stay the same wet or dry, acrylics darken as they dry. This could present a problem for matching colors when the artist resumes painting after a pause. Therefore, it is a good idea to prepare a larger amount of color and to store it in a container with a tight lid.

A UNIVERSAL PALETTE

Every artist favors the use of the colors that allow him or her to create the most familiar chromatic tones. However, it is better to start with a conventional color palette—for example, titanium white, light cadmium yellow, medium cadmium yellow, yellow ochre, light red, pink, burnt Sienna, raw umber, permanent green, phthalo green, cobalt blue, Prussian phthalo blue, and ivory black. This selection of colors is a good one to begin with as you familiarize yourself with acrylic paints, their techniques, and their mixtures.

WORKING WITH PURE COLORS

Pure acrylic paints have a visual strength of their own, which artists can use any time they

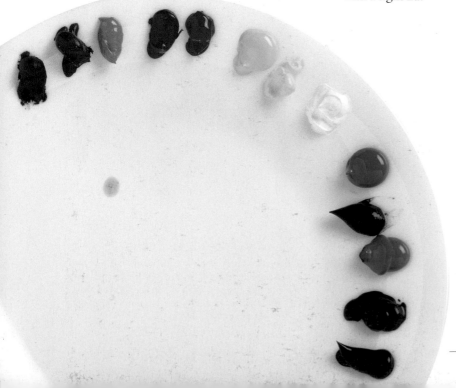

There is a range of basic colors that should always be present on an initial palette. Later, with time, new colors that personalize the palette can be added.

Acrylic paint is clean and glossy in its pure form, although it tends to darken slightly when it dries.

Working with pure colors and limited mixtures is the best way to keep them clean and bright.

MAKING THE UNREAL REAL

Paint, when it is a matter of capturing reality, always works by comparing colors. In other words, a color is real in the painting as long as the ones next to it make it so. Therefore, any color from the object that is being represented can be painted by establishing a range of colors that have the same relationship among themselves as those in the real model, regardless of whether the chosen palette has any similarity to the real colors.

wish, or if they are willing to sacrifice the pure realism of the painting. Alternating warm and cool colors, saturated and diluted, is a factor that goes beyond the color of a painting and that affects the spatial definition of the work. In these cases, realism becomes less of a focus, although it does not mean that compositional aspects and matters related to form and to the study of proportions have to be neglected.

CHROMA

Chroma paints are of higher quality than acrylics, containing a better-quality acrylic resin. They have the same characteristics as acrylics but with a slower drying time, which can be an advantage. Given their high proportion of pigment, the colors tend to be more intense, even when they are diluted and applied in very thin layers, and the tonal value does not change when the paint dries. The final result is reminiscent of gouache because it is very opaque and because it forms a velvetlike matte film when it dries.

If the initial gloss of acrylics can be preserved, the resulting paintings can have bright colors that highlight their vibrant and expressionist aspect.

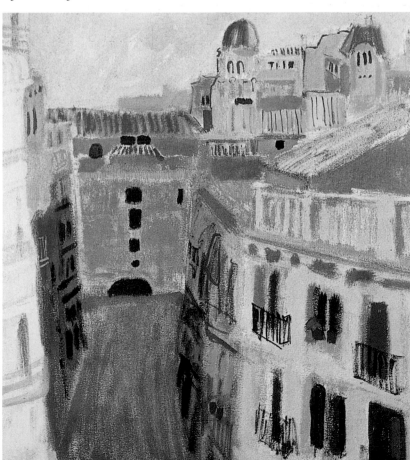

If the artist plans to work in sessions, it is a good idea to prepare color mixtures in jars that can be tightly closed with lids to prevent the paint from drying out.

MATERIALS AND TOOLS

The Mediums

Acrylic mediums are substances that can be added to the paint to alter its consistency and to create textural effects, to make the paint more or less bright, and to delay its drying time making the surface of the painting suitable for extended periods of work. These products are not a necessity because both commercial paints and those prepared in the studio have these properties; however, it is always a good idea to know them and to use them whenever new and rich effects are needed.

Samples of transparent gels, a matte, and a latex medium.

LATEX

Latex is also a substance that is normally used as an acrylic medium. It is a product of milky appearance that comes from the rubber tree. However, there is also a synthetic type available now. Sometimes this glue is used as a binder or as a thinner.

GLOSSY AND MATTE MEDIUM

Acrylics are water-based paints. It is not a good idea to increase the proportion of water because this could affect the structure of the suspension of acrylic resin. Therefore, when the artist wants to apply a wash with this medium, the use of a thinner, which is also acrylic, is recommended.

The thinner can be glossy or matte. The former is a suitable medium for any type of work, because it heightens the paint's transparency and luminosity. It can also be used as a finishing varnish. The second is basically a glossy medium to which an agent has been added to tarnish its brilliance. This product increases the thickness of the paint and makes diluting acrylics for glazing easier, without reducing the intensity of the color. This type of medium is not recommended as a finishing varnish because it could darken the colors too much.

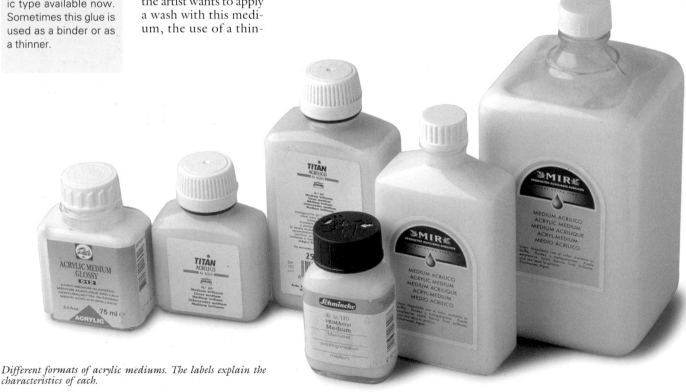

Different formats of acrylic mediums. The labels explain the characteristics of each.

Gels increase the creaminess, the body, and the consistency of the paint.

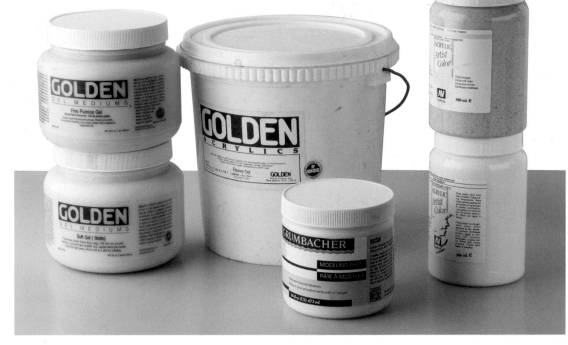

TRANSPARENTIZER

A transparentizer helps to better disperse the pigment in acrylic paint without losing its density and elastic properties. In reality, the transparentizer is an acrylic gel that can work as a medium. Any color can be added to it because it is transparent, and used in small quantities it produces glazes and transparencies.

GELS

A gel creates a wide range of effects. A large amount of gel with a little bit of paint results in a translucent paste. A thin layer of gel mixed with paint and applied with a spatula or a brush results in a transparent glaze. Gel added to paint can counteract shrinkage and makes it possible for the paint to main-tain its volume after it dries, resulting in a finish similar to oils.

A dense gel thickens the paint and increases its transparency and glossiness, making it look even more like an oil paint. The main purpose of this type of additive is to produce a specific texture on the surface of a painting. It is useful for impasto work because it preserves the traces of the spatula and brushwork. Opaque gels thicken the paint and increase its opacity and consistency without affecting the color.

RETARDANT

The quick drying of acrylics can turn into a serious problem when the work requires more time for manipulation or when a hot environment excessively speeds up the drying period. To delay the drying process, a retardant can be added to the medium or to the paint. Using it makes the edges of the painting stay wet longer and helps the blending of colors or tones. It should be used at a ratio of 5 parts drying retardant (up to a maximum of 10) to 100 parts of color. This way, the drying time will be delayed by 5 to 10 minutes. If a mixture of 20 percent or higher is used, the paint may crack.

FORMAT

Some manufacturers distribute the product in small, glass bottles. This format is especially suitable for the beginner or for the professional who uses the modium as a paint diluter for small work. It is also available in cans of 1 quart, 2 quarts, and 1 gallon (or 1, 5, and 10 L). These sizes are always cheaper compared to small containers. Some brands offer products of exceptional quality.

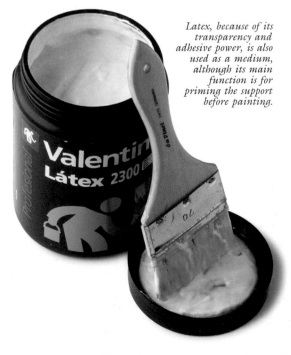

Latex, because of its transparency and adhesive power, is also used as a medium, although its main function is for priming the support before painting.

The drying retardant allows the manipulation of the paint on the surface of the painting for a longer period of time, before it dries completely.

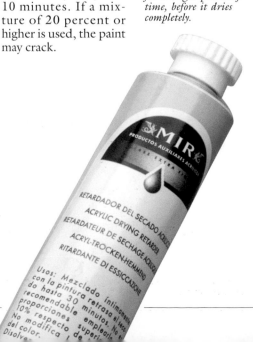

Other Tools

Acrylic paints can be applied with a wide range of tools besides brushes. The materials required to work with acrylics are paint, auxiliary products, the support, and the tools. Also, there are other complementary materials that at times are indispensable.

An excellent palette can be improvised with a piece of glass.

Sponges create an interesting textured effect on the paint.

PALETTE

The palette that is most readily available consists of a piece of large, thick glass, which is excellent for use in the studio. Because it is transparent, a sheet of paper the color of the canvas can be placed underneath so the effect of the color mixtures can be easily seen.

A spatula is needed to scoop paint out of the tube and to carry it to the support or palette, and also to scrape the paint.

PALETTE KNIFE

The palette knife is needed for dispensing, applying, and mixing the acrylic paint on the palette. Palette knives are also excellent for mixing mediums to create textures or small amounts of ingredients on the palette.

SPRAY

A spray is used to apply water to the palette once in a while so the paint stays fresh and easy to work with. The nozzle should be adjusted so the setting does not spray too finely and cause water to puddle on the palette.

SCRAPERS

Scrapers are used to apply acrylic primers or paints evenly, and to produce striated, rounded, or mixed color effects.

SPONGE

A natural sponge has the property of absorbing the paint very well; therefore, it is ideal for applying washes and for creating different textures. Sponge rollers can also be used to make applying texture easier.

ROLLER

Interesting textures can be created with a sponge roller. Light pressure should be applied when charging the roller with paint so the

texture is applied evenly when rolling it over the support. To produce a lively and atmospheric effect, the layers of paint should be superimposed, changing the direction of the roller.

VARNISH

Acrylic paints, like oils, always look shiny, as if they were just painted. However, unlike an oil medium, some colors always remain a little tacky to the touch. To prevent this, one of the many available commercial varnishes can be used.

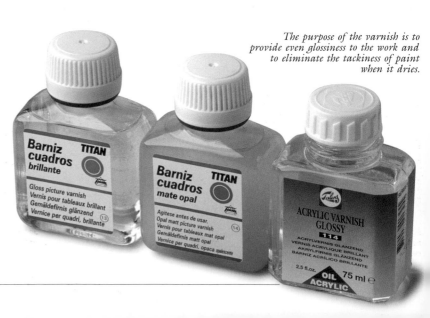

The purpose of the varnish is to provide even glossiness to the work and to eliminate the tackiness of paint when it dries.

Manufacturing Acrylic Paints

Acrylic paint is a relatively easy medium to prepare. There-fore, many artists choose to mix their own paints instead of buying them already prepared, making this a more affordable method.

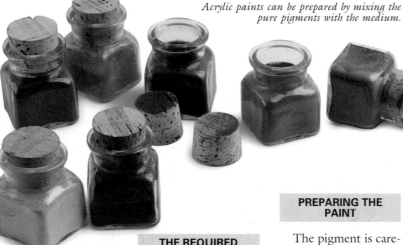

Acrylic paints can be prepared by mixing the pure pigments with the medium.

In the mixing process, the pigment is gradually added to the medium, which works as a binder. It is better to add small doses so it binds better.

EASY TO MAKE

Acrylic paints are easy to make, especially if we compare them with oil paint or glue paint. However, the mixing process requires great care if a quality result is desired.

THE REQUIRED ELEMENTS

Before the process begins, all the materials need to be gathered. First the medium, which can be pur-chased in a number of sizes. Keep in mind that it is always cheaper to buy large containers. The pigment is sold in glass bottles, but it is better and cheaper to buy it in bulk.

PREPARING THE PAINT

The pigment is care-fully measured and added with a spatula or a spoon. It is always better to add more pig-ment than liquid to the mixture. A brush can be used for stirring, go-ing around in circular motions and picking up and mixing the pig-ment from the sides of the can, as well as dis-solving and breaking up the bubbles that can form in the bottom of the mixing can.

PROBLEMS AND SOLUTIONS

If the paint separates when it dries and the pigment comes loose, it is because there is too much paint or because it has not been stirred long enough. When the surface of the paint, even when it dries, has an incomplete adhe-sion, it is because the product has not dried properly or the medi-um that makes the composition lacks wa-ter. When the dry paint shows small holes on the surface, it is be-cause froth has formed when stirring. To pre-vent this from happen-ing, it is a good idea to use a stabilizing prod-uct and a completely dry brush for mixing.

PREVENTING INHALATION

A pigment is a very fine powder, so fine that it easily becomes airborne. For this rea-son, it is a good idea to use a face mask that protects the nose and the mouth when work-ing with pigments.

First, the required amount of medium is poured into the container that will be used for mixing.

With the help of a spatula or a plastic spoon, the required pigment is added.

The mixture is stirred with the brush until it becomes homogenous and has no lumps.

During the mixing process, it is a good idea to test the paint to check the quality of the product.

Brushes: Quality and Types

B rushes are the basic tools used by acrylic artists. They are available in different sizes, shapes, and qualities. Obviously, each produces a different effect on the canvas or support. For example, stiff brushes are generally used for broad brushstrokes. Soft ones, on the other hand, are ideal for applying diluted washes, for doing watercolor techniques, and for very small work.

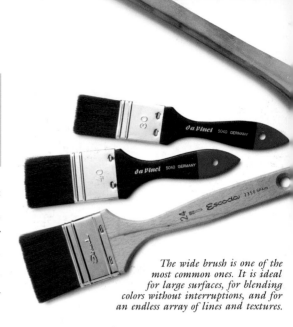

The wide brush is one of the most common ones. It is ideal for large surfaces, for blending colors without interruptions, and for an endless array of lines and textures.

BRISTLE BRUSHES

Bristle brushes are the most common and affordable of all. Their hair is not completely smooth, but slightly textured, which makes it possible to charge and hold the paint longer. In addition, this type of hair has a split end, which creates a smooth trace. Bristle brushes are flexible and absorb large amounts of paint, so it can be spread over the surface delicately and continuously.

SYNTHETIC BRUSHES

The other most common type of hair for acrylic paints is synthetic, which imitates top-quality hair, like sable or badger. Synthetic brushes have been highly perfected. Nowadays, high-quality synthetic brushes, with great absorbency, that can create soft and uninterrupted lines are available. Although, unlike bristles and natural hair, synthetic hair is completely straight, which is not a problem with acrylic paints, especially when working with dense materials. This type of hair is very durable if cared for properly, and it is highly recommended for acrylics. These brushes are easy to clean and are designed to withstand the rough conditions required by the acrylic medium.

CARING FOR BRUSHES

It is important to keep the brushes clean because acrylic paints dry quickly and are indelible when they dry. The paint on the brushes should never be left unattended for more than a few moments, and the brushes must be rinsed after they are used. Also, it is a good idea to wash them with soap and water after each session to remove all traces of paint. Hot water should never be used because it hardens the acrylic paint that is still in the brush. Brushes should not be in water for a long period either, because the hairs bend out of shape when they touch the bottom of the container and the lacquered paint of the handle can flake off. It is advisable to place the brushes on a tray, with the bristles submerged in water and the handles resting on the edge, so they do not get wet.

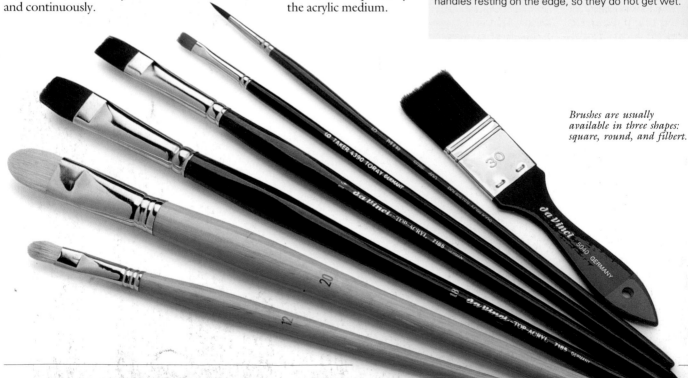

Brushes are usually available in three shapes: square, round, and filbert.

There are wide sponge brushes available that can spread the paint evenly and can be used to create textures and dragging effects.

Washing the brushes with soap and cold water after each session is vital for keeping the brushes in optimum condition.

WIDE BRUSHES

Many artists prefer wide brushes. The hair extends along the width of the brush. The handle is not rounded but flat, which sets the hair as a continuation of the handle. These brushes, which are much larger than round ones, can cover vast surfaces and are good for blending and grading quickly.

Wide brushes can hold a lot of paint and, despite the volume, are suitable for delicate work, of course always keeping in mind that the quality of the hair is an important factor.

THE SHAPE OF THE BRISTLES

The shape of the bristles helps in distinguishing one brush from another. The round ones are more versatile because they can be used for fine lines as well as for thick ones. Square brushes are the ones whose hair has the same length all the way through; they are useful for drawing heavy lines and outlines. The almond-shape brushes combine the characteristics of round brushes with flat ones: Their tips are round, but their hair is held in place by a flat ferrule, which is why they are so versatile and practical.

For people who are painting with acrylics for the first time, the following brushes are recommended: one medium wide brush, one small round brush, one flat synthetic brush, two square brushes, and two short round bristle brushes.

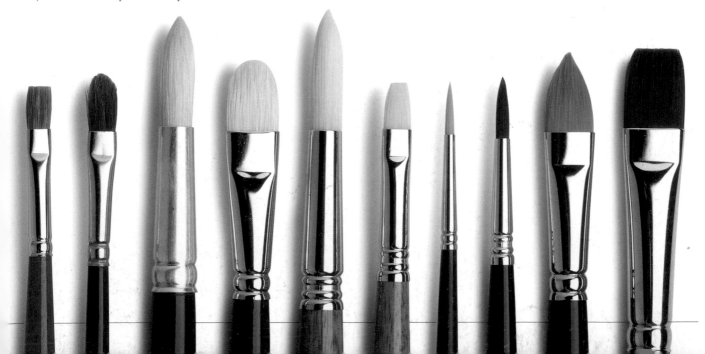

MATERIALS AND TOOLS

Supports: Canvas and Boards

Most artists prefer to work on a flexible surface, such as canvas or paper. However, rigid materials can also be excellent supports once they have been properly primed. The quality of the painting on these supports varies according to the level of absorbency and the density of the painting.

PAPER

Paper is one of the most commonly used supports for painting with acrylics because it is the most affordable one. Watercolor papers are mostly recommended for their resistance to water and their capability for absorption.

There are three main types of paper surfaces: hot pressed, or HP, which have a smooth texture; cold pressed or lightly textured; and textured. When a wash is applied on smooth paper, even when the paint is liquid, it is difficult to achieve an even tone, and the brush marks are very visible. When the wash is applied on a textured paper, the heavier pigments settle in the indented areas, which creates an effect of halftones.

Industrial, rigid boards are very affordable and are available in various weights and sizes.

CARDBOARD

Cardboard is more stable than canvas, and almost any type of rigid cardboard is suitable for painting with acrylics. Rigid boards are a popular type of support and have the reputation of being affordable and durable, because they can be painted on either side. There is also the possibility of using thick construction paper and linen board, which combine the stability of the board with the texture of linen, making them an invaluable support. When painting with acrylics, thick boards are always better than thin ones; however, they are more difficult to handle when they buckle as a result of excess humidity. This is why it is a good idea to secure them with nails or staples to a rigid surface before priming or painting on them.

CANVAS

The canvas used for painting with acrylics is the same as for oils, with the difference that another primer is used. When purchasing a canvas, you should make sure that it has the proper primer, because even though oils can be

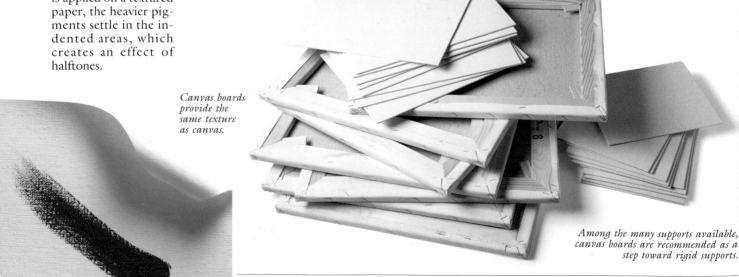

Canvas boards provide the same texture as canvas.

Among the many supports available, canvas boards are recommended as a step toward rigid supports.

24X30

Acrylic paints can be applied on any surface that allows good adhesion and that has enough body and is capable of resisting the paint's humidity.

used to paint on an acrylic base, acrylics do not allow an oil base.

Linen offers the best support, although its high price makes it unsuitable for beginners. In its place, a good-quality cotton fabric is recommended. There are also high-quality fabrics available with a mix of synthetic fibers, cotton, and linen.

The weave can be fine, medium, or heavy; the selection depends on the type of work being created. A very detailed painting requires a very fine weave, whereas a more liberal, expressionist work calls for a medium or heavy weave.

RIGID SUPPORT

Wood is a good support for acrylic paints, as long as the priming was done with an acrylic medium, latex, or gesso. Solid boards are no longer used because they can cause problems with breakage, woodborers, buckling caused by humidity, etc. Particle and plywood boards of various widths are used in their place because they are much more resistant to warping and shrinking. However, because they are sensitive to humidity and can sustain damage if they get wet, it is a good idea to prime them properly. These boards are available from carpenters or specialized stores.

PAINTING ON AN OIL BASE

It is usually said that acrylic paints can adhere to all types of surfaces and are permanent, but this is not true. For example, they will not adhere to an oily surface; therefore, painting over a layer of oil paint is not recommended because the acrylic would end up cracking and flaking off of the surface.

*The best fabrics are linen (**A**), although its price makes it less suitable for beginners. Cotton (**B**), or burlap (**C**), is recommended instead.*

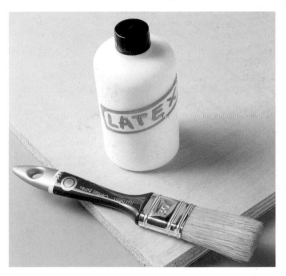

Latex makes the priming of any porous surface, like wood, easier.

Plywood boards are suitable for painting. Although the color can be applied directly on them, some artists prefer to prime them first.

Priming for Acrylic Paints

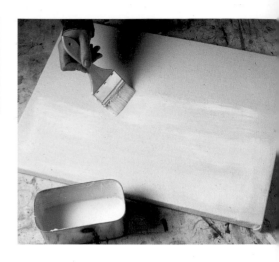

Acrylic paints can be applied directly on any surface, but paint will be absorbed in greater or lesser degree depending on the porosity of that surface. That is why many types of supports require a primer that seals the raw surface and that allows painting to be done without a problem. Different products that are suitable for each material (fabric, wood, or board) are available for this purpose.

UNPRIMED FABRICS

Unprimed fabrics show the natural quality of the thread. They are available in their natural state, so the painter can prime them as desired. They are the lightest and most resistant type of support among those available in the market. Unprimed fabrics are made of threads that cross each other forming a weft. The weft varies depending on the separation existing between the fibers. Keep in mind that the fabric, in its natural state, may have been woven with different natural fibers, such as cotton, linen, or hemp.

PRIMED FABRICS

The purpose of a primer is to preserve the support from direct contact with the paint, decreasing its absorbency. Primers for fabrics should seal the support, preserving its elasticity. The main products for priming fabrics are latex, gesso, and acrylic primers. Latex and acrylic mediums are resinous, and elastic varnishes that produce a glossy appearance when they dry.

PRIMING WITH ACRYLIC OR LATEX

A fabric can be primed with an acrylic or latex compound, after first reducing the medium to the point where it has a milky consistency that completely penetrates the weft of the fibers. It is applied with a wide brush, always in the same direction and covering the canvas until it is completely soaked. No part should be left uncovered. Once the first layer has dried, a second layer is applied crosswise. Finally, a third denser layer is applied lengthwise, with zinc white or any other color pigment.

Another useful system for larger supports is to spread the primer with a flat tool made of flexible plastic. This can be done by stretching the canvas with adhesive tape or staples, either on the studio floor or upright on a wall.

In rigid supports, the primer is applied with a brush. Generally, two layers are applied depending on the degree of absorbency. The first layer can be slightly diluted if needed. In large formats, a smooth surface can be achieved by spraying the primer with a gun and a compressor.

A solution of gesso and water is prepared in a container for priming. Then, a very diluted first layer is applied following the same direction.

MAKESHIFT PRIMER

A relatively simple method for priming boards, wood, and paper for small and quick sketches and studies with acrylic paints consists of rubbing the surface of the painting with garlic, which will seal it.

Unprimed fabrics show the thread when they are in their natural state. If acrylic paints are used to paint directly on them, the resulting brushstroke is porous and streaky.

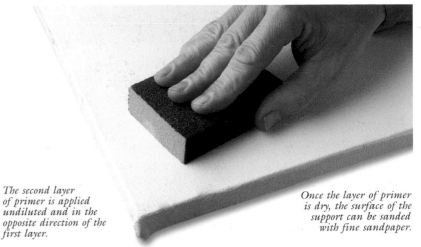

The second layer of primer is applied undiluted and in the opposite direction of the first layer.

Once the layer of primer is dry, the surface of the support can be sanded with fine sandpaper.

PRIMING WITH GESSO

An acrylic primer should be used for transparent painting techniques on a board or canvas where the white of the background is important. Commercial acrylic gesso has strong covering power and is very dense. It is applied with a wide brush on raw fabric, covering the pores and the weft completely.

As with acrylic primers and with latex, gesso should be applied in several layers, finishing up with light brushstrokes to smooth out the surface.

PRIMING WOOD

To prepare wood for painting with an acrylic medium, first the surface and the edges should be sanded, and then the dust removed. Next, a first layer of acrylic gesso primer, diluted with 10 percent water to make it easier to handle, is applied with a wide brush and left to dry. The surface is sanded again before the second layer is applied. It is a good idea to paint the edges and the backside of the panel to even out the tension of the wood and to prevent it from warping.

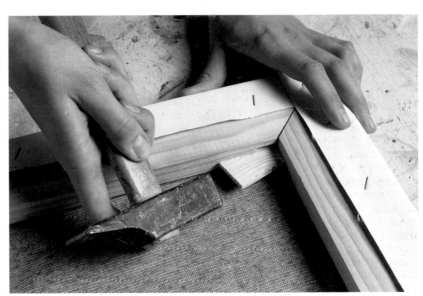

Wedges are inserted in the frame once the canvas has been primed and mounted, to slightly increase the tension.

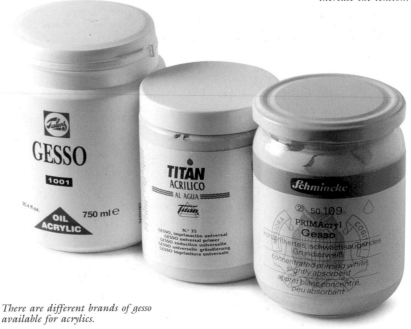

There are different brands of gesso available for acrylics.

The Palette and Other Mixing Tools

The palette is an indispensable tool for mixing paint. Any flat surface can serve the purpose, although it is best if the surface is nonporous, waterproof, and completely flat, to make cleaning easier.

WOOD PALETTES

Wood palettes should be properly treated to prevent the pores from absorbing the paint. The treatment consists of protecting the surface with a couple of layers of varnish. Most palettes purchased from a specialty store have already been treated. It is easy to improvise a wood palette: First a rectangular piece of plywood is cut and the edges sanded, and then both sides are varnished.

PLASTIC AND PAPER PALETTES

Plastic palettes are most suitable for acrylic paints. Their surfaces are nonporous and completely smooth, so the paint does not get absorbed; therefore, they can be reused without a problem, whether the paint is still wet or has dried out completely.

Many types of plastic palettes are available, from the ones with the classic traditional palette shape, to those that are completely round and contain wells for more liquid paint.

WELLS

A well is a concave receptacle where the paint is placed for mixing and for dipping the brush. It is especially designed for holding liquid paint, such as watercolors, oils, or acrylics. Palettes that come with small wells placed in a circular arrangement so the colors can be kept organized are also available.

STAY-WET PALETTE

If work with acrylics is done on a regular basis, a Stay-Wet palette especially designed for acrylics can be purchased. The surface of these palettes is covered with a waterproof sheet of paper that is protected with another nonabsorbing layer underneath that fits inside a plastic tray that can be filled with water. The paint is placed on the top layer, which is slightly porous and lets through the water needed to prevent

THE RIGHT AMOUNT

One of the most desirable qualities of acrylic paints is their quick drying time. However, in some cases, this property can exasperate the artist. This is why attention should be given to the amount of paint deposited on the palette: If it is too much, the remainder will be wasted at the end of the session, unless it is stored in a wide-mouthed bottle with a tight lid; if it is too little, it will surely dry out for lack of humidity if it is not used right away.

It is important to dispense the right amount of paint on the palette to prevent it from drying out.

Plastic palettes can be cleaned quickly and thoroughly.

The wells can be attached to the palette. This is the best way to work with acrylic paints in liquid form.

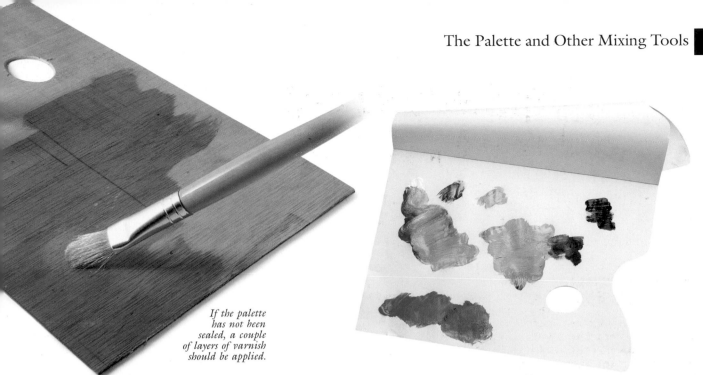

If the palette has not been sealed, a couple of layers of varnish should be applied.

acrylic paints from drying. This type of palette usually comes with a plastic lid that can be closed after each use to keep the paint moist. If you have difficulty finding one, you can easily make one in the studio.

KEEPING THE PAINT MOIST

If a Stay-Wet palette is not available, the best way to keep the palette moist while working is to wet it once in a while with a water spray or cover it with a piece of plastic wrap. This way, if you decide to take a break, the paint will stay moist.

OTHER CONTAINERS

If a professional palette is not available, the mixing can be done on any homemade support. If the artist is working on a small scale, or acrylic paints are used as if they were watercolors, a plastic or

ceramic palette is the ideal tool; even an old ceramic, metal, or plastic plate will work. Ceramic and plastic containers are easy to clean, even when they have a thick layer of dry paint. In this case, the dried out layer will have to be peeled off the side of the container.

Pads of paper used as palettes are available, and they eliminate the cleaning process, but they are not good for the environment and are expensive.

Plates make good palettes for mixing paints.

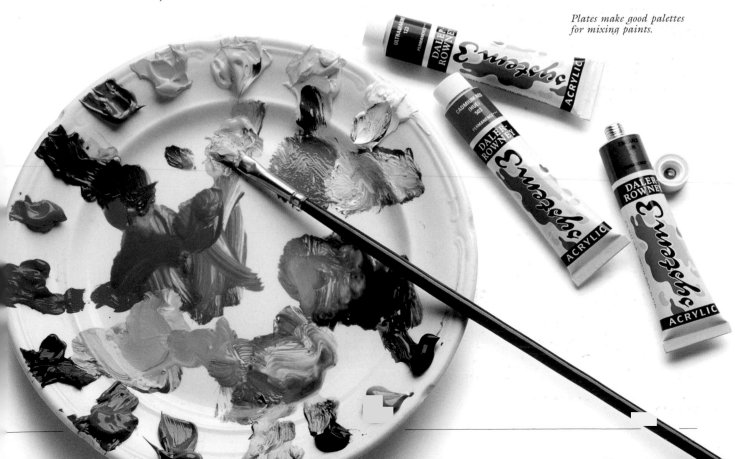

Mixing Colors

Acrylic media have a milky consistency and are slightly viscous. The paint is creamy and sticky, and can be mixed thoroughly. Powder pigment, aside from being easy to dissolve in the acrylic medium, can also be mixed with other colors of the same base.

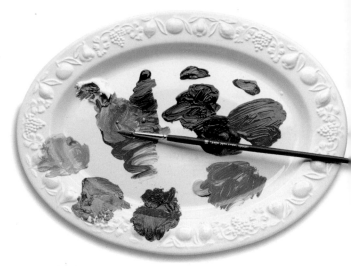

Every artist should learn to create a personal palette and to introduce colors that agree with his or her personality.

ARRANGING THE COLORS

Before you combine colors, it is important to arrange them correctly on the palette. This arrangement is a very personal choice, one that is subject to the color range that is to be used and to the chosen procedure.

Colors are usually arranged by temperature, being divided into warm and cool colors. Many artists place a large amount of white in an area of the palette that is easy to reach.

If the appropriate use of colors on the palette is important for any artistic endeavor, it is even more important with acrylic paints, because their fast drying time requires efficiency. Colors should be arranged in the most practical and organized manner possible, by schemes or tones, in such way that access to them is always logical and clean.

A PERSONAL PALETTE

All acrylic paints are created from synthetic pigments. Therefore, it is not possible to reproduce their colors by mixing with other commercial paints. If there is a color that is especially appealing to the artist, even if it is not very common, it should be incorporated at once. It is a good idea to personalize the palette and to get used to the mixtures that can be created with the colors that are available. Artists should follow the impulse to discover a world full of new sensations.

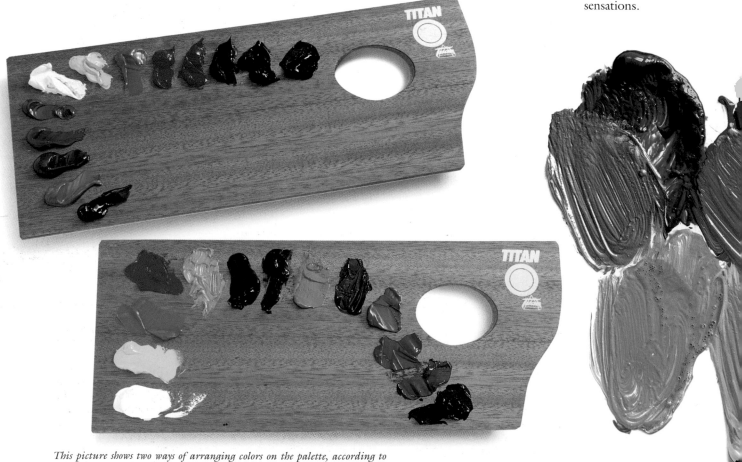

This picture shows two ways of arranging colors on the palette, according to a tonal range or to a harmonic range.

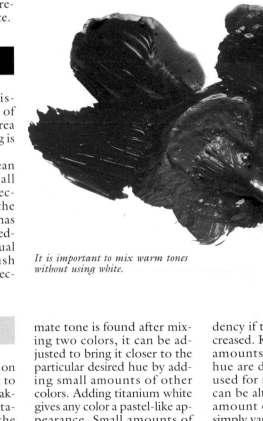

Mixing on the palette should be done by comparing the color base with the tones created.

To paint large areas, like the background, colors can be mixed in a container that allows the artist to work comfortably with a considerable amount of paint.

SEARCHING AND FINDING

Any tone or color found on the model can be created from the paint on the palette. Once thing to keep in mind while searching for that particular color is that a single brushstroke is sufficient to create

Warm and cool colors equally intervene in the mixtures, each contributing its own luminous properties.

the desired tone. For the different hues, small dabs of paint are added and can be lightened or darkened as needed. It is better to err from too little paint than from too much, because if the resulting mixture is too dark, all the initial colors will have to be repeated, causing a lot of waste.

HOW TO MIX

A spatula is used to dispense an amount of paint of each color to the mixing area of a palette or a well. Mixing is done with a brush.

Using a spatula or a clean brush to pick up a small amount of each color is recommended. A spatula is the best gauge that the artist has for measuring the paint needed. However, for the actual mixing process, the brush used from dispensing the second color can be reused.

APPROXIMATING THE COLORS

To find a particular hue on the palette, it is always best to begin with a base color, making all the necessary adaptations from that step. To the first color, the next one is added, which will determine the chromatic tendency of the mixture. When the approxi-

It is important to mix warm tones without using white.

mate tone is found after mixing two colors, it can be adjusted to bring it closer to the particular desired hue by adding small amounts of other colors. Adding titanium white gives any color a pastel-like appearance. Small amounts of red create warm tones, whereas blue and green added to warm colors turn them into earthy tones, with a cool ten-

dency if the proportion is increased. Keep in mind that the amounts used to adjust the hue are different from those used for mixtures. The latter can be altered with any small amount of a third color, by simply varying the tone within its own chromatic value. This is why the amounts used for correcting the tone must be very small.

LIMITING MIXTURES

It is generally recommended that paints not be combined excessively and that mixtures be limited to two or three colors to avoid muddying the tones. Therefore, it is a good idea to test mixtures on scrap paper, trying possible combinations and saving the best ones, while always remembering to make notes of the mixture.

To mix colors, it is best to begin with a base color, which in this case is yellow ochre.

To create new tones, the artist can begin with different proportions of the three primary colors. Mixing yellow, red, and blue in that order results in an ochre color if yellow is predominant, raw sienna if the amount of red is higher, and a blackish brown if the proportions of blue and red are increased.

A little amount of carmine red is added to the previous color to create an intense brown.

Tone variations are created by mixing tiny amounts of green and white to the resulting color.

When the desired color is achieved, tone variations are created by adjusting the initial mixture. Our palette illustrates the search for new tones to enrich the color of the paint.

DIFFERENT BRANDS SHOULD NOT BE MIXED

When painting with acrylics, it is not a good idea to mix different brands; it is better to use colors from a single source. Otherwise, problems can arise with the binding process because each manufacturer adds different types of agglutinants to the composition or different pigments. As the artist becomes more experienced with mixtures, he or she will realize that some pigments are not opaque by nature, but transparent or translucent. If these pigments are used, they should be mixed with a little amount of white or some other opaque color. If the resin binder contains water, it will lighten the color and maintain its moisture. When the paint dries, the agglutinant becomes transparent and the colors darken slightly and become more intense.

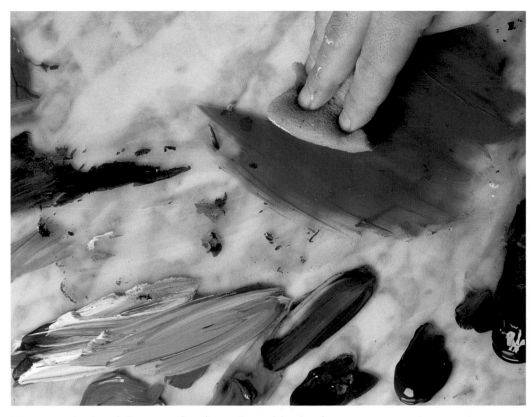

To prevent paint from drying out on the palette or from mixing in subsequent combinations, it can be washed off with a wet sponge.

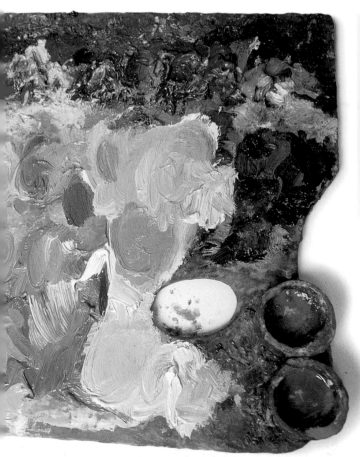

SPATULA OR BRUSH

A spatula is recommended for mixing large amounts of color because brushes get saturated with paint and are difficult to wash. A brush can be used if a small amount of paint is required, but always remember to clean it or dip it in water to prevent the paint from drying out.

The use of a spatula is recommended for retrieving paint from the can.

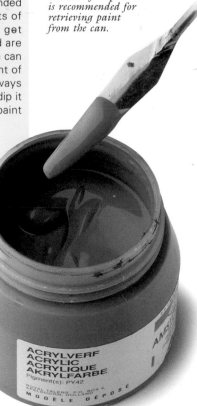

ACRYLVERF
ACRYLIC
ACRYLIQUE
AKRYLFARBE
Pigment(s): PY42

MODELE DEPOSE

Darkening and Lightening Colors

There are basically two ways of darkening and lightening colors: One is to use similar lighter or darker tones, depending on what is required, and the other is to add black or white to the mixture. The second option should be used with caution because white produces a pastel-like effect and tones down some compositions. Black muddies the mixture and alters the chromatic perception.

Lightening a color with white is the fastest method, but not necessarily the most effective.

Even when used in small amounts, black muddies light and bright colors immediately, like this cadmium yellow and light permanent green.

LIGHTENING COLORS

It is easy to darken colors by mixing them with other colors, getting farther away from the desired tone. Amateur artists tend to use white to lighten color mixtures, but it is important to remember that white, in addition to producing lighter tones, gives the mixture a pastel-like quality and also takes away some of the luminosity. It is always better to use the lighter colors of the same chromatic scheme, because the resulting tones will be lively and luminous. Also, white turns colors gray, cooling warm tones and warming cool tones. However, this should not deter artists from using white; on the contrary, if the white is used skillfully in contrast with other purer tones, the result will be a creation rich in light and color.

If the artist wishes to lighten a violet color that is too dark, a lighter violet should be used before proceeding with the white. White should always be used in moderation.

White has been used in these two mixtures to lighten them. However, the color has acquired a gray tone in the process.

BLACK IN MIXTURES

A similar phenomenon occurs with black. When used in color mixtures, it turns them black rather than darker. This is easily noticeable with the light permanent green of the illustration. Also, black spoils the tone when mixed with other color combinations. For example, when black is added to yellow, it alters the tone besides darkening it, turning the mixture into a muddy green.

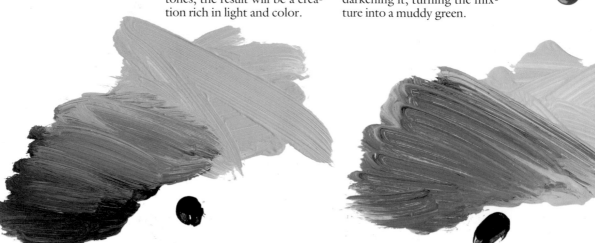

A very dark color, practically black, is obtained by mixing pink, burnt umber, and Prussian blue, or phthalo green and burnt umber.

To darken colors without turning them black, it is best to use the darker tones of the same group.

Yellow is made darker with ochre.

DARKENING COLORS

The cleanest way to darken colors is to use a darker tone of the same group. Yellow can be darkened with ochre, light permanent green with phthalo green, and cyan blue with Prussian blue. If no darker color is in the group, sienna tones can be applied. Black should be used only as a last resort.

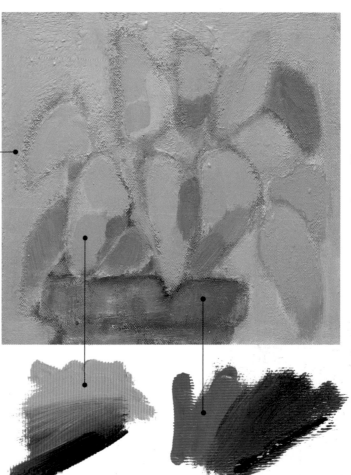

To darken permanent green, phthalo green is added.

Cobalt blue is darkened with Prussian blue.

CREATING BLACK

When emerald green is mixed with magenta and Prussian blue, the result is a very dark black. This color can also be created by combining magenta, burnt sienna, and Prussian blue. The combination obtained this way is called a mixed black because a particular color tendency can be achieved with it by using one color predominantly over the others.

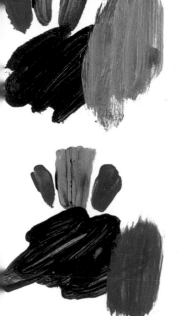

The range of grays is created by adding a touch of white to the mixture of blacks.

It is a good idea to make a habit of properly closing the tubes after each session; otherwise, the opening can become obstructed.

CARING FOR PAINT TUBES

It is a good idea to close the tubes properly at the end of each painting session. If they are left opened, the paint around the tube's mouth can dry out in a short time and obstruct the opening. Also, it is a good idea to store the tubes of acrylic paint in a plastic container with a tight lid. If, despite such care, the paint around the mouth hardens and makes opening the lid difficult, you can try loosening the lid by running it under warm water.

Washes

Most of the effects associated with watercolors can be achieved with diluted acrylic paints. Washes created with acrylics do not produce the delicate and light impression of watercolor washes; however, the resulting colors are very light and deep.

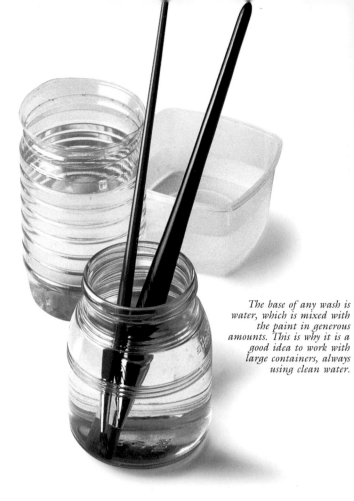

The base of any wash is water, which is mixed with the paint in generous amounts. This is why it is a good idea to work with large containers, always using clean water.

PROS AND CONS

Acrylic paint, thoroughly diluted with water, can be similar to watercolors. It offers the advantage of turning insoluble once it dries, so additional paint layers do not dilute the lower ones. This means that the artist can layer as many thin coats of paint as needed without running the risk of smearing the color underneath, which once dry is not soluble in water. However, this presents the disadvantage of not being able to apply any sponging or washing techniques, which can be done with watercolors.

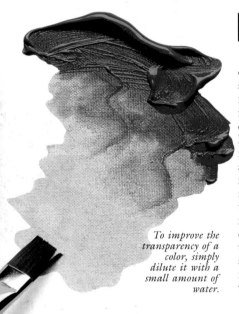

To improve the transparency of a color, simply dilute it with a small amount of water.

Degraded wash. After wetting the entire surface, the paint is spread with a dragging stroke applied in different directions, absorbing a larger amount of paint with the brush in the lightest area.

APPLYING WASHES

There are two different ways of applying washes with acrylic paints. The first one is by washing the surface of the support with a brush and clean water, adding small amounts of acrylic paint on it before the water dries out. This way the paint spreads over the wet areas. The second is by preparing two containers with medium and a small amount of two different colors, just enough to make the color noticeable. Then the brush is wetted to apply controlled washes over the dry support, superimposing one color over the other once the previous layer has dried.

CONTROLLING THE WASH

One problem with watercolors is controlling the wash so the paint is evenly distributed. With acrylic paints, this problem is solved by adding a fluidity enhancer to the wash or a small amount of matte or glossy medium. This provides the proper consistency for the paint to be applied easily. The brushstroke maintains its shape when it is applied with a medium and water, rather than with water alone, and it is easier to control. A wash increases the transparency of the color, but the paint maintains its consistency.

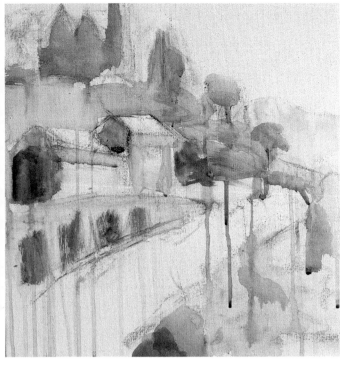

The first applications to a painting should be in the form of generous washes that resemble the first color, paying no attention to dripping.

If the artist wishes to add a medium, gel, and so on, to make the wash more transparent and consistent, the paint should be placed in one dish and the additive in another.

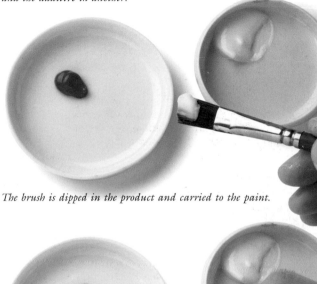

The brush is dipped in the product and carried to the paint.

WASHES AND THE SUPPORT

Paper or a hard surface primed with gesso are the best supports for applying wash techniques. Watercolor paper is ideal, and it can even be stretched if needed.

Also, beautiful effects can be created by layering transparent paints on untreated canvas. The lack of absorbency prevents the paint from expanding too much, creating delicate contours and slightly diffused colors that maintain their glossiness.

The paste is mixed into the paint thoroughly with the brush for paint that is more fluid and easier to use for applying washes.

A B C

*Notice the different intensities of cobalt blue. Straight out of the tube is the darkest (**A**). By adding a thinning medium (**B**) or a thickening gel (**C**), lighter tones are created.*

EFFECTS OF WET ON WET

Acrylic paints can be applied wet on wet. Colors are spread on the support while they are wet and are left to flow freely. This spontaneous effect is similar to painting wet on wet with watercolors.

Layering with Glazes

Because acrylic paints are insoluble, a painted surface that is dry can be painted over without being altered. Also, as with watercolors, acrylic washes should be applied with a firm, steady hand, achieving the desired result the first time, without the need for corrections.

Glazing offers the possibility of mixing the paint right on the support. The resulting colors are richer than if they were mixed on the palette.

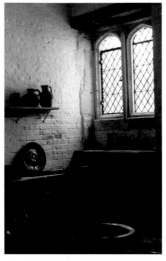

Interior with a bright source of light coming from outside through a window.

GLAZING

Glazing consists of applying a thin layer of transparent color over some areas or over the entire painting. In other words, covering a color with a glaze can create specific color effects. Glazing can be done with any acrylic medium or paint. The mixture is applied on a painted surface that is already dry, so as not to alter the background, or over the still wet paint if the desired effect is a fusion of both layers. The latter must be applied quickly to prevent the base color from washing off.

GLAZING ON OPAQUE

A layer of opaque paint can be painted over and covered completely, once the first layer is dry. Layers of paint that have been previously thinned with a medium can also be added over this. Glazing with acrylics is used not only to create graphic effects, but also to create different glazing gradations. A painted area that is already dry can be graded with glazing. This way, if something is painted on a white or colored surface, its edges can be graded over the layer already painted by wetting the area beforehand.

INCREASING THE TRANSPARENCY

A commercial paint that is transparent, opaque, or semi-opaque can be treated to increase its transparency. Commercial paints produce the most spectacular effects. There are two methods for increasing the transparency of an acrylic color: by adding water to the paint to obtain a very thin layer of color or by mixing the paint with a transparent acrylic medium.

2. When the initial glazing dries out, a second glaze is applied with different tones to better define the window frame and the volumes of certain objects.

1. Once the drawing is completed with graphite, painting begins with a first layer of brown glaze. This will help define the shaded areas.

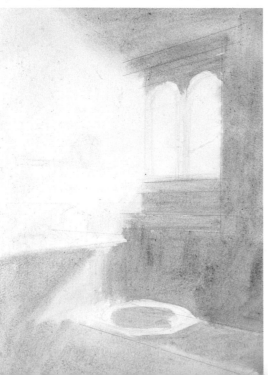

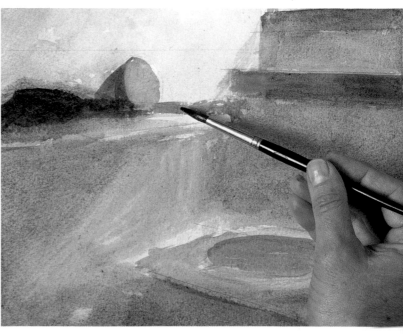

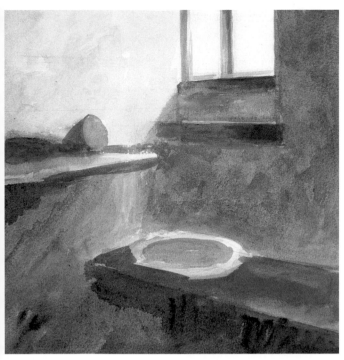

3. *The bottom part of the painting is darkened with new translucent brushstrokes, creating the feeling of a defined atmosphere.*

ATMOSPHERIC EFFECTS WITH GLAZING

Acrylic paints make it possible to create interesting glazing effects. By superimposing several washes, tones become more intense, mimicking reality. Glazing is the ideal method for creating atmospheric effects, to represent the space that lies between the observer and the object represented. To cite an example, imagine a room with bright light coming through the window.

A thinning medium is added to the paint to give the glaze the desired transparency.

COLOR FILTERS

The entire surface of a painting can be glazed over to create an overall, dominant tone. On the other hand, glazing can be applied sporadically to alter the color of individual objects that have already been painted. Applying glaze over the entire painting is like covering the surface with a color filter.

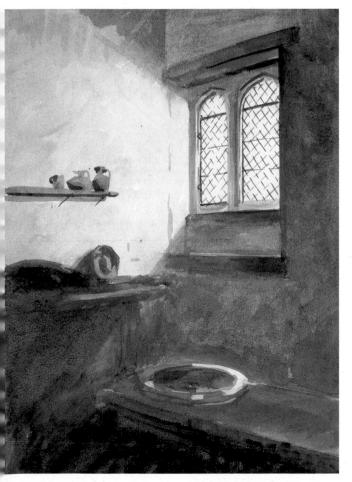

Repeated layers of glaze create brown and gray gradations that become darker as they go from the window down toward the bottom of the painting. Finally, the metal grid of the window and a few other objects are painted directly using a fine, round brush.

This illustration shows how ochre glaze partially covers a painting, changing its harmonious color.

Gradations and Transparencies

Acrylic paints are often used to create transparencies. To do this, they must be diluted to the maximum, as if they were watercolors, and should be applied in successive layers over the previously painted ones, until they form new colors that convey the feeling of depth or add an interesting grading effect to the composition. When practicing with gradations and transparencies, it is best to use watercolor paper, because the results are easier to control.

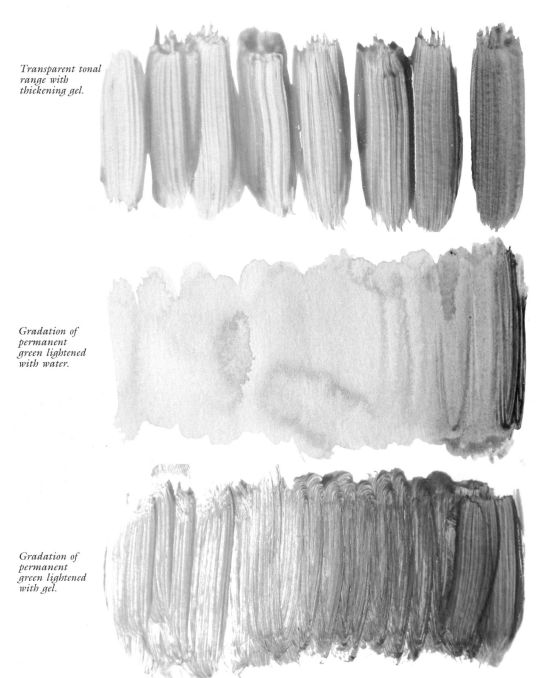

Transparent tonal range with thickening gel.

Gradation of permanent green lightened with water.

Gradation of permanent green lightened with gel.

To create a gradation, the surface is wiped from top to bottom with a clean brush. This way the color will be graded without having to go back and forth with the brush, which could ruin the gradation.

TRANSPARENT TONAL RANGE

It is easy to see that the greater the transparency is, the lighter the tone becomes. When the tones are classified, arranging them from darker to lighter, a transparent tonal range is created. This is done by diluting the paint with water or with a medium for the thinner layers, and by adding thickening transparent gel for those that are pastier and have more consistency.

A mixing well is used for the task, and the paint is placed in it. A brushstroke of that color is applied. Then, a medium in gel form or water is added with a brush to the portion remaining in the well, only once, and it is mixed. A lighter tone is already noticeable with the second brushstroke. The same procedure is repeated for the third brushstroke, which will be lighter than the one before.

GRADATIONS

A gradation consists of a gradual transition between colors within the same tonal range. This is done beginning with a specific color that is applied on the surface of the support with a soft brush and following the same direction, the one toward which the color change will occur. As the support is lightly stroked with the brush, a portion of the color or tone that is to be incorporated is added to the edge of the gradation and is softly brushed in the same manner toward the initial color. This procedure is repeated until the two tones are completely blended.

SOFTENING TONES AND EDGES

When making transparencies with acrylic paints, it is difficult to avoid harsh edges. Although it is easier to correct the borders with watercolors, there are two ways of doing it with acrylics. One way is by wetting the paper—that is, by using the right amount of water to wet the paper and make the paint flow over the wet area. The other is by applying a heavy brushstroke of transparent paint with a thick, round brush. Then the outline is softened with a clean brush dampened with water. Because a thin layer of acrylic paint dries very fast, the process should be executed quickly.

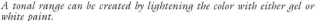

A tonal range can be created by lightening the color with either gel or white paint.

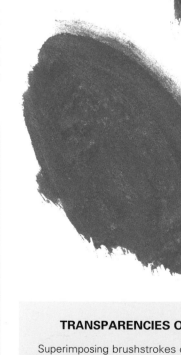

This is the procedure to follow for softening the outlines of certain objects. After applying the paint to the desired area, the edge is softened by smoothing out the paint with a different small brush and softening the transition between the colors.

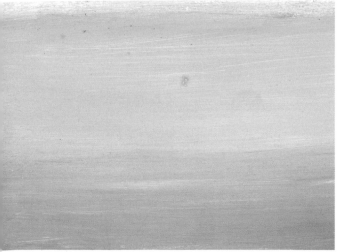

The blended gradation effect constitutes a perfect background to begin painting. This background could represent, for example, a clear evening sky.

TRANSPARENCIES ON PAPER AND FABRIC

Superimposing brushstrokes of transparent paint on canvas produces a different effect than it does on paper. Pigment particles settle in the weave of the fabric, enhancing its texture and creating expressive medium tones.

Transparent Impastos

A very diluted layer of paint can be applied over impasto or over an area with heavy textures or a relief done with paste. Conversely, thick translucent impastos can be applied to modify the final perception of the background color and the relief of the surface of the painting.

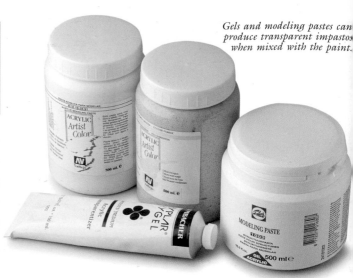

Gels and modeling pastes can produce transparent impastos when mixed with the paint.

TRANSPARENCIES WITH TEXTURE

The different commercial mediums available for acrylic paints can be used to create a number of effects. A small amount of acrylic paint thoroughly mixed with a thickening gel provides a glossy color effect if applied over a surface that has already been painted. To do this, it is better to add a small amount of color to a large amount of gel—and not the other way around—so the transparent paste is slightly tinted by the color. The combination should be thoroughly mixed with a brush until the desired tone and consistency are achieved. Then, the impasto can be applied over the paint in different ways. Do not worry if the paint initially shows a thick white film, because the gel does not become transparent until it dries. A combination of white acrylic paint that is thick and textured with a colored transparent glaze produces a glossy effect and a type of surface that changes according to the light.

A thick gel glaze can be applied with a small amount of very diluted violet color on a white background.

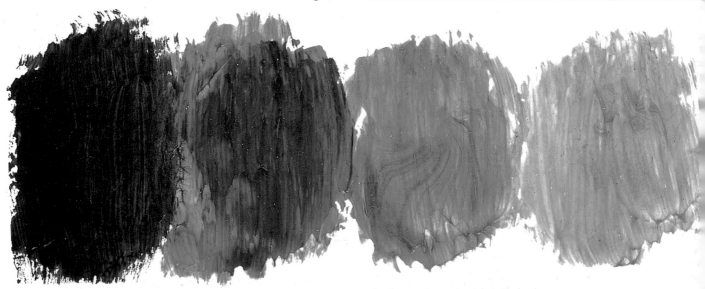

A color can be rendered completely transparent without losing its intensity or body, by using the medium by itself.

Glazed impastos can be obtained by mixing a small amount of color with the transparent gel.

The effect shown in the illustration is created by placing a piece of paper over the impasto and removing it after slight pressure is applied.

Pressing with the tip of the brush breaks up the evenness of the impasto and creates a much bolder effect.

Any object can be used to distress the surface of the gel. For example, a comb produces the irregular lines shown in this illustration.

TEXTURES WITH TRANSPARENCIES

Acrylic transparencies are not in competition with texture; on the contrary, this medium lends itself perfectly to textures and to the modeling executed with the brush. The pasty consistency of the medium favors the creation of round shapes that mimic certain results, giving way to texture and forms with a three-dimensional effect.

GLAZING OVER WHITE IMPASTO

A textured surface can be created by applying modeling or thickening paste over the surface. After it dries completely, it is painted over with very diluted colored glazes and the excess paint removed with a paper towel to create the effect of an impasto. This way, when the brushstrokes are glazed with an even color, it appears as if the impasto had been applied with the color of the glaze.

WASHES OVER TEXTURE

The technique of painting with washes can also be applied over a thick layer of paint. This way, the new layer will concentrate in the pores and crevices of the painting's surface, creating the typical broken effect of the texture. In addition, because of its transparency, the color of the superimposed glaze modifies the appearance of the colors that are underneath.

Glazing can be applied when the impasto is dry, so the color that is deposited into the lines made by the brush produces an interesting effect.

Dry-Brush Technique

The dry-brush technique can produce very interesting effects. The technique consists of rubbing the relatively dry paint over the surface of the painting. This effect is achieved with a bristle brush over a textured background, where the high areas catch the paint but the original color stays in the low areas.

A sunny street with stone walls offers different textures that can be created with the dry-brush technique.

RUBBING ON THE PAINT

The dry-brush technique consists of painting with abundant, almost undiluted paint in such way that dragging the brush over the paper reveals its texture. The dry-bush technique produces a broken effect that partially covers the surface of the support. A rubbed effect can be created by applying different layers of paint or tonal effects using a dry brush and a very small amount of paint. This technique should be carried out quickly to prevent the paint from drying in the bristles.

The bristle brush should be old and worn so the marks are more visible. A brushstroke applied over a dry background gives the work more expression.

UNDILUTED PAINT

It is important to charge the brush with the right amount of paint; otherwise, the support will be completely covered and it will ruin the effect. When the dry-brush technique is applied with acrylic paints, the excess water should be eliminated with a rag or paper towel. If the paint is thick, which is normal in this technique, the paint should be dispensed onto the brush right out of the tube before it is worked on the palette or on a rag. Because the paint is thick, it remains on the surface of the paper or on the texture of the canvas, so small areas of the support or of the background color remain visible. The paint adheres only to the raised grain of the paper, and this creates a mottled effect.

BROKEN COLOR

The dry-brush technique can be used to paint directly over the clean canvas or paper, but this method is particularly effective on a support already painted with a base color. So, the color that is underneath can be exposed in some areas, producing an interesting final effect. The example in this exercise shows a sunny, old street in a small village painted by Óscar Sanchís.

The more textured the paper is, the coarser the paint will look on the surface of the support.

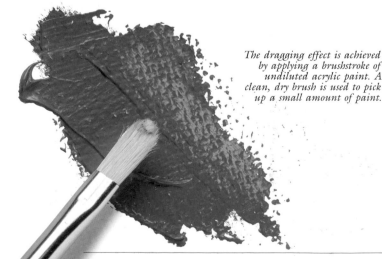

The dragging effect is achieved by applying a brushstroke of undiluted acrylic paint. A clean, dry brush is used to pick up a small amount of paint.

The brush is rubbed against the unprimed fabric or over an area of paint that is completely dry.

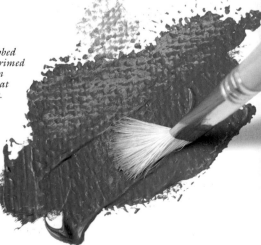

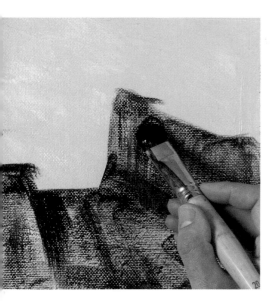

1. To create the large shaded area of the bottom of the painting, the paint is applied thick and semiopaque, very lightly, and with broad, controlled brushstrokes.

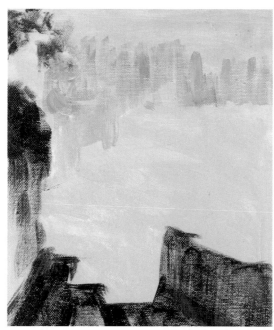

2. The blue of the sky is created with vertical, dry brushstrokes. The idea is to paint a gradation that goes from a lighter tone, near the horizon, to a darker blue toward the top of the painting.

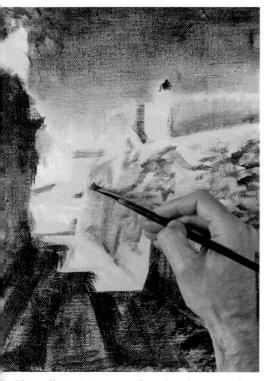

3. The medium tones emerge where the paint approaches the surroundings, where the color of the support is still visible in the texture of the wall and the areas of light.

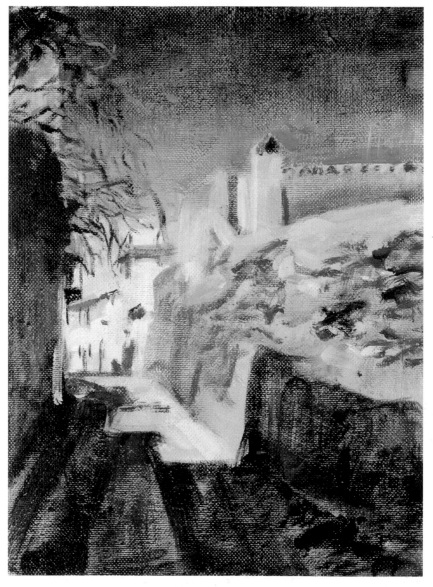

4. The result is a color sketch with interesting texture effects, where the different layers of color are superimposed.

Flat Paint

Acrylic paints are particularly suitable for this technique because they can be applied very easily. This medium allows each area of color to be properly contained with outlines that are well defined and "filled in" with a flat, even color.

Painting with a flat medium requires preparing enough paint to cover the entire surface evenly.

Before working with flat paint, it is important to make a well-defined drawing clearly showing the different areas of contrast.

tones, depending on the light that each plane receives and on the purity of each color.

THE IMPORTANCE OF DRAWING

One of the fundamental aspects of every piece of art is the drawing. Without it, it is impossible to embark on any project. The painting that will develop from it is made up of colors that are completely flat, without any type of shading, therefore each area of the drawing must be perfectly defined by enclosed lines.

FLAT STROKES

One of the characteristics of acrylic paints is that brushstrokes blend together without causing tonal changes. This produces a completely flat appearance, with color variations through a progression of areas and without the need for gradation. An example of this can be seen in the painting of this rural landscape.

The paint should be applied opaque and flat, and should be spread thoroughly to cover the color of the background.

FLAT AREAS OF COLOR

The method of painting with flat colors is similar to working with gouache, which is an opaque form of watercolor. Acrylic paint works better than gouache because the paint can be applied layer upon layer without mixing them together. The tonal variation is achieved as a result of the flat, separate areas of even color. Flat color is one of the basic techniques of colorist painting; there is no need for value because the contrast is achieved with the use of different colors or with the overall simultaneous contrast. The color is applied within each area, keeping in mind that each will affect the surrounding colors and

THE TRADITION OF POSTERS

Billboard advertising has traditionally used painting media to achieve a surface that is flat, with no tonal changes, quick drying time, and, whenever possible, a matte finish. Tempera was the most commonly used medium for many years, but acrylics have taken its place because they allow for better layering, do not soften the lower layers of paint, and are completely resistant to water.

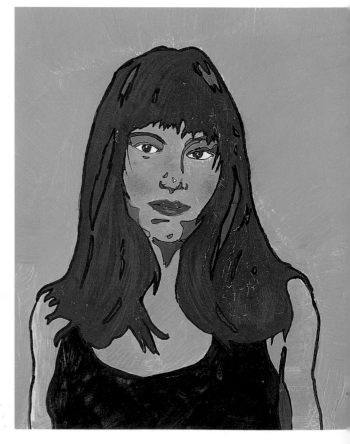

Each sketched area is painted with a color or tone that perfectly stands out against the adjacent color.

3. *Same is true for the background. The execution of the clouds and the distant mountains will be consistent and without gradation.*

The landscape is clean and presents areas of well-defined color. It is the ideal model for working with flat paint.

1. *As explained previously, the drawing is vital because it helps define the planes and tones as separate masses, independent from one another. The first applications of even color are applied over the drawing to depict the grass.*

2. *The volumes and texture of the vegetation are represented through gradations of dark green into yellow and lighter green tones.*

4. *The first application of color is quick, but the last one is even quicker because there is a well-thought-out plan to guide the brush and the new tone. In this case, it is not so much a matter of following the form with color but defining the areas of light and shadow.*

Preliminary Drawing

A preliminary drawing serves several purposes. It can be the base for a subject matter that is appropriate for acrylics, but it also serves to define the theme and to lay out the composition.

steps of the painting have no other function than to approximate the colors to the model. Acrylic paints can be worked practically as washes, without consistency or density. In such cases, the support should be maintained flat, without tilting

it at all, to prevent paint from running. As the work progresses with denser paint over a dry background, the support can be tilted again. Nevertheless, many artists choose to work with the support completely flat.

THE DRAWING ITSELF

Drawing before painting is not absolutely necessary. Some artists sketch only a few pencil lines or a few marks with the brush to establish some reference points for the composition. However, unless the person has a lot of experience and knows exactly how the painting is organized, it is a good idea to make a preliminary drawing, especially if the composition has any complicated or difficult elements. If the medium used is opaque, the paint will cover the sketch, so any material can be used for the drawing. However, it is a good idea to stay away from charcoal if the first steps of the painting used light colors, because they could be muddied. Some artists prefer to maintain the purity of the colors from the very beginning.

PRELIMINARY OR QUICK PAINTING

Paintings are created in layers, beginning with the general application of color, which establishes the composition and the forms. The initial applications can be executed loosely because they will be changed later and the first

The preliminary drawing can be executed with charcoal. However, it is a good idea to wipe it off with a clean cloth to prevent the fine dust from muddying the acrylic paint. The lines of the finished work can be redrawn with a brush and a diluted blue paint.

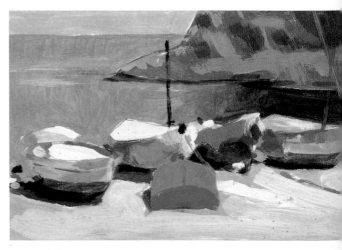

This shows three sequences of a correct process—the ideal way to begin painting with acrylics. The background is covered with flat and clean colors. Then, parting from the previous-colored base, the composition and layering of tones continues to define the forms.

When the background has been completely covered with paint, a second layer of color is applied to better define the initial sketch.

If the work is going to be executed with washes and diluted colors, drawing with a graphite pencil is recommended. The sketch should be precise and linear, because it will serve as the base for the initial phase of the painting.

EVOLUTION OF ACRYLICS

Forms, tones, and colors begin to solidify in the first dry layers of acrylic paint. If the base is not completely dry, the artist can mix the colors, creating in this way an interesting effect of solid, blended color. The development of the painting may involve any acrylic method, including blending tones in some areas or incorporating opposite colors that create simultaneous contrasts. Sometimes, there are areas that allow the bottom layer of paint to show through when the work is finished, so it is important to choose the color carefully.

TRANSPARENT TECHNIQUES

The wash techniques require more preparation. Mistakes cannot be concealed without sacrificing the transparency; therefore, the preliminary drawing must be more elaborate. This drawing would not present any problems because pencil lines go well with watercolor effects. It is important to remember, though, that once the pencil lines have been painted over they cannot be erased because they are protected by the film formed by acrylic paints. Therefore, it is important to draw the lines softly, avoiding shading and delaying painting until the artist is completely sure that the drawing is correct.

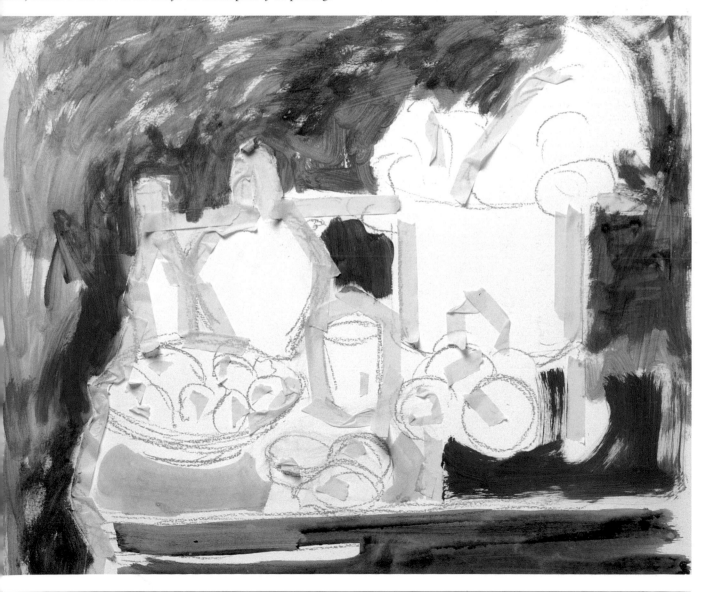

Opaque in Acrylics

The artists who work with acrylic paint often use it in its opaque form. Acrylic paints adapt well to opaque techniques, and because the mistakes can be corrected by painting over them, this is probably the best way of getting acquainted with the painting process.

After the graphite drawing is completed, the main lines are reinforced with gray paint. Then the first areas of color are applied using flat and opaque colors.

OPAQUE TONAL RANGE

If the artist wishes to create an opaque tonal range of a particular color—in other words, an organized succession of tones—white paint should be added gradually. We begin with a specific amount of color, which is placed in a well. The first stroke, which is the one that has the highest saturation, is applied. The brush is thoroughly cleaned with water, and a small amount of white paint is dispensed with it into the well, where both colors, the original one and white, are blended thoroughly until an even mixture is achieved. With the same brush an application is made next to the first one by repeating the process several times, and a range of opaque tones is produced.

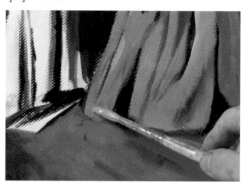

The paint used should be dense, although it is not necessary for it to create texture—that is, to leave brushstroke traces on the support.

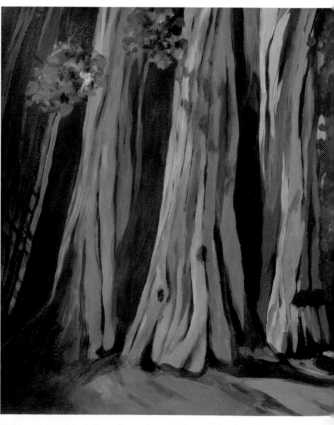

Volume is expressed through tonal gradation, using opaque paint to combine light and dark tonal ranges.

MAINTAINING THE OPACITY

The paint that comes directly out of the tube is opaque, which means that it has high covering power. To maintain its opacity, the paint must be mixed with a medium or with colors that preserve that property. An opaque, semiopaque, or transparent color can be maintained or rendered opaque when mixed with another opaque color. Also, adding acrylic products that have that property (such as gesso, modeling paste, or pumice) can produce mixtures that are very opaque. To maintain the opacity, a little bit of medium is added to the paint.

PAINTING WITH OPAQUE COLORS

Opaque colors can be applied quite satisfactorily over a background with medium-tone washes. First, a pencil sketch is drawn and then shaded with a blue color wash, leaving the white of the support visible for the light-colored areas and for those touched by light. Then the color is applied over it. It is not necessary for the opaque paint to be thick. Opaque, matte, and even finishes can be achieved with the paint used straight out of the tube or even diluted with a small amount of water.

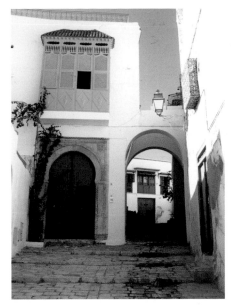

The dominant element of this theme is light, and it shows clean and lively colors.

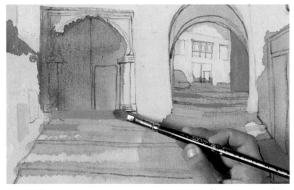

1. First, the model is painted with loose, linear strokes. A blue wash is painted over the structural lines to separate the areas of light and shadow.

OPAQUE AND TRANSPARENT COLORS

Some acrylic colors are opaque by nature—for example, cadmium red, yellow ochre, and chromium oxide. Other color varieties, because they are less pigmented, are more transparent, such as quinacridone red or the range of yellows. In those cases, colors can be rendered opaque by mixing them with white or with any other opaque color.

2. Several strokes of color are added to the pavement, and the arches are painted. The color applications are flat, executed with thick, perfectly defined brushstrokes, without gradations or color transitions.

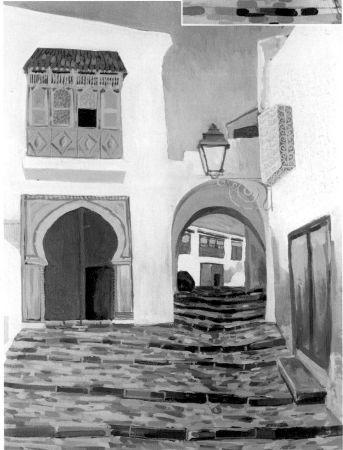

3. More, gradually smaller strokes of color are added to the previous ones on the pavement. The building façades and the sky are executed with colors that have been slightly graded. Once the large areas of color are established, a similar procedure is used for the details, but this time using a smaller brush.

4. The painting has been carried out with opaque colors, using gradations only when needed and preventing the colors from mixing with each other. The color range used is characterized by the clean, luminous colors. The style is somewhat reminiscent of naive art but convincing.

Painting with the Sfumato Technique

The sfumato, or modeling, technique, which is closely related to the dry-brush painting method, is usually executed with thick paint, although it can also be done with diluted paint. It consists of blending the outlines of the masses of color, giving the work an atmospheric feeling and a certain airy effect.

Here are a couple of examples of how two colors should be blended using the dry-brush technique: applying circular motions over a dry background with the bristles of a worn-out brush.

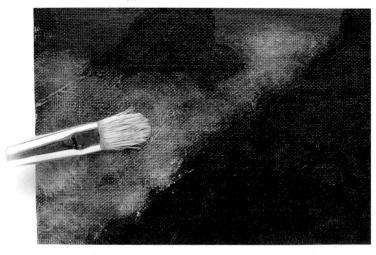

The sfumato technique is applied with the idea of creating an airy mist among a group of mountains, incorporating the color with circular movements.

BLENDING

Blending consists of making one color flow softly into another without a brusque transition. Physically blending is actually making a true mixture of the colors.

The paint is usually applied with a light rubbing movement, using a hard brush, a rag, or even the fingers. If the work is executed on a canvas or a canvas board, the roughness makes the job easier because the paint only sticks to the area of the texture that stands out. However, it can also be modeled on a flat surface, such as the hard textured board.

Blending is done with a clean, wet brush. It is easy to create soft transitions with transparent colors. On the other hand, the blending of opaque colors requires that the work be executed quickly because of the short drying time. Transparent colors make it possible to create tonal gradations with superimposed layers of diluted color, and to soften the tone at every step with a clean, wet brush.

BLENDING TWO COLORS

Blending two colors requires rubbing over the line that separates the two mixtures until the transition is softened. To do this, whenever a different pair of colors is involved, it is a good idea to wash the brush thoroughly with water, and to dry it. Notice how the fusion greatly softens the tonal transition, although this effect is not always desirable.

APPLYING THE PAINT

It has been mentioned before that the paint is applied with soft rubbing motions, using a hard brush, a rag, and even the fingers. This way the blending effect is coarse, and the lines remain concealed. This artistic effect derives from oil painting, although it is more appropriate for acrylic paints because they dry much faster.

This technique can be combined with the previously mentioned dry-brush technique, because, as it has been explained, they are both closely related.

SFUMATO WITH THE FINGERS

One of the least conventional ways of applying sfumato is by blending by hand. For this technique, the composition is painted first with relatively flat tones, and then the colors are blended while still wet, using the tips of the fingers. The final touch consists of new glazing, which will give the composition a greater atmospheric effect. See a sample of this technique in a winter mountain landscape with snow.

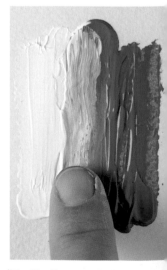

The blending can also be carried out with the tips of the fingers. Both colors are blended over the line that separates them with back-and-forth movements.

This luminous mountain landscape with snow will be transformed into a scene using the effects of sfumato.

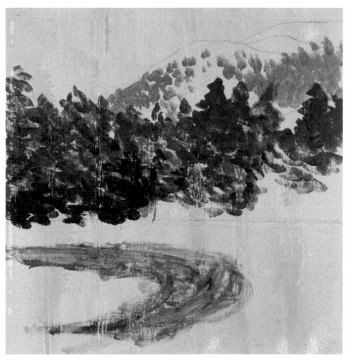

1. The preliminary under painting is applied over a gray background to identify the main elements of the composition.

2. The composition has been defined with short, dry brushstrokes. Around the tree groupings the color is more opaque and has more covering power.

3. Glazing is applied with white and diluted violet color to give the painting a feeling of sfumato. Contrasts should be kept to a minimum, and color transitions should be soft and gradual.

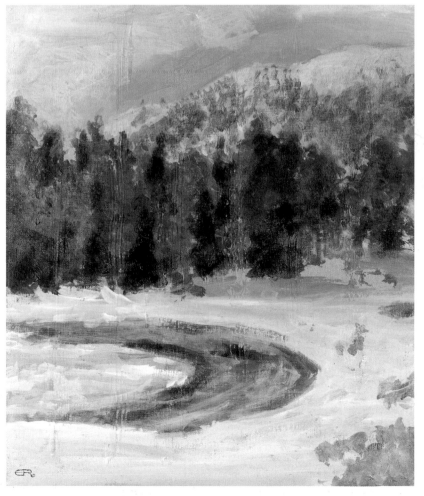

4. When blending with the fingers, it is important to remember that the previous color should not be covered completely. The sfumato technique produces an atmospheric effect.

Painting with Impasto

mpasto is a technique for acrylic paints that emphasizes the feeling of volume and textures. Working with impasto allows the artist to model the surface independently of the color, making it possible to emphasize the tactile quality of the painting. The application of impasto offers many possibilities, such as the creation of effective textures, to take advantage of the direction of the brushstroke or to give the painting more expressiveness.

Acrylic paint can also be applied with thick impastos that give the surface a textured effect, without losing the quality that characterizes the medium.

IMPASTO

Impasto is the name given to the painting that is created with heavy layers, where the marks of the brush or spatula are highly visible. Because impasto shows the brushstroke traces, it is also used to create special effects or to represent direction and volume. The texture of acrylic impasto is similar to that of oil paints, its only difference being the drying time, which in acrylics can be less than 24 hours. Even when the layers are very thick, acrylic paint remains flexible and does not crack.

PAINT IN TUBES

Acrylic lends itself to impasto, if the paint is used straight from the tube, thanks to the special characteristic of one of the polymers found in acrylic paints. Given the thick, creamy consistency of acrylic paints, it is not a good idea to mix them with water or with any other solvent.

The consistency of acrylic paint is creamy, making it ideal for impastos. If the artist wishes to create thick impastos without a gel, it is better to purchase large containers instead of the traditional tubes.

A

B

C

There are many ways to treat the surface created with impasto. Here are the three most common: (A) striated (the colors blend on the surface of the painting); (B) directional (all the brushstrokes present a specific direction, which helps describe the volume of the objects represented); (C) irregular (made up by superimposing random and expressive brushstrokes).

IMPASTO WITH A BRUSH

Impastos can be produced with very opaque colors applied with a brush. Although the effect created is similar to that of oil paints, acrylics provide a different texture and a characteristic color quality. Paint should be flexible, but it should also be sufficiently dense to maintain the stroke and the mark created with the brush. When the colors are applied with impasto, the thickness of the paint cancels the transparency of the color and makes the brushstrokes visible. If this technique is to be used for a painting, the filbert brush is recommended, because it is versatile and create all types of marks.

Dens acryli paint car provide a lo of coverage so muc that it car completel cover the dr pain underneath

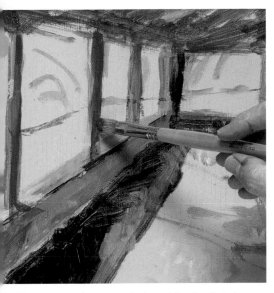

1. To execute an impasto painting with a brush, it is a good idea to progress from less to more—that is, to start with less dense colors that allow the original design to be corrected.

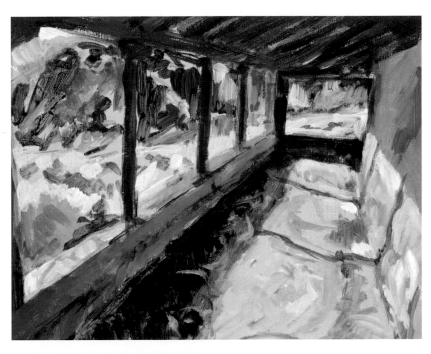

2. As the painting progresses, the brushstrokes become larger and denser, and the bristles carry more paint.

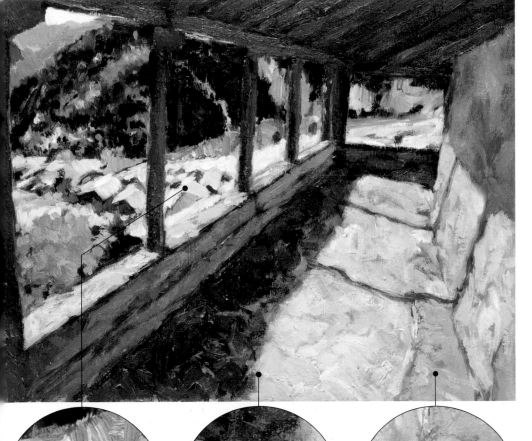

ADDING MATERIALS

The quick drying time and extraordinary versatility of acrylic paints make this an exceptionally suitable medium for adding other materials. The mixture can be made sandy and coarse by adding sand, sawdust, or wood chips to latex or acrylic paint. These materials can be thoroughly mixed with the paint on the palette or sprinkled over the support while the layer of paint is still wet.

3. In the applications in this last step, it is seen that the brush can model the paint on the canvas, leaving the characteristic trace of the bristles.

A spatula can be used to apply large quantities of opaque and dense paint directly on the surface of the canvas.

The paint applications will be more precise and marked if the work is done with the tip of a spatula.

PAINTING WITH A SPATULA

A spatula is suitable for working with acrylic paints, not only for mixing them on the palette but also for applying them to the surface of the painting. At first glance, a spatula may appear less precise than the brush, but it allows the creation of very attractive and creative textures. The main difficulty when using a spatula with acrylic paints resides in the application of details and concrete shapes. Although the edge can be used for this task, the straight side can produce only small marks or applications of color.

The paint should not be diluted if a spatula is used; instead, it should be applied straight out of the tube. The largest spatula is recommended for the first phase of the work, saving the smaller ones for later applications. It is a good idea to experiment with the different ways of applying the paint, to scrape it and flatten it, and to discover the wide range of possibilities that this technique offers for creating texture.

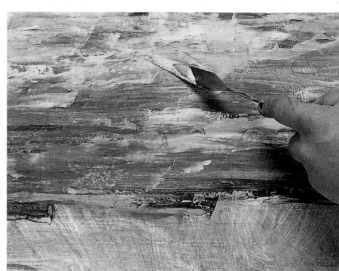

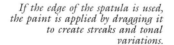

If the edge of the spatula is used, the paint is applied by dragging it to create streaks and tonal variations.

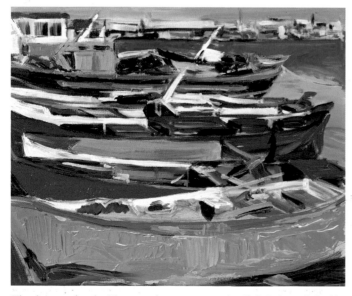

The themes painted with a spatula are not very detailed. It is precisely this coarse, undefined finish that gives the work an expressive strength.

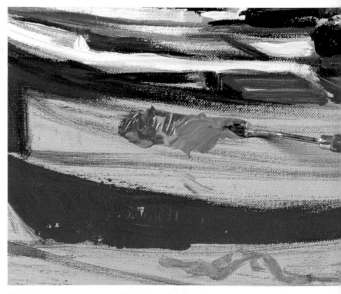

If the impastos are created with a spatula, it is sometimes interesting to mix the colors directly on the surface of the painting instead of on the palette.

PASTE FOR MODELING AND GEL

The real function of the gel and modeling paste is to create textures that are almost three-dimensional. This is something that only acrylics are capable of doing with some guarantee of success. They are used to produce pronounced textures and three-dimensional effects on a hard surface and to minimize the use of paint. The color does not change when modeling paste is added to the paint. However, if a thickening gel is used, the mixture appears lighter at first until it dries because the gel is white, which makes it difficult to gauge the strength of the mixture. It is a good idea to mix the colors before adding the gel.

This painting is an interesting composition in which the texture of the palm trees lies in contrast to the arid ground of the desert.

1. The first step is to prepare the background with generous applications of paint, using a flat bristle brush.

2. When the background paint is dry, the color details are added: The paint, which has previously been mixed with thickening gel, is applied with a spatula to create the first groups of palm trees.

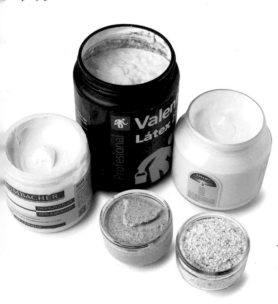

There are many complementary products available that are suitable for adding volume to the paint, making them ideal for painting impastos.

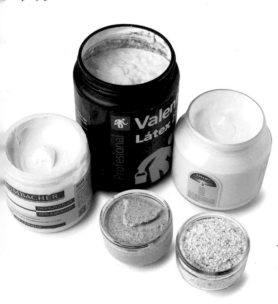

3. The completed painting shows how the thickening gel and the spatula produce interesting texture effects on acrylic paint.

Spattering and Spraying

Sprayed dots look attractive on even surfaces and give a strong atmospheric feeling to the composition.

The spattering and spraying technique consists of splashing the paint on the support. Applied with washes and drips that enhance the atmospheric effect of the painting, the technique is an effective way to suggest grainy textures and to provide consistency to the flat areas of color.

SPATTERING THE PAPER

Artists can experiment with spattering on paper by dipping an old toothbrush in paint that has been diluted a little and then scraping the bristles with a knife or with the fingers. The paint will fly out in a mist of small drops spraying the surface of the paper. It is important to keep in mind that for this technique to be successful the paint should be thin, although not too wet. It is possible to cover an area with heavy spraying in a short amount of time and without mixing the colors, thanks to

the quick drying process of acrylic paints. To apply this technique, the support should be flat on a table to keep the sprayed paint from running and smearing.

SPATTERING WITH A BRUSH

Spattering can also be done with bristle brushes. For example, a finer mist can be applied by using a brush with short bristles. Also, a large bush charged with paint can be tapped against the palm of the hand or against another brush to spray larger areas. To create large, oblique blocks of color instead of dots, the brush should be held at an angle. The density of the dots is reduced or increased by changing the distance between the brush and the surface of the painting.

The toothbrush is charged with paint. This can be done by dipping it in a well or by transferring the paint to it with a painting brush.

SPATTERING WITH RESERVES

It is difficult to control the area to be sprayed; therefore, it is important to work with reserves—that is, to protect or to limit the areas of the surface that need to be sprayed, preventing the others from being painted. To do this, a cardboard stencil or paper tape is used.

This picture, which represents a simple subject but has a variety of textures, is used as the model.

1. The process begins by covering the background of the picture with flat tones and reserving, without painting, the area of the windows.

Using a knife or any other object, the bristles of the brush are scraped away from the direction of the paper.

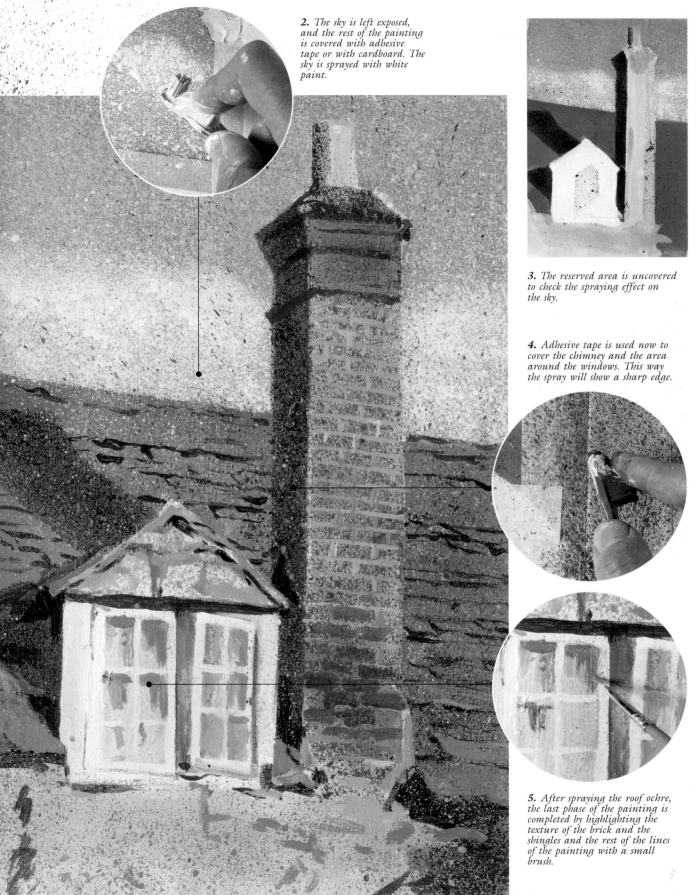

2. The sky is left exposed, and the rest of the painting is covered with adhesive tape or with cardboard. The sky is sprayed with white paint.

3. The reserved area is uncovered to check the spraying effect on the sky.

4. Adhesive tape is used now to cover the chimney and the area around the windows. This way the spray will show a sharp edge.

5. After spraying the roof ochre, the last phase of the painting is completed by highlighting the texture of the brick and the shingles and the rest of the lines of the painting with a small brush.

6. Notice how the spraying gives a rich textural quality to the composition in the finished painting.

Scraping and Rubbing Techniques

There are many different ways of applying acrylic paint. The scraping technique, among them, offers very interesting results. It is ideal for creating compositions with broken colors, where superimposing them enriches the artistic effect and the texture of the painting's surface, producing a work of art with little precision and few details, but with great chromatic and plastic quality.

Spreading the paint with a metal spatula creates wide, thick, and streaky bands of color.

1. The sketch for the drawing can be made with a small brush and blue paint. The first areas of color applied with a spatula are large and flat.

SCRAPING AND TOOLS

The scraping technique can be executed with a flat spatula, a metal or plastic rasp, or even an old credit card if those tools are not available.

With scraping, the color does not need to be applied evenly. On the contrary, variety can be achieved in a composition by contrasting areas of flat paint with others that are highly textured and thick. If the artist wishes to introduce more visual variety to the composition, a trowel with toothed edges can also be used.

Scraping and rubbing allows mixing the fresh paint directly on the surface of the painting creating interesting striated effects.

2. The paint conceals the surface of the painting little by little, the first objective of the artist being to cover the white paper.

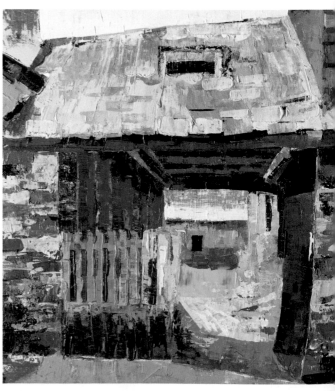

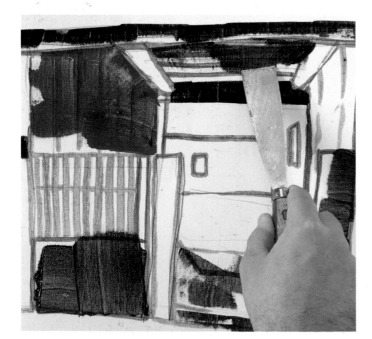

3. During the last phase, the colors are not applied evenly; instead, they have a broken effect that allows the color below to show through. Dragging the paint in the areas where the colors meet creates the texture of the stone walls and the slate roof.

Working with Textures

Texture plays an important role in acrylic painting. Texture can be created using impasto techniques, a spatula, scraping, extruded paint, etc. Acrylic paints can also be mixed with other materials, such as sand, sawdust, or a medium for creating textures.

1. The structure of the bridge is created with modeling paste, emphasizing the direction and alignment of the tree trunks.

APPLYING LAYERS

When working with paste, it must be applied in layers that are a maximum of ¼ inch (7 mm) thick, and each layer must be allowed to dry before the next is added. If layers are applied too heavily, the outer film will dry faster than the one under it, and the surface will look cracked.

MODELING PASTE

In general, modeling paste consists of washed sand, marble or alabaster dust, or grainy products that can create an even texture throughout the mass. The acrylic modeling paste, manufactured specifically to form textures before the painting begins, is applied over the entire support. It is recommended for use on a hard surface, otherwise it may crack. It can be used to create spontaneous, irregular textures by applying the paste with a spatula, by forming straight or wavy lines, or by combing the surface. Textures that are created before painting begins give good results if the paint is applied later with a glaze. Opaque paint over texture loses its power.

2. The rough texture of the wood is painted in more detail, and new shading is applied to the water.

It is important to choose a model that has an obvious textured look, like this old wooden bridge.

The modeling paste produces a compact structure that provides a hard, dimensional finish (A), or a softer, more fluid effect (B) if it is diluted with a small amount of water.

A

B

3. To create the texture of the bridge, ochre and raw sienna washes are combined and then applied over the texture with a brush charged with dark brown paste, which accumulates in the high areas.

Reserves with Acrylics

Reserves are used to isolate one or several parts of the composition so paint does not invade the adjacent areas. They also allow the paint to dry according to a specific or predetermined shape. The support can be protected with a product or a template that repels the acrylic paint that is applied over it.

THE USE OF LIQUID FOR MASKING

Transparent techniques require the use of the white of the support to represent the light; therefore, it may be necessary to protect some of the areas of the painting. A good way to do this is to use masking liquid, which covers the area that needs to be protected with latex. The product should be dry before painting begins.

Masking glue and transparent self-adhesive masking can be easily eliminated. Simply wait until the work is dry and then remove it by using an eraser or simply by rubbing the area repeatedly with the finger until the film is eliminated.

If an area that was previously reserved with masking fluid is painted over, it can be removed with an eraser or by rubbing with a finger after the paint has dried, leaving the white of the paper to show through.

RESERVES WITH ADHESIVE TAPE

One of the most common methods for creating a composition with sharp, straight edges is to use opaque adhesive tape. Masking and electrical tapes make it possible to paint perfect edges and straight borders. Artists who look for sharp contours and perfect divisions of shapes use this type of reserve. The tape can be placed over thin layers of paint, so diluted paint can be applied first, and then pieces of tape can be shaped to the edges of each form so the work can be carried out comfortably without sacrificing the definition of the forms.

A simple piece of masking tape can create a reserve. Notice the results when the tape is removed.

There is a trick to preventing the rubber of the reserve from damaging the bristles of the brush. It consists of keeping the hair moistened with a small amount of liquid soap while painting.

RESERVES WITH WAX

The wax technique is based on the fact that oil and water are incompatible. It consists of rubbing the area of the reserve with a stick of wax and then applying the acrylic wash. The wax is hard to remove once it dries; therefore, it is important to identify carefully the areas where wax is going to be used and to apply it with precision. The effects created with wax reserves vary depending on the texture of the paper and the pressure applied when drawing with it.

The reserves created with adhesive tape make it easy to make straight lines. This is the cheapest and fastest method.

Reserves are made with adhesive tape over the blue and yellow surface to create the lines with dense paint.

Normally, plants and flowers are made of a series of points of color where attractive forms and contrasts mix. It is an ideal theme for working with reserves.

1. Some areas are covered with masking glue and some lines are drawn with white wax. Both are waterproof and isolate the areas of the paper that have been covered with them, preventing them from becoming mixed with the pigments.

2. Washes can be applied over these reserves without a problem. If the area has been covered carefully without leaving any gaps, the paint will not invade it because the liquid masking repels water.

3. When the painting is almost finished, the reserves can be eliminated with an eraser. These areas will have preserved the original white color.

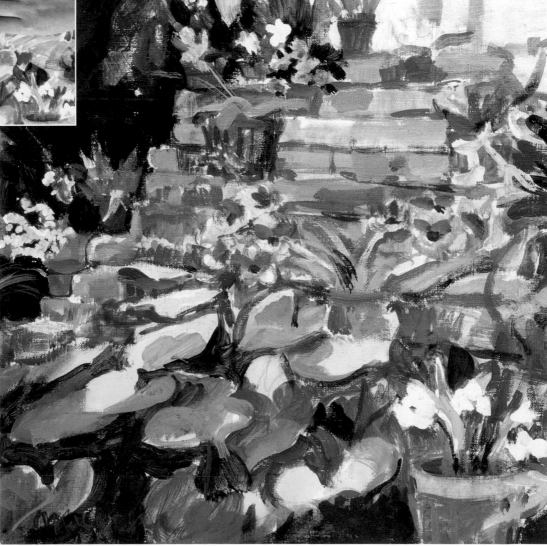

4. The completed reproduction shows that the artist has introduced dark areas at the bottom and right sections of the painting. The dark background defines and delineates the forms. Notice how the flowers reserved at the beginning stayed white.

Stenciling

he artists who work with acrylic paints often use stenciling techniques. They are normally used in furniture and wall decoration, but they offer interesting possibilities for this type of medium, especially in work that includes flat shapes and geometric figures.

Because the stencils isolate the space where the color is to be applied, it is a good idea to choose forms that are not complicated.

WORKING WITH STENCILS

Stenciling is a form of reserve in which the paint is applied in specifically defined areas of the composition. In its simplest form, it consists of cutting out a shape in cardboard, acetate, or waxed stencil paper; placing it over the support; and applying the paint inside of it. The cutout shapes are ideal templates, which can be painted or applied to a work surface to create a printed image. When painting is completed, the stencils can be saved for future use.

THICKNESS OF THE PAINT

Paint of medium consistency is more easily applied with a sponge or with a stenciling brush. It is not a good idea to use paint that is too thin because it could seep under the template. It can be made thicker by mixing it with a special medium that will increase the volume or be used for texturing. When working with thick layers of paint, the template should be removed carefully before the paint begins to form a hard layer, otherwise the edges will stick.

Openings are cut in the cardboard to paint the windows on the fronts of the buildings. The stencils make it possible to extend the brushstrokes beyond the edges of the forms; therefore, the color abruptly stops at the edge of the template creating a clean, well-defined edge.

Painting can begin by applying the background with washes over wet. Using a square cardboard cutout, the edges are created with thicker, more opaque paint.

The edges have been created with stencils and will serve as guidelines. The painting is finished with direct brushstrokes.

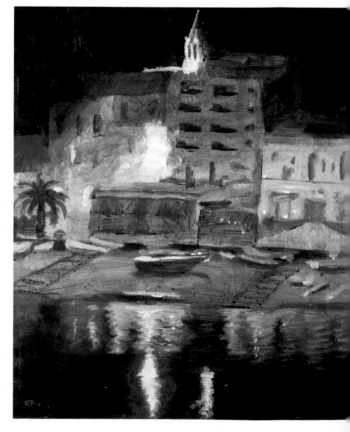

Sgraffito

The sgraffito technique consists of scraping the relatively thick layers of wet or dry paint to expose the original surface or the color that was underneath. In other words, it is a technique for manipulating and altering the layer of paint. Different effects can be achieved depending on the tool used.

SCRAPING THE SURFACE

The sgraffto technique can produce many effects and textures. However, it is more difficult to use with acrylic paints than with oils because the paint must stay wet long enough to be able to do it and acrylics dry very fast. Therefore, an artist who wishes to work with sgraffito should apply thick layers of paint or mix the color with a medium that prolongs the drying time. It is not a good idea to do sgraffito on a dry layer of paint because it could puncture the surface of the painting.

1. After a new layer of color is applied, the paint can be manipulated while still wet to create new textures.

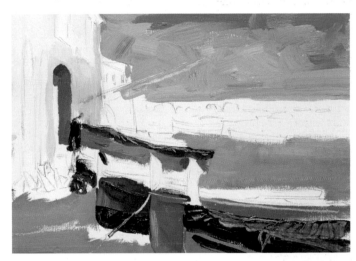

2. After the boat is worked with sgraffito, the initial color presents tonal variations.

3. By combining areas of dense opaque paint and lines created with the sgraffito technique in the same painting, the artist has created more visual contrast and richness in the resolution of the work.

Sgraffito done with the tip of the brush.

When the layer of paint is still wet, the sgraffito technique can be used to expose the color of the background.

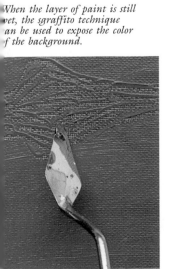

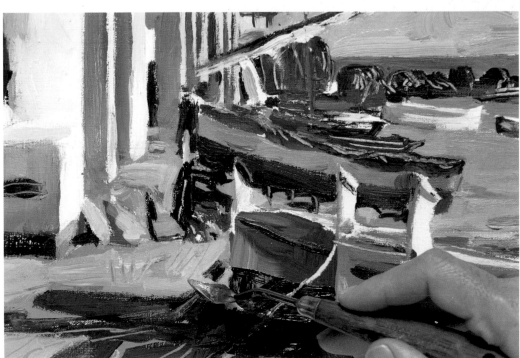

Collage and Acrylics

Collage is a simple technique used as much by fine artists as by illustrators to create interesting deco- rative effects. The simplicity of this technique and it possibilities to create complicated and refined effect is precisely what makes it so attractive in the eyes o many professionals. This chapter focuses mainly or two-dimensional collage and the juxtaposition o color papers.

CUTTING AND PASTING

The word "collage" comes from the French *coller*, which means to glue, and describes a composition created from pieces of paper or fabric glued to a support. All that is needed to make a collage are a few cutouts of paper, cardboard, fabric, or other materials and glue. They can be used to compose shapes and combine textures and colors. Acrylic paint is a medium that easily adapts to this technique be- cause it is adhesive and is able to hold relatively heavy ob- jects on the support.

COMPOSITION IN COLLAGE

The composition of a col- lage is similar to that of a painting, with the difference that the shapes and color masses exist beforehand. When the subject matter has been decided on, the shapes, the colors, and the textures are selected.

When using these cutout figures, it is a good idea to make a sketch of the layout of the collage; this way the com- position can be studied from a more objective, graphic per- spective.

If the collage technique is to be used often, it is a good idea to collect paper cutouts in different colors.

The best models for collage are those that present a series of superimposed planes and areas of color.

COLOR PAPERS

Like mosaic artists who work with a large selection o tessella (small colored pieces) painters also use paper cutout in a large variety of colors fo this technique. Having such great variety for a single com position is perhaps overdoing it. However, artists who make collages often have as man color samples as possible, s they have a selection to choose from.

1. It is a good idea to cut out the papers before work begins and to move them around on the surface into the desired arrangement.

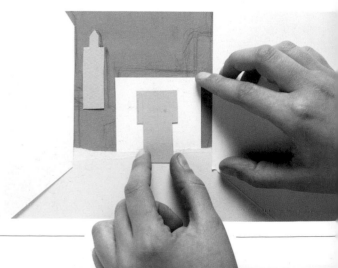

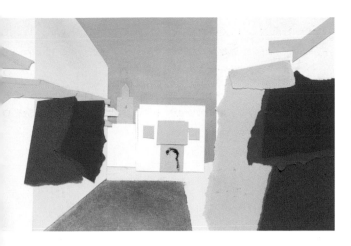

2. When the desired arrangement is achieved, the pieces of paper are attached to the support with glue.

EXTRUDED PAINT

Extruding consists of forcing the paint through a nozzle, a bag, or a funnel. This method creates an intense linear effect, with some relief. The technique is similar to that used by ceramic artists to make shapes with glazes or liquid clay, who use a sort of syringe to extrude the paint on the plate or jar being decorated. It is important to carefully control the amount of paint that is squeezed out, and to maintain a constant flow. Before color is applied to the surface of the work, it is helpful to check the width of the line on a piece of test paper.

3. Lines of thick extruded paint are applied over the previous layer of color.

4. In this work by Marta Bru, the result of combining the techniques of collage and extruded paint, which consists of applying the paint with a squeeze bottle, can be appreciated.

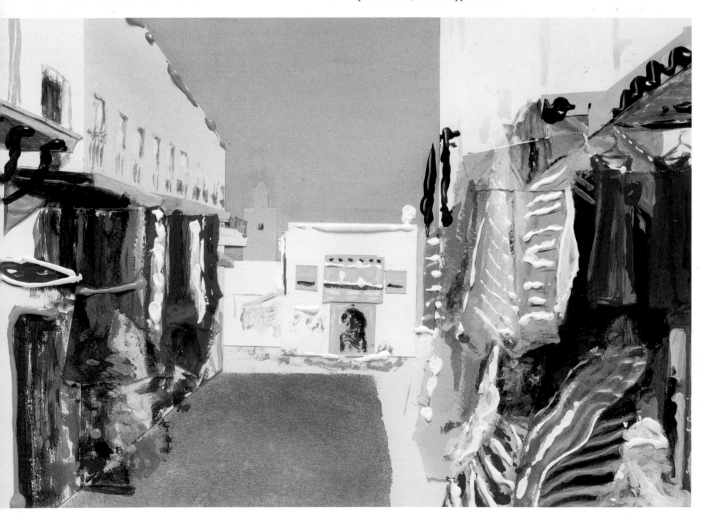

Quick Painting

Quick painting allows only a little elaboration, with barely any details. It consists of capturing the model quickly, with wide, generous brushstrokes, color impastos, and vigorous and expressive lines. This type of quick execution was often used by the Impressionists, especially Monet, who painted landscapes outdoors very quickly, often mixing colors right on the support.

With quick painting the different brushstrokes are layered while still wet, letting the colors mix directly on the support.

PAINTING *ALLA PRIMA*

Painting *alla prima*, or direct painting, is an Impressionist approach that is executed in a single session, quickly and without corrections. The ability of the artist and the quick, accurate application of color on the support are the key elements of this technique. Futhermore, there is usually neither a preliminary sketch nor a color background over which to paint.

Quick painting allows the artist to mix colors directly on the support; therefore, the brushstrokes should be concrete and previously planned if the colors are to be kept clean.

When painting alla prima, *it is a good idea to work with thick paint that has a high covering power to allow better manipulation on the support.*

Painting alla prima *is based on the combination of spontaneous brushstrokes and direct color applications.*

QUICK APPROACHES

In quick painting, acrylics play an important role because their quick drying time prevents the mixing of the colors and tones with those found underneath. Over a background that has been painted in detail or simply covered, the artist can add areas of color or figures; these quick interventions can be corrected by painting over with opaque colors or by wiping with a wet rag if the paint is still wet.

THE SPONTANEITY OF GESTURE

In quick painting, the artist's ability to work out color planes without the use of complicated forms is very important. The hand gesture, the line, and especially the mastery of drawing are basic elements in this type of procedure. Every artist develops his or her own style, almost like calligraphy, and as time passes and more experience is gained, this style becomes synthetic and explicit.

SKETCH OF A LANDSCAPE

Acrylic paints allow the artist to work at a fast, immediate pace and can be manipulated while they are still wet. The artist must sketch the structure on the canvas and then concentrate on the colors and shapes, aiming at representing forms on the support that can be recognized at first glance. See the following landscape by Pere Mon, which is a good example of what has been explained so far.

1. A quick preliminary sketch is created with charcoal, simply a few lines to define the forms of the landscape and buildings.

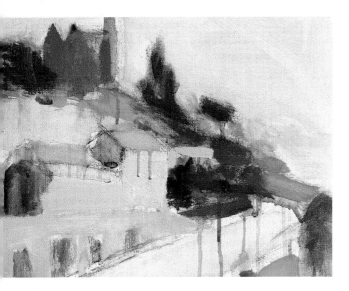

2. *The darker and lighter tones of the building fronts are painted with diluted colors. It does not matter if the paint drips because the subsequent layers will cover and correct the mistakes and the first colors.*

3. *The hand motion helps shape and direct the paint.*

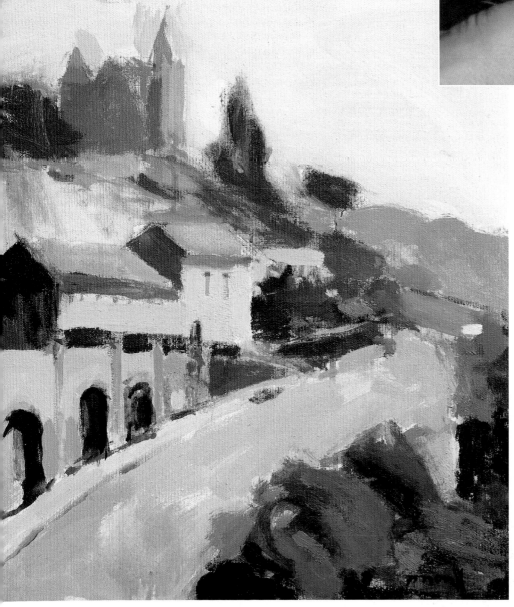

4. *The drawing is covered with new sporadic applications of color. The bushes of the background are painted with direct applications of light and dark green tones. Notice how the composition is sketchy but fresh.*

Working over Medium and Dark Backgrounds

Some artists prefer to work over a painted background because a white support is intimidating—that is, it can produce the effect of simultaneous contrast where the majority of the colors look darker on a white surface than on a colored one.

THE INTIMIDATING WHITE

There is no problem with working on a white surface, which gives a strong luminous quality to the paintings. However, a completely white background can be intimidating, and it can make choosing the first colors to be painted on the canvas difficult. The artist normally runs the risk of using a tonal range that is too intense because most colors appear very dark against white. This is why many artists prefer to paint the canvas before beginning to work, and they cover the entire surface with the same color.

If work is done over a painted background, contrasts are easier to achieve because lighter and darker tones can be applied from the beginning with ease.

NEUTRAL AND DARK COLORS

Choosing a color is important because it will be the base over which subsequent colors will be applied. Intense colors will, without a doubt, affect the appearance of the final work; therefore, the colors chosen are normally more neutral, meaning they do not determine so obviously the selection of the colors for the first phase. Neutral colors and medium tones are the easiest to work with, especially the soft browns, ochre, and gray. Generally, using greens and blues gives the painting a cool effect, whereas using yellows, reds, and oranges convey a

A few vegetables are placed on the kitchen counter to prepare the model.

warm feeling. Some artists prefer to use a color that contrasts with the theme, and they deliberately leave small areas unpainted. (This point is covered later under the topic of alternating effect.) Other artists prefer dark colors, but traditionally these are used for chiaroscuro effects in which the contrast between partially or totally illuminated objects and the dark background is emphasized. The best way to work is with brushstrokes of opaque paint over a dark background.

PAINTING OVER A MEDIUM TONE BACKGROUND

The color of the background provides the intermediate tones, whereas covering one area of the background with soft, opaque paint creates

One of the advantages of acrylic paints is being able to prime the background surface with them, and then applying paint to it soon after.

the bright areas and the point of light. Working with medium-tone primer and highlighting the light color with white represents the value and makes the image appear three-dimensional.

Although the majority of the colors used traditionall[y] are ochre, grays, sienna, and orange browns, notice how still life can be painted on greenish gray background.

1. The white of the support is firs[t] covered with a layer of greenis[h] gray colo[r]

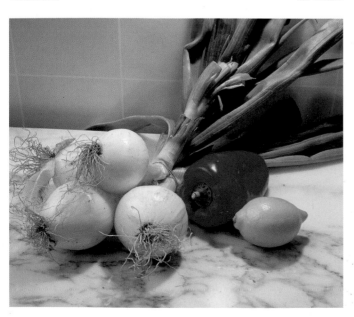

2. The first colors applied are dense and opaque. The dark tones of the background are defined and the first brushstrokes of color are applied on the vegetables.

3. The areas of light are created with variations of violet and pink colors generously mixed with white.

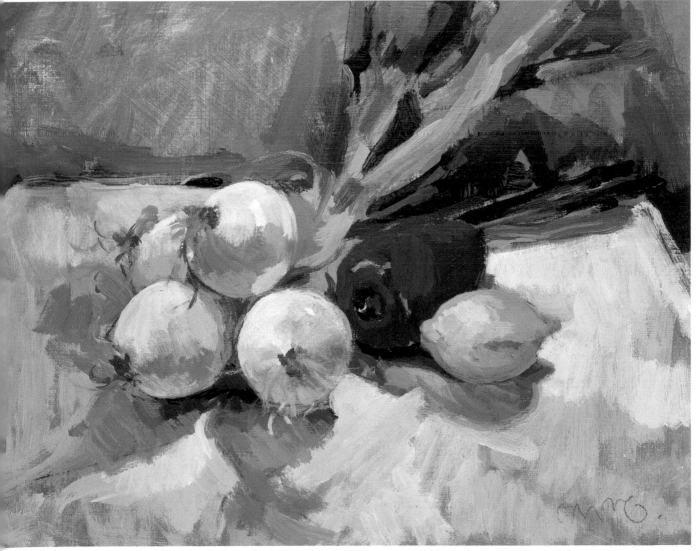

4. When working over a painted background, it is a good idea to leave unpainted spaces so the colors of the background can be seen through, contributing to the harmony of the work. Painting by Mercedes Gaspar.

Mixed Techniques

Acrylic paint can be combined with any other medium that uses water as a binder, as well as with oils or any other dry techniques like pencil, pastels, or colored pencils. Using two or more techniques in the same painting sometimes opens the door to new working ideas and possibilities.

Manipulating acrylic paint while still wet makes it possible to create areas of light that will later be used as the background for oil paints.

ACRYLICS AND OILS

Many artists tend to combine acrylics with oils to maximize the expressive quality of the painting. Acrylic paints dry very fast; therefore, they are useful for preparing painted backgrounds or blocking in. The subsequent phases of the painting and the touch ups are usually done with oil because of their characteristi brilliancy, quality, and thicke consistency. If this method i chosen, it is important to re member a basic premise: Oi can be applied over acrylics but acrylics cannot be applie over oils.

The composition can begin with a first application of acrylic paint (above) and be finished with oils (below).

It is not unusual to find combinations of dry techniques, oils, collage, and acrylics in modern paintings to achieve an effect that is more expressive.

RULE OF COMPATIBILITY

Acrylic paints can be used to paint over any nonoily surfaces, because acrylics contain water as a medium for the resin, and water and oil do not mix. However, the characteristics of acrylics should not be minimized when painting with oils. On the contrary, if used intelligently, the two can be combined in the same painting taking advantage of both: the transparency and drying time of acrylics and the finish of oils.

Different qualities can be observed in the finish of a painting created with pastels and acrylics, a clear contrast between the areas of lines and the areas of color.

MIXING ACRYLICS AND DRY TECHNIQUES

Acrylic paint can also be combined with dry drawing techniques, such as charcoal, chalk, or pastels. Keep in mind that if the work is executed with charcoal and chalk, these pigments do not have a varied chromatic range and they tend to muddy the color quality of acrylic paints slightly.

Pastel colors use gum arabic as a binder. This provides consistency to the sticks, which disintegrate as they are rubbed against the paper and the pigment lightly adheres to its porous surface. It is easy to see when they are touched with the fingers that pastels are not a stable medium. However, if they are mixed on the palette with an acrylic medium or with acrylic paint, they produce a unique combination because the bright color of acrylic paints acquires the pastel-like tone of the dry medium and maintains great stability after it dries.

Mixed techniques are ideal for executing expressive works of art that respond to a contemporary style. Work by David Sanmiguel.

WATER AS A BINDER

Certain media, such as tempera and watercolors, are compatible with acrylic paints because they also use water as a binder. Incorporating watercolors lets one take advantage of the best qualities of both media.

Notice the results of combining acrylic paints with charcoal.

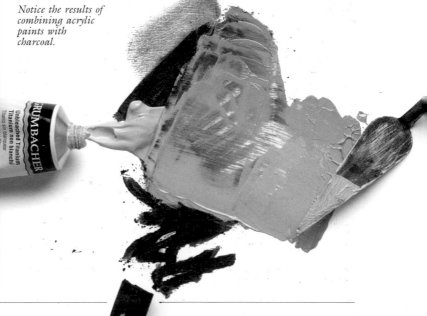

Expressive Color

One of the most important aspects of color is its emotive nature, capable of stimulating all the senses, not only the visual. Expressionist painting goes beyond what the eye can see, and that is why it uses technique and compositional resources that reinforce the delivery of a specific mood, helping create a particular feeling.

Optical effects between contrasting complementary colors. They become more luminous when they are in contact with each other.

COLOR INTERACTION

Colors should not be viewed in isolation but through their relationships with other colors. Every color and tone is affected by those that are nearby—for example, the contrast between two juxtaposed colors may increase or intensify. Every color alteration applied to the paint affects the relationships between the existing colors. By distorting or exaggerating the color of the theme, the artist guides the spectator's response toward the emotive qualities of the painting, whose content is much more subjective than objective. The use of expressionistic color always includes a subjective component, although there are also predictable color combinations that can be exploited to create a specific atmosphere in the painting.

Tone and color intensity also play an important role. Red is a vital, dynamic color. Nonsaturated light blue can be associated with serenity and tranquility; however, in its pure form, it produces an effect that is as marked and intense as red.

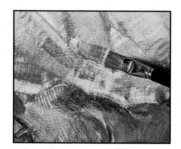

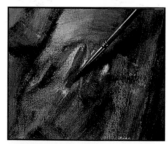

COLOR CONTRAST

The most powerful sensations are created with color contrast, a color opposite its complement, a light color opposite a dark one. A way to use color expressively is to surprise the spectator by using a color scheme that is not naturalistic at all.

Color can be used to suggest and highlight the character of a painting, as well as to create an emotional response in the mind of the spectator.

Color can create space in the representation independently from drawing or perspective. The contrast between warm and cool colors or between diluted and saturated colors affects the definition of the space in the painting.

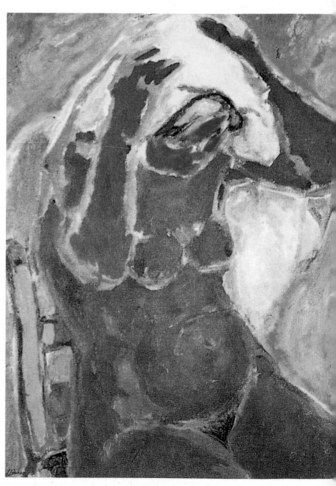

In colorist techniques, flat colors find a counterpoint in their complementary colors, but at the same time both are saturated by the surrounding tone.

PLAY OF CONTRASTS

Contrast, in all of its meanings, is the main characteristic of colorist painting. The acrylic medium allows the use of pure and bright colors; therefore, working with them is a great advantage because one can be certain that the luminosity is not going to vanish after the paint dries.

In colorist painting, the planes are not indicated by using shading or tonal gradations, but by giving each one their own color that is not necessarily similar to those of adjacent colors.

Warm colors are very expressive and give the painting a stunning luminosity.

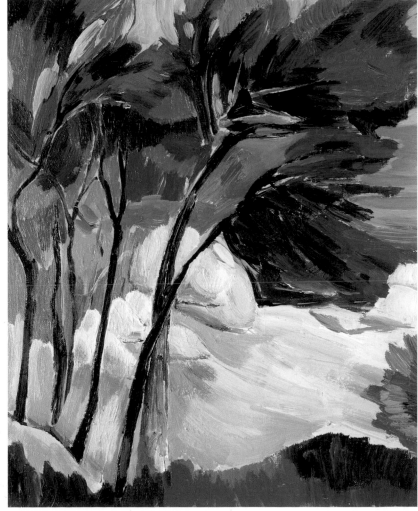

In principle, any model can be painted with the expressive technique; the artist only needs to saturate the colors and to keep the palette clean and bright.

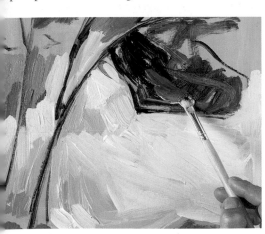

1. Acrylic colors make it possible to paint flat, even areas of color that dry very quickly. This characteristic allows the artist to paint fast and superimpose different layers of color.

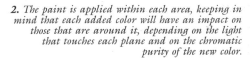

2. The paint is applied within each area, keeping in mind that each added color will have an impact on those that are around it, depending on the light that touches each plane and on the chromatic purity of the new color.

TECHNIQUES FOR ACRYLICS

Alternating Effect

By using color with the alternating effect—that is, letting the color of the background show through in certain areas—a very striking and dramatic effect can be achieved. If the colors are chosen and organized effectively, the harmony created will be both surprising and attractive and will add more vitality to the composition.

The alternating effect encourages the application of brushstrokes over backgrounds covered with bright colors. This way the new applications will stand out, producing an obvious expressive effect.

INTEGRATING THE COLOR BACKGROUND

The alternating effect is a technique that consists of painting in such a way that the color of the foundation shows through, allowing the background or the color of the support to form part of the composition. By applying areas of color with vigorous brushstrokes, the artist conveys an expressive feeling to a surface of flat paint. These effects emerge at the edges of contiguous colors; therefore, to create the greatest impact, as many spaces as possible should be left visible.

In the alternating effect, the goal of the colors is to convey the energy, vitality, power, and the feeling that the artist is experiencing.

tary colors, but also between the contrasts that occur between areas of light and shadow.

COLOR PAPERS

The use of color papers or color supports is ideal for painting with acrylics because of their opacity. Many artists prefer to paint on a color background because white paper is intimidating, and it can produce a simultaneous contrast, in which the majority of colors appear darker against the white than when they are surrounded by other colors.

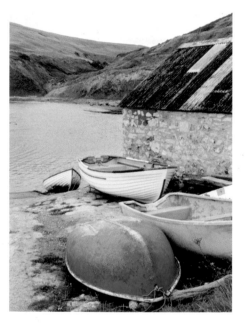

The following model represents a seascape where the green of the distant coastline contrasts with the lively colors of the nearby boats.

1. The initial drawing is sketchy and linear. It is not necessary to define the forms too much because the lines will soon be covered by dense, opaque brushstrokes.

CONTRASTING EFFECTS

There are certain colors that clash: They oppose each other and do not match, creating visual vibration. Therefore, a contrasting visual effect can be achieved by juxtaposing two complementary colors of the same intensity. As a general rule, it can be said that one color appears softer when placed next to another that has more intensity, and stronger if placed next to its complementary. Artists take advantage of the contrasts between complemen-

2. The first brushstrokes of color are applied without hardly mixing them or without any other manipulation, establishing each area from the very beginning.

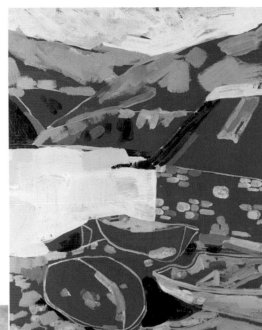

3. Spontaneity and dexterity with the brush are essential for resolving a composition like this one. It is necessary to forget the real color of the objects and to let the imagination of the artist dictate the colors of the painting.

4. As can be observed in these two close-ups, the colors are applied leaving small spaces open for the color of the background to breathe through.

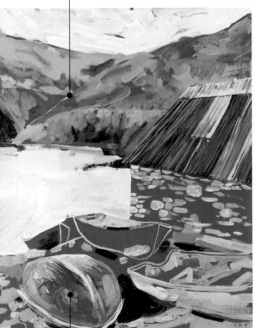

5. The color of the background forms an integral part of the finished work, to provide a transition between the different brushstrokes or to add a glimmering light, an interesting counterpart to the greens, blues, and ochre that dominate the scene.

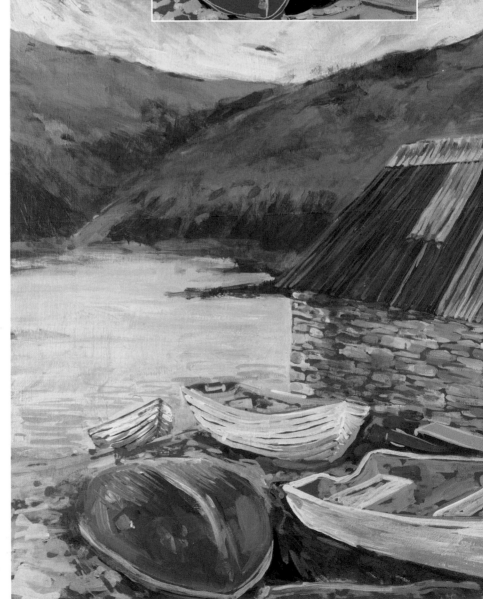

Abstract Painting Based on Nature

An abstract representation may consist of the two-dimensional interpretation of a three-dimensional motif or may emphasize some conventional aspect of the perspective or division of the painting's plane. Objects or images from the real world can be used as points of reference from which to develop a personal, abstract interpretation.

For best results in abstract painting, it is a good idea to work with large formats that encourage looser brushwork.

ABSTRACTING OF REAL MODELS

Abstracting from nature refers to the creation of images based on things that have been observed. Often, nature offers striking abstract forms.

Landscapes are a frequent source of inspiration in this type of abstract development, perhaps because the dimensions of a landscape make it possible to view the overall scene without getting lost in the details, which are not perceived because of the distance that separates them from the observer. Other common sources of inspiration are flowers and plants, which can be summarized with the layering of colors without apparent reasoning, and architectural spaces, which are generally full of geometric forms that provide interesting artistic compositions.

SIMPLE FORMS

Abstract painting consists of choosing elements of the visual world to create an effect, without taking into account the representation in the normal sense of the term.

"To abstract" means to reduce what we see into simple, sometimes obvious, forms. From this point on, the details can be taken into account, the same way it would be done in figurative painting. Compositions can be based on a visual theme or on a poetic idea, from which, and with the help of sketches, photographs, or real objects, a personal rendition is created.

DISREGARDING THE INITIAL MODEL

The first thing to do to create an abstraction of a real model is to find one that will work so it can be analyzed and to lay out the first sketch on a canvas. As the image progresses, the artist's interest for what is being developed on the canvas or paper increases and the original source of inspiration is typically forgotten. From that moment on, the artist must decide whether he or she wants to remain truthful to the real model or to transform it subjectively.

Also, the artist must choose how the medium is going to be applied based on the type of image that will be created on the two-dimensional surface.

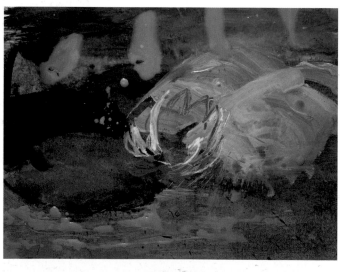

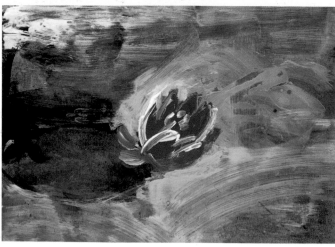

Nature is one of the main sources of inspiration for many abstract painters. The shapes and the bright colors that they provide justify this choice. Work by Josep Asunción.

Any architectural feature constitutes a valid model for creating an abstract painting. The wood beams of an old tower's ceiling are the parting point for the following example.

1. *The sketch is solid and, despite some variations, it is quite close to the real model.*

2. *The main motif is the way the beams connect with each other; therefore, when the background is covered with the first wash the beams look isolated.*

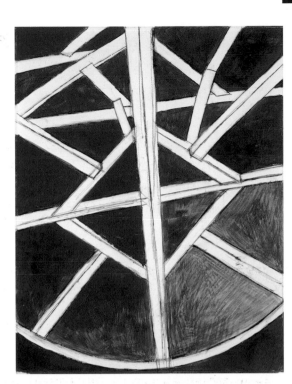

3. *The wood beams are painted with variations of brown colors using a small brush, highlighting their volumetric effect.*

4. *Pink, violet, and orange colors are added to make the composition livelier. To conclude, Almudena Carreño emphasizes the geometric effect of the composition by drawing the edges of the beams with permanent black marker.*

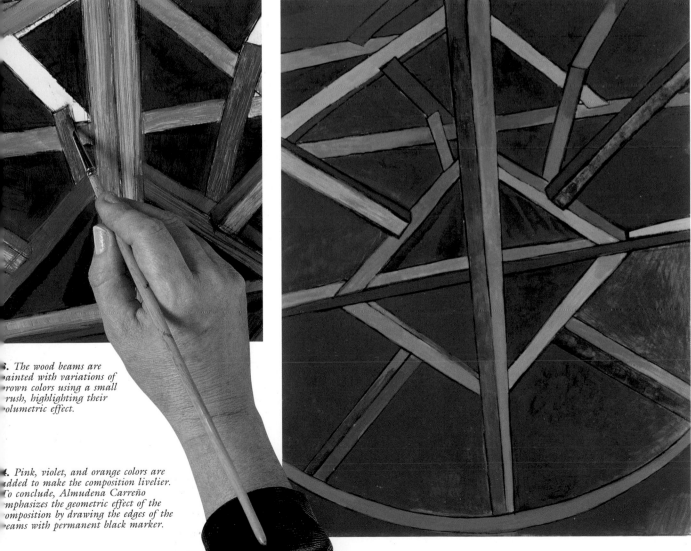

Pure Abstraction

The idea that figurative painting and abstract painting are two completely different worlds is false. Both figurative and abstract representations have en- riched each other in the development of styles, concepts, and techniques, and as a consequence, in the evolution of both. Abstraction stems from a different concept; it forgets spatial and naturalistic painting to concentrate on the combination of forms and colors that conform to a visual message.

BASIC INGREDIENTS

One of the important concepts of certain currents of abstract painting consists in the absolute rejection of spatial illusion. Abstraction is about the purely formal elements of painting and the qualities of the materials, such as forms without a reference, color relationships, and surface effects that refer directly to the properties of the medium chosen. In abstract paintings that have no reference in the real world, such basic ingredients as the color composition and the way it is executed become the protagonists of the work.

However, abstraction is not easy. Therefore, it is a good idea to work from sketches or to use a painting done before as a base for the abstraction or series of abstractions. Many artists adopt this approach, gradually disassociating the image from the sample until they have filtered what they consider is its essence.

PAINTING SURFACE

When working with abstractions, the creation of different surface levels in the painting is inevitable. Texture is important in abstract or semiabstract painting. When the artist moves away from the strict representation of objects, the interest must be balanced out with the treatment of the surface. By manipulating the color, the forms, and the texture, the paint and the color take center stage.

It is important to always keep in mind the possibilities of the materials being used to represent an image that responds to the expectations of the artist.

The hand is a very useful tool in abstract painting for applying the paint coarsely or pressing it against the support.

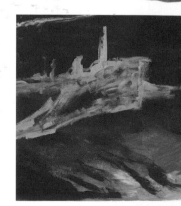

Pure abstraction is based on purely compositional aspects, textures, and chromatic effects.

1. Every abstract painting must begin with a solid foundation of color over which the following phases will be added.

2. The first applications consist of dense color washes, which are applied on the support held horizontally.

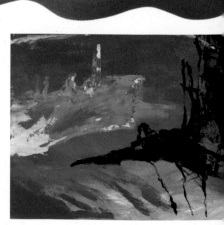

3. If the support changes positions repeatedly, the paint will flow, giving the work a more spontaneous appearance.

PAINTING WITH OTHER TOOLS

If the artist wants to create suggestive textures and effects in abstract painting, it can be interesting to apply the paint with tools other than the brush. Anything that is capable of transporting the paint to the support or making an imprint on it, from the fingers of the artist to a scrubbing pad or brush, is valid. The creative artist can resort to a number of objects that can be used instead of the brush to produce special color effects.

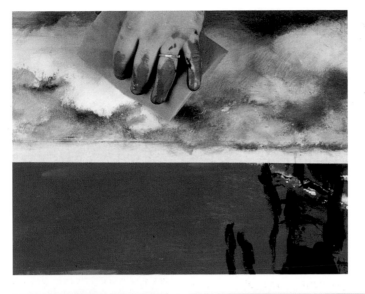

4. Then the paint is applied with a sponge on one of the previously reserved white bands. The washes created with the sponge are reminiscent of cloud formations.

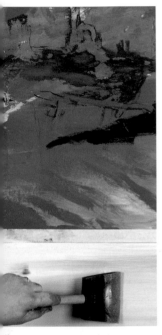

5. The color is spread on the lower band with a sponge brush. Keep in mind that the edges of the central band should be protected with masking tape to prevent the paint from invading it.

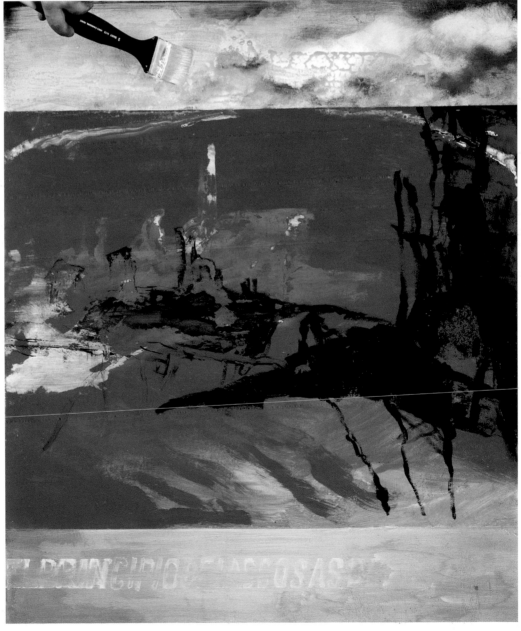

6. The graphic effects come after the color. Letters and more color are applied on the upper and lower bands. Work by Ramón de Jesús.

TECHNIQUES FOR ACRYLICS

The Impressionist Heritage

Impressionism laid the foundation for a new realism, which is now completely established. However, even today, Impressionist paintings continue to surprise the spectator with their freshness and inspiration, and this realistic approach continues to be valid for the creation of contemporary themes.

In the Impressionist style of painting, it is important to take into account the mark that the brush leaves on the canvas.

SHORT AND THICK BRUSHSTROKES

Impressionist painting is the result of an analytical observation and recording process that culminates in the creation of images full of vitality, color, and happiness. In Impressionist painting, the motif is usually laid out as a sketch and developed through a combination of short and thick applications of color. Besides creating an attractive surface that is full of character, brush strokes help define the object. Acrylic paints preserve the brushstroke traces very well, especially when they are enhanced with a thickener.

LINES WITH THE BRUSH

Beginners pay little attention to the brushstroke, which is surprising, given the difficulty involved in creating an expressive look and a provoking color. For example, in a landscape, the artist must let the brush follow the direction of the tree trunk or the lines of a tilled field to give the painting a dynamic feeling and a sense of movement. The direction of the brushstroke, therefore, plays an important role in the technical treatment of the painting; it can make a mark or be so subtle that it leaves none.

Controlling the direction of the brushstroke is essential for creating highly expressive effects.

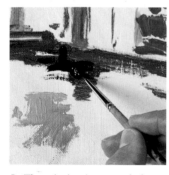

1. The painting is approached directly with the brush without paying attention to the preliminary sketch. A few violet lines will be the initial guide.

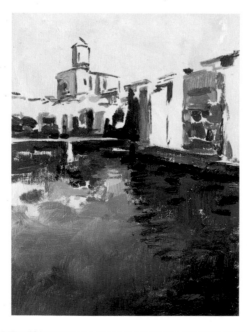

2. The surface of the water is covered quickly with thick, barely mixed brushstrokes.

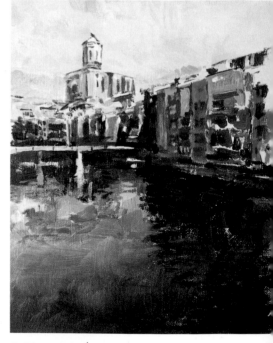

3. The study by Óscar Sanchís, finished in the Impressionist style, looks fresh and spontaneous. Controlling the direction of the brushstroke has been vital to describe, especially the water in the river, the sky, and some of the elements of the fronts of the buildings.

BRUSHSTROKES, QUALITIES, AND MARKS

The gesture, the insistence of the brush and its bristles on the surface, the quality of the paint, and the support are the main factors that condition the brushstroke and its marks. An old brush makes an irregular mark. If lack of paint is added to this effect, the mark will be especially visible, and this can be combined with the direction of the brushstroke to create a mark or texture. If the background paint is still wet, the brushstroke will blend with it spreading the paint.

A landscape has been chosen with several trees in the foreground, which is reminiscent of Japanese themes painted by the first Impressionists.

In pointillism, the fusion of the colors on the surface of the painting takes place in the eye.

If a darker tone is desired, the artist should mix colors from the same tonal range.

POINTILLISM

The eye does not perceive colors in an isolated or individual manner, rather it receives them all combined. In pointillist paintings, a succession of dots organizes the colors by combining or complementing them; in other words, affirming each other. Therefore, pointillist paintings create an illusion of light reflections using many juxtaposed color brushstrokes or dots. The colors are optically mixed, blending in large gradations or unified nuances when they are viewed from a particular distance, and they appear more intense than if they had been previously mixed on the palette.

1. Covering some areas of the landscape with washes decreases the impact of the white color of the paper.

2. The first areas of color are applied over the dry wash with a small brush. First, the most shaded areas are painted with blue.

3. As the work progresses, the color dots can be combined in more daring shapes. Touches of red or yellow paint can be added in areas where no such color is visible, to help give the composition more vitality.

4. Pointillism always gives the finished work an unexpected effect, making this an ideal technique for less experienced artists, because it is a good way to practice mixing colors on the canvas.

TECHNIQUES FOR ACRYLICS

Monochromatic Paintings

This simplified chromatic scheme will help convey the importance of color selection and the "translation" of the real colors into monochromatic arrangements. The goal of this exercise is to teach the beginner how to master tonal gradations by practicing the concept of light and dark. Translating the original model into a scale of grays is as important as mixing colors correctly to create a painting of these characteristics.

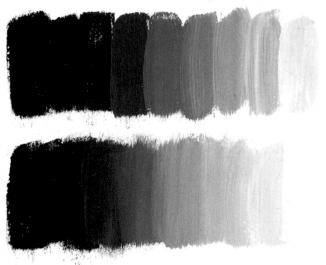

The tonal range with black and white allows the artist to create gradations by gradually adding white paint.

ARRANGING A STILL LIFE

To develop a monochromatic scene, several gray objects are first arranged on a surface of the same or similar color. If there are no such objects available, bottles or plastic containers can be painted gray with acrylic paints. In addition, the corner of a table is prepped with two pieces of gray cardboard, which will serve as background. Place the objects on a neutral surface, of the same color if possible, and direct the light to them from the side. Notice how the tonal variations offer a complete and three-dimensional image o the objects. Changing the position of the light and the objects is a good exercise in finding the desired composition.

MONOCHROMATIC STUDY

The creation of a monochromatic study is a useful exercise, which will help illustrate this effect. It will allow the reader to focus on the luminosity and the darkness of the color without paying attention to whether it is the appropriate color or not.

The model is developed with monochromatic tones, not solely with black and white but also blue, violet, and brown tones to make it more realistic. With practice, a beginner will soon be able to notice the smallest tone and color variations. In practice, the form is created by the effects of light and shadow on the image.

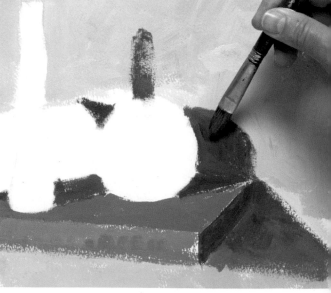

2. The largest white areas are covered with flat, even paint. Different tones of gray are added for each edge of the shelf, and a mixture of violet and burnt sienna for the most shaded areas.

1. The model is sketched with a graphite pencil. The background is covered with a fairly uniform blue-gray color.

TRANSLATION OF COLORS

Once the still life has been defined, the goal is to translate the tonal impressions into colors, keeping in mind that they should not be exaggerated on paper so the desired effect can be achieved. A theme that can be executed only within a restricted range of colors requires great mastery and imagination on the part of the artist, because he or she must rely on close and complete observation, disregarding any preconceived notions.

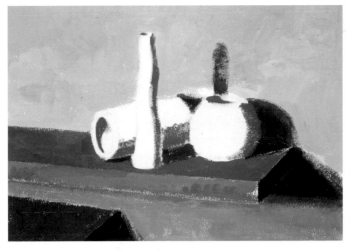

3. *The shadows of the objects are painted with a medium gray to emphasize their volume. The lower part of the wall is painted with violet to set it apart from the upper part, which receives more light.*

4. *From this point on, a medium brush is used to help create the volume of the objects. New brushstrokes of lighter gray are mixed with raw umber to help define the areas of light of each one of the shapes.*

Blue tones can be added to the scheme of grays to obtain greater tonal variations and a harmonious range of colors.

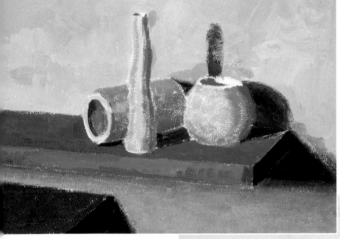

5. *A metal ruler can be used as a guide to create the sharp lines of the shelf. This will protect the lower part of the wall, which should not be painted.*

6. *The artist should always have the dominant tone in mind to achieve balance among colors. If blue or brown is used in excess, the colors will appear too saturated and they will clash with the dominant gray tone, decreasing the brilliancy of the work, which in this case is by Carlant.*

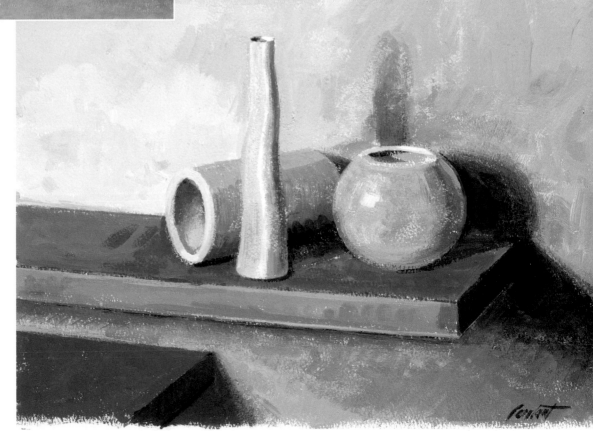

Skies and Clouds

The sky and the clouds are subjects that every artist should know how to paint, because their light determines the overall character of the landscape. Sunlight and the atmospheric elements affect how natural light is perceived, transforming the sky into a huge display of forms and short-lived colors that influence the color of the landscape.

In this sky, the clouds are pink, brown, and violet. Below them is the landscape, from which stems a ray of light that resembles a rainbow.

CLEAR SKIES

Clear skies are, without a doubt, the easiest to paint because the absence of clouds eliminates the need to create their characteristic shapes, tones, and shadows. However, a clear sky always requires a certain amount of work and great mastery in the use of acrylics because, as a general rule, the color gradations that are involved are brighter in the upper part of the composition and lighter near the horizon. This type of gradation work requires some expertise.

CLOUDS

Painting clouds requires synthesizing, improvisation, abbreviation, and imagination. In other words, it is an interpretative exercise that helps transform this natural phenomenon into a synthesis of forms and colors.

The first step in painting clouds is to draw their shape with a pencil. Then, the sky is painted, making reserves for the white clouds. Next, the volumes are formed with subtle indications of light and shadow. In general, clouds have one side that has more light, a second one that is intermediate, and a third one that is darker, which is normally the area below.

Pay special attention to the contours of the clouds so they blend naturally with the space around them. Clouds that are located faraway have soft outlines. To create this effect, the dry bristles of the brush are rubbed around their perimeter.

1. After a light pencil drawing, the bottoms of the clouds, the darker area, are painted with violet.

2. The clouds are painted with pink, slightly mixed with light cadmium yellow, to highlight the tone and to create a contrast that will make the lighter areas more luminous.

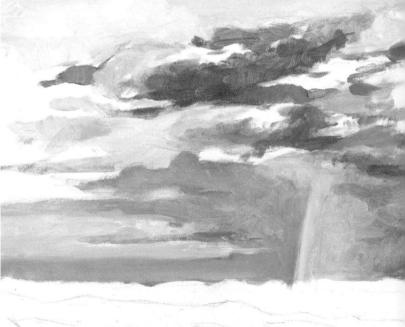

3. The white spaces of the upper part of the painting are covered with blue, whereas the areas closest to the horizon are created with variations of ochre and violet. The bands of the rainbow are painted very lightly with soft colors.

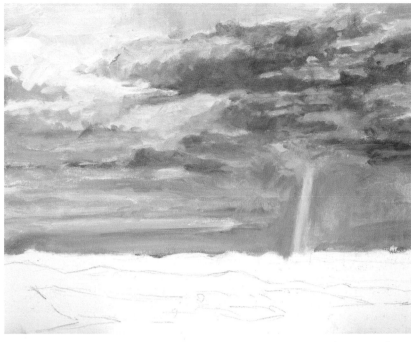

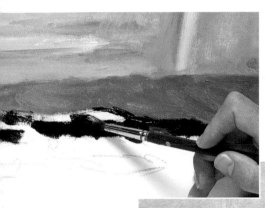

4. As the painting progresses, the brushstrokes are more defined, and the paint is combed to create a more suggestive and volumetric effect for the clouds.

5. To finish the sky, new touches of white and light violet are applied, which reinforce the ones painted before, and a few orange details convey warmth to the clouds.

6. The mountains in the distance are painted with a layer of light violet. Their outlines are diffused and blend with the sky. The mountains in the foreground are painted with darker colors and more defined contours.

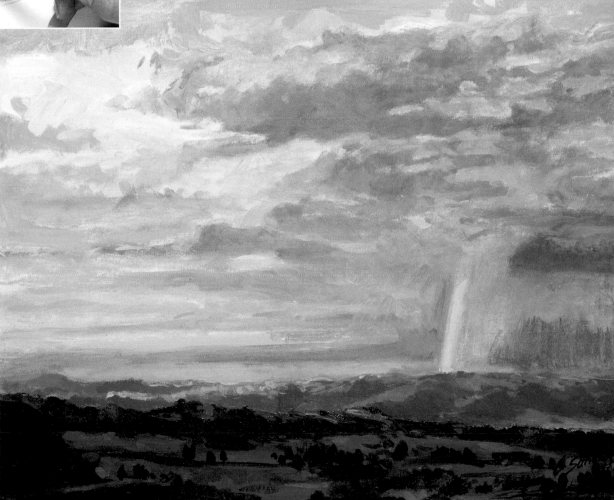

7. At the end, Óscar Sanchís has applied touches of color over the base painted in the previous step, with thicker paint to define the elements that make up the landscape.

THEMES WITH ACRYLICS

COLOR TENDENCIES

The sky shows different color tendencies that convey a specific atmospheric feeling to the landscape. This chromatic effect is most spectacular, with the explosion of light, color, and shapes that the sky shows at sunset, when twilight bathes the horizon with an orange glow. At that moment, the sky and the landscape are at their prime for painting. Notice the effect of the sunset on the desert sand in this exercise by Marta Bru.

The sunset wraps the horizon in a violet blanket, with skies highlighted in orange and yellow. The white ground of the desert picks up the colors of the sky, giving way to an explosion of color.

1. The background of the painting is created with very diluted acrylics applied over the canvas without a drawing. This is done using a light gradation that ranges from the violet tones of the sand to the light ochre and puffy yellows of the sky.

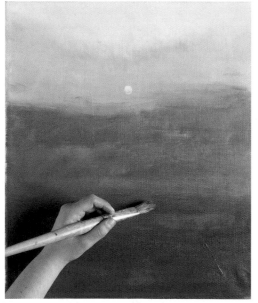

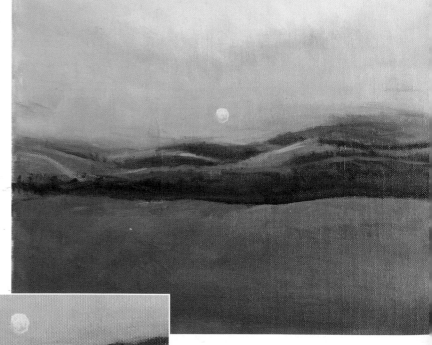

2. With the background barely dry yet, the initial colors are redefined with a flat brush. The new applications further soften the violet tones of the sand and new yellows and oranges are added to the sky. The round sun is painted with a bit of Naples yellow using a small round brush.

3. The shadows of the distant dunes are contrasted with a violet color mixed with burnt sienna. The idea is to give the hills a perception of volume by darkening their base and defining each plane.

4. Despite the new applications of violet to the horizon, it does not appear clearly defined with respect to the sky. It is a good idea to blend the silhouette of the dunes slightly with the sky to mimic the atmospheric effect. A darker violet wash moves down the painting until it reaches the foreground.

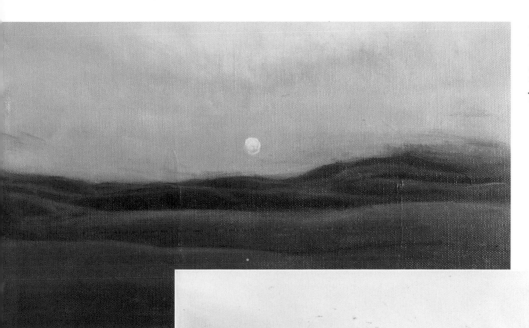

5. *The tops of the dunes that receive more light are painted with a small round brush. These areas are not clearly defined but they blend with the darker violet colors to create a gradual transition between the two tones.*

6. *The tops of the dunes are highlighted with a salmonlike pink color, which helps create harmony with the orange of the sky. Then, attention shifts to the foreground. The lower part of the painting is spattered with dark violet and then brushed with a toothbrush charged with paint.*

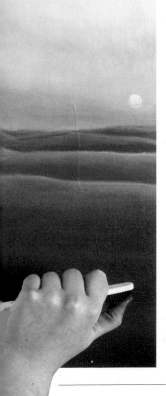

7. *Finally, a few areas of contrast are added to represent the footprints on the sand. Remember that the contrast in the foreground helps emphasize the three-dimensional effect.*

Water of the Ocean

Water, perhaps because it is a transparent mass and a mirror at the same time, has always been a fascinating subject for artists. This is why lakes, rivers, and the sea are among the most popular landscape themes. Although there are many ways of painting water with acrylic paints, the artist, as a starting point, must know some basic principles, including the use of washes for color impact.

COLORS OF WATER

To be able to understand the chromatic variations that water presents, it is best to begin by accepting the fact that water is not always blue. Water has no particular color in itself. The water from oceans and lakes reflects the color of the sky above. Therefore, depending on whether it is a clear or cloudy day, water can offer a variety of colors that range from the most intense Prussian blue to the brightest reds and oranges. When the water is clear and transparent, the color of the sea bottom with the rocks, algae, and sand is visible. The mass of water is the combination of mixing all these elements.

THE MOTION OF WAVES

The surface of the water in the ocean is always changing because it is in constant motion, having no particular form. A painting of a distant sea appears diffused, with barely any chromatic definition. It is perceived as an even mass of color describing a light tonal gradation. However, when the water is closer, its surface depicts the pleasant undulation of the waves and the impact of the sunlight's reflection. The foam is represented with brushstrokes of pure white paint, sometimes even dabbed with a bit of yellow, applied over the base color or an area that has already been painted.

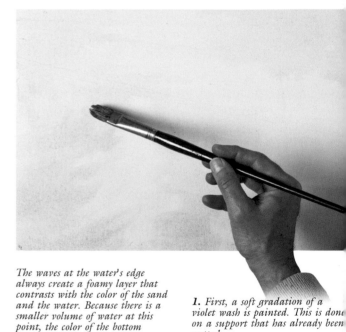

The waves at the water's edge always create a foamy layer that contrasts with the color of the sand and the water. Because there is a smaller volume of water at this point, the color of the bottom becomes visible.

1. First, a soft gradation of a violet wash is painted. This is done on a support that has already been wetted.

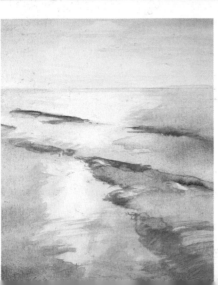

2. When the first washes are dry, the foreground is painted with additional washes that are preliminary shading for the waves.

3. The contrast between a distant background with less color and the edge of the water is created gradually using differences in color intensity and treatments of the texture.

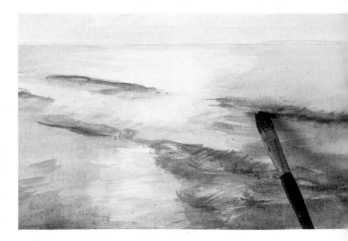

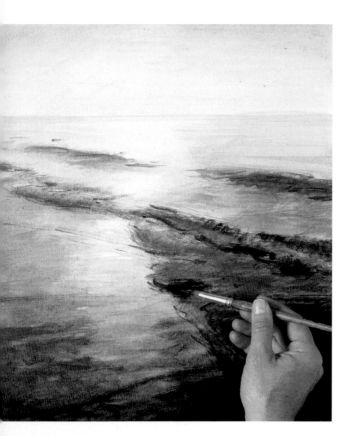

4. *To represent the effect of the waves in the water, new washes of violet, lightly mixed with an earth tone, are applied. The wet-on-wet technique is combined with drier touches. As the painting progresses, the consistency of the paint becomes thicker and more opaque.*

5. *Because water is a transparent mass, the brushstrokes applied to the foreground should convey freshness and spontaneity, so they should be gestural and dry.*

As with any other theme, it is a good idea to save the highlights for the end, to prevent light colors from getting dirty. It is important to remember that water has many reflections, which can be indicated with small dabs of color.

7. *In the completed exercise, it is apparent how the artist, Carlant, has represented the foam and the wet sand. Also, the sunlight reflecting from the water has been created with pure white and yellow-tinted white to suggest the reflections of the iridescent light.*

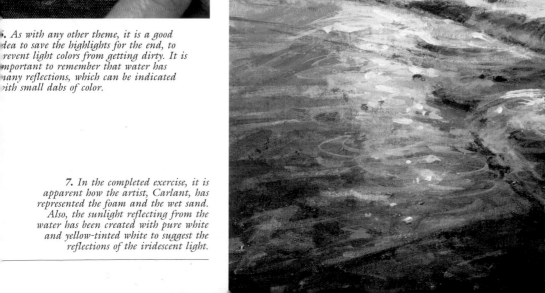

Vegetation

Natural vegetation is complex and diverse, and appears unpredictable with its shapes, textures, and colors. In a landscape, the artist must be ready to depict everything from the grass on a meadow and the most exuberant tree, to every type of bush. Therefore, it is a very good idea to analyze the vegetation and to paint it spontaneously, as artist Marta Bru has done in this example.

1. Once the decision is made on the type of format, the first colors and lines of the sketch are applied to define each plane without too much detail. This step is left sketchy, because soon it will be covered with paint.

When observing the tonal structure of the real landscape, the artist should notice not only the colors that are present but also their tones. The fog also plays an important role in helping define the foreground from the more distant planes.

2. Painting begins with the broad areas and continues with the smaller ones, which will be painted in more detail. Therefore, the overall structure must offer a good foundation for the added details.

DEPTH AND ATMOSPHERE

An important aspect of painting a realist landscape is the representation of depth and a three-dimensional effect. There is an optical illusion caused by the water vapor and the dust particles in the atmosphere, meaning that the farther the plane of the landscape is the fainter and less defined the shapes appear because the contrasts of light and shadow become diffused. As the planes appear farther away in the distance, the landscape shows lighter colors.

Another classic way of conveying depth consists of choosing a foreground that allows comparison to the distance and size of the farthest planes.

TEXTURE

One way of suggesting depth and volume is to treat the elements that appear in close, medium, and distant planes differently. Paints such as acrylics, that can be applied either very thin or very thick, can provide an immediate sense of depth. The process begins with the most distant planes, which are painted using very diluted acrylics or the sfumato technique. Then the painting progresses to the closest planes, which are created with denser, thicker paint.

3. When the landscape begins to acquire a marked effect of depth and atmosphere, the sky and the distant planes should be resolved first. The sky is covered with a gray wash, and the first touches of green color begin to emerge in the background.

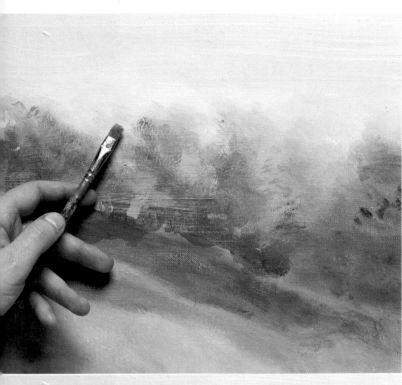

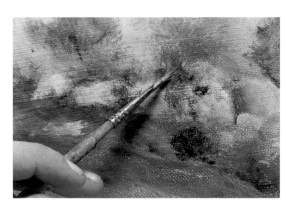

4. *The most appropriate technique for representing the background is a gradation, although rubbing is also recommended for its visual effect. Remember that the background should look diffused from the effect of the fog.*

5. *The group of rocks in the distance is painted with a tone that is a little bit softer. Their faint look is similar to that of the background, although the shapes of the rocks appear more defined than the vegetation.*

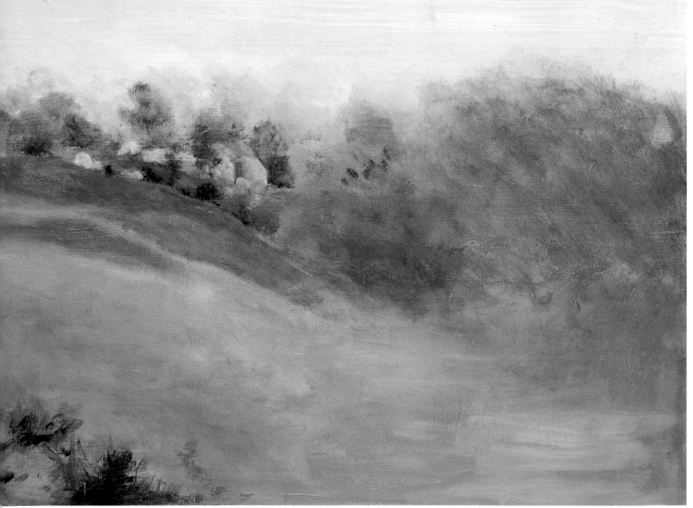

6. The background is now completely finished. The treetops and the sky blend from the effect of the atmosphere. The contours of the rocks painted before are diffused and hardly noticeable, in perfect harmony with the background.

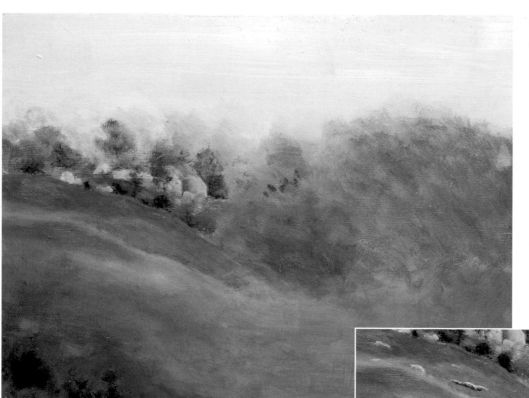

7. *The vegetation of the foreground is sketched out. In this case, it is a good idea to enhance the orange tones of the bushes, because warm colors cause the foreground to advance, whereas cool colors are more appropriate for depicting distant objects.*

8. *A group of stones is incorporated by painting their tops with a light gray and their bottoms with a dark brown, using a small round brush. Some difference between intermediate and distant planes should be created; therefore, it is a good idea to paint these areas with colors that have greater covering power.*

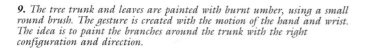

9. *The tree trunk and leaves are painted with burnt umber, using a small round brush. The gesture is created with the motion of the hand and wrist. The idea is to paint the branches around the trunk with the right configuration and direction.*

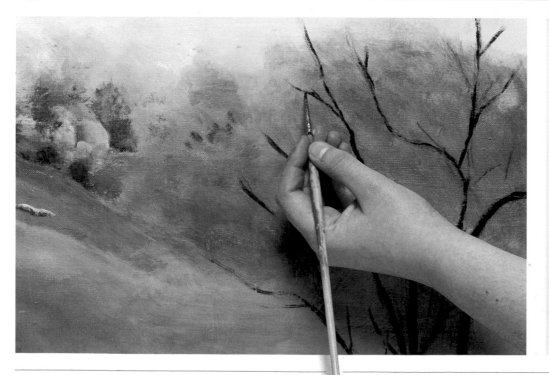

THE COLORS OF NATURE

It is inevitable for the artist to think of using a variety of greens when he or she sets out to paint nature scenes. However, although green is undoubtedly the most important color, do not make the mistake of thinking that it is the only one. Any foliage may have so many contrasts and intermediate tones that the same green can present a cool or warm tendency, making it look violet in some areas and bright yellow in others. Furthermore, the effect of the seasons in the cycles of the vegetation creates a wide range of ochre, reds, earth tones, and yellows in summer and fall.

0. A tree in the foreground is painted with denser and more opaque colors to create contrast. This way, this element will stand out more clearly against a diffused background.

11. Everything is perceived in more detail at close range. The tree trunk has more contrast, the texture of the leaves is clearer, and the contrast of light on them is more obvious.

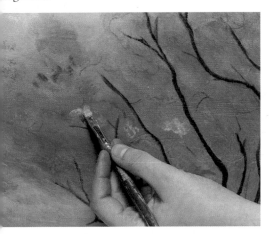

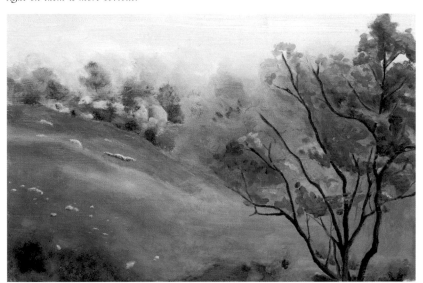

2. Notice the difference between the texture that was used n the background and the texture of the volume of the tree n the foreground, which is used as the focal point.

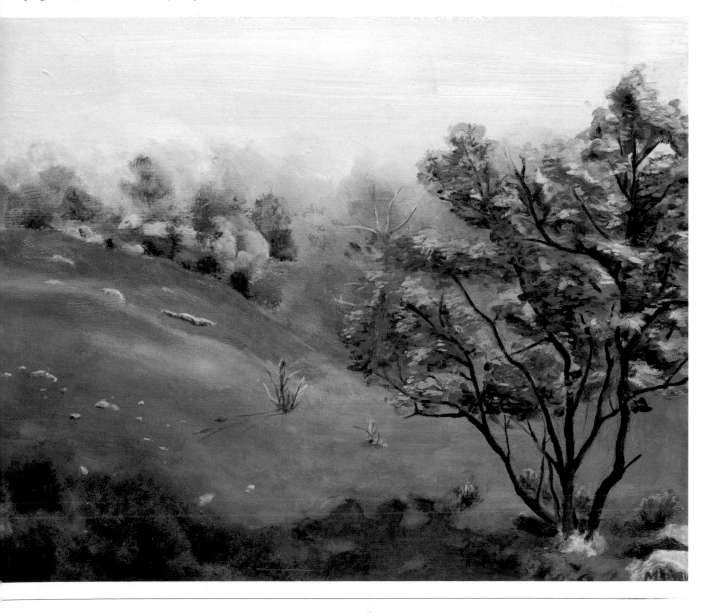

Trees

Trees constitute an important element in most landscapes and inspire a number of different treatments. Their shape dictates their artistic interpretation. Trees also have a number of different textures, offering a rich variety of details and color combinations.

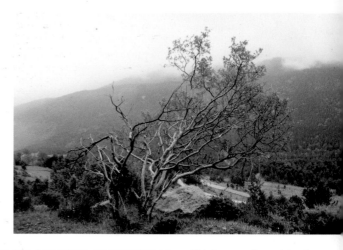

This lone tree located in the foreground against a foggy background is the perfect exercise for practicing the puddling technique.

STRUCTURE AND BRANCHES

The texture of the foliage is created with soft, firm brushstrokes that mimic the movement of the leaves. Most artists look for the basic forms of tree groups by studying the changes in the density of the foliage and the color variations caused by the seasonal changes. Painting trees does not require a deep knowledge of botany, but it is important to have a keen sense of observation to analyze the characteristics of each species, whose structures can be very complex. Therefore, every scene that depicts a tree requires a deep evaluation of its structure, and specifically of the branches that stem from its trunk.

1. The vegetation-covered background is diffused. The most appropriate technique for representing it is usually a wash on wet, to produce gradations that enhance color blending. When the background wash is dry, the outlines of tree trunk and leaves are sketched in red with a thin brush.

WET-ON-WET TECHNIQUE

The technique of painting wet on wet to create the vegetation in the background produces an atmospheric result with diffused contours. If the work is done on paper, it is a good idea to wet it first with clean water. If fabric is used, it is best to place the support flat on a table. This technique produces excellent results. Washes can be completed with puddle effects, which consist of applying the paint by forming puddles on the surface. The following exercise by Gabriel Martín is a good example of this method.

2. The previous puddles of paint are left to dry, and new washes are added, this time with more intense colors—orange, turquoise, carmine, ochre, and yellow—on the lower part of the painting. Also, new glazes are applied, to darken the vegetation of the mountain in the background.

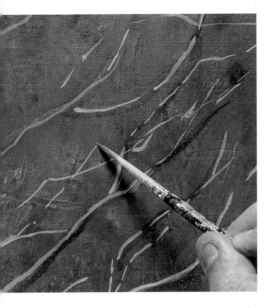

3. *Lines are powerful and useful for highlighting the tree trunk and branches. To express the contrast of the foreground with respect to the background, the silhouettes of all the branches are painted with dark brown, and each individually highlighted with light gray.*

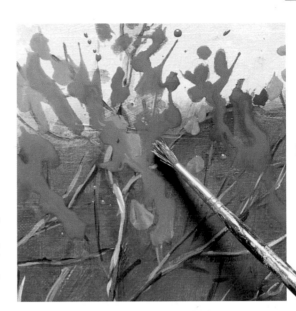

4. *The foliage is painted with the puddle technique. Watery applications of saturated ochre, green, yellow, and red are painted over the flat surface. The direction and blending of each application is controlled with the brush.*

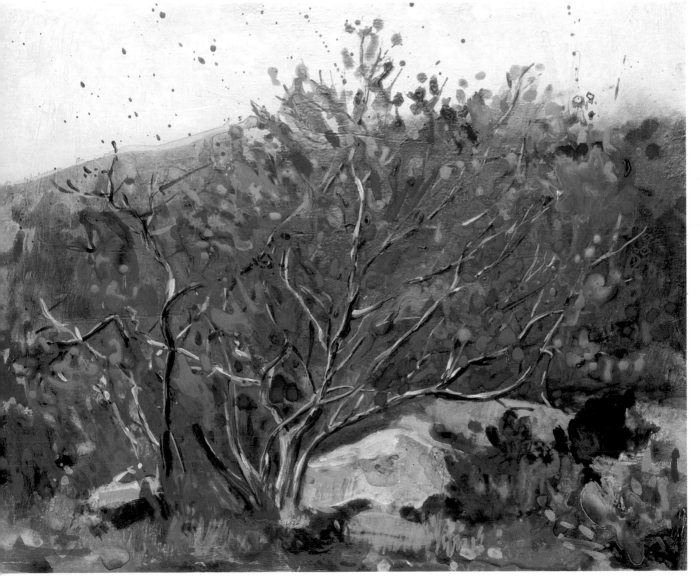

After a first layer of leaves is created, a second layer is applied with brighter colors like red and orange, which even cover some of the previous foliage. The blocks of color are smaller, and in some areas of the upper part of the painting, the spattering technique is used.

NEAR AND FAR

One way of suggesting depth and volume is by treating near, intermediate, and distant planes differently. Paints, such as acrylics, that can be applied in thick layers make it possible to convey an immediate feeling of depth. To express distance, very di-luted acrylic paint is used, gradually moving toward closer planes, which can be created with denser, thicker paint. Artists come across this type of challenge when painting the inside of a forest, because the succession of tree trunks can create confusion. Notice how artist Almudena Carreño solves this problem in the next step-by-step exercise.

The goal of this exercise is to paint this scene inside a forest. The play of light and shadow, as well as the feeling of depth, must be resolved correctl

1. The preliminary drawing done with charcoal shows the repetition of lines and shapes that creates an interesting effect of rhythm. The trees are so simplified that they are reduced to sketchy shapes.

2. In this first application of paint, the artist deliberately used large brushes to avoid details. The background as well as the undergrowth are simplified and treated as large areas of color. Th structure of a good portion of the painting is almost abstract.

3. Structural lines and blocks of color are worked out simultaneously. The closest trees are painted with a medium round brush. The most distant trees are indicated with a smaller brush. Not every tree should be painted with the same color; each has a specific tone that is conditioned by the quantity and the quality of the light that shines on it and its position wit respect to the viewer.

5. *After the structure of the trees and the colors of the ground have been worked out, the leaves are painted. These last additions to the painting are translucent to help describe the effect of the light filtering through the treetops. The last touches on the undergrowth are more delicate, subtly blending with the paint underneath.*

The color should be applied according to information required by the intermediate planes. Notice how the closest trees are painted with more detail and more intense colors than the most distant trees, which are sketchy.

6. *The final details that basically define the texture of the rocks, leaves, and bark are applied with thicker, almost undiluted paint. The last brushstrokes, which are opaque and have a good covering power, are applied only to the closest trees.*

Flowers

Flowers are appealing for their fragrance, beauty, color, and texture. They are seen as objects capable of inspiring poetry, as symbols of the most passionate feelings, and as artistic subjects offering freedom from rigid academic guidelines. Unlike other themes involving vegetation, flowers can be painted in the studio or outdoors, so the artist can choose to paint them in their natural environment or outside of it.

MODEL AND TECHNIQUE

Flowers form their own category within the still life genre. The techniques required to paint them are different from those applied to a conventional still life. Flowers should be painted with loose but well-defined brushstrokes. As the painting progresses, the first direct applications of color are modified with new dense brushstrokes of color that alter the initial tones until an even more colorful result is achieved. It is important not to mix the colors, to prevent the tonal scheme from getting muddied.

INTERPRETING FLOWERS

The biggest difficulty of painting flowers is their interpretation. Forms are free and open, and they demand a certain freedom in their execution. However, if this freedom is carried too far, the result can be a series of senseless brushstrokes. The other approach is to try to represent the bouquet of flowers methodically, with small brushstrokes and so much detail that the model lacks spontaneity. The ideal approach is a compromise between these two extremes.

A FLOWER CENTER

Painting an arrangement of flowers that have been cultivated and collected is an enriching and satisfying experience. Besides, it is an appropriate subject matter for practicing painting color and composition. The flowers are arranged in a natural way, creating different levels of blooms and pointing them in different directions.

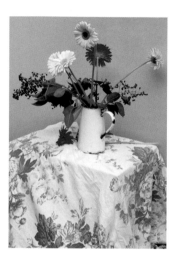

In this exercise, the painting is a still life with flowers placed on a tablecloth with a floral design. This composition is simple and original, and its main elements are color and light.

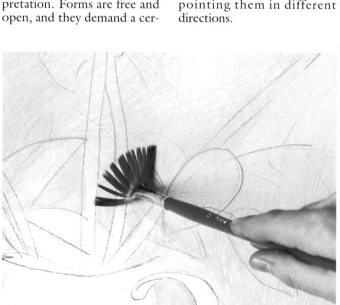

1. The preliminary drawing should be sketchy but sharp and without any shading. The entire background is painted with bright green that is diluted with white and not very dense. The transparency of the color does not cover the drawing. The tablecloth is created with a mixture of white and natural raw sienna.

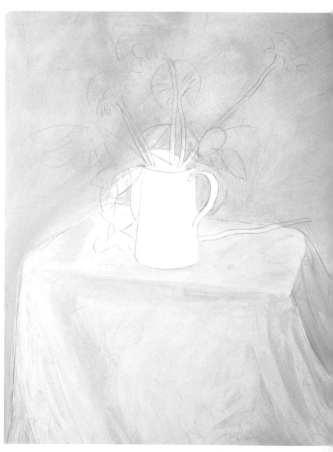

2. The painting is brushed with a fan-shaped brush (called a fan blender) and acquires an interesting striated texture that provides an attractive effect for the flowers.

To make the flowers look opaque,
they are painted with denser colors
than the green of the background.
For the red flower, various tones of
carmine mixed with white are
used. The pink tones of the central
flower are also painted with
carmine and white.

4. When painting flowers, it is
important to keep in mind the
direction of the brushstroke,
which must always be
concentric and precise. Each
petal brings a variation to the
overall color. In addition, by
mixing lighter petals with
darker ones, the result
obtained is more effective.

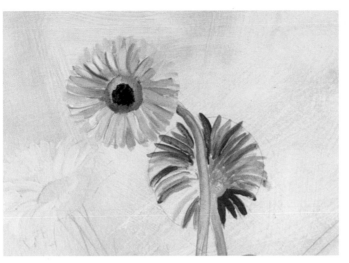

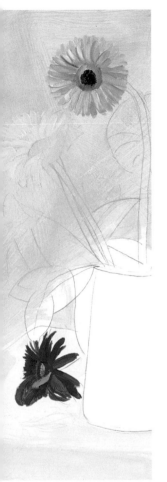

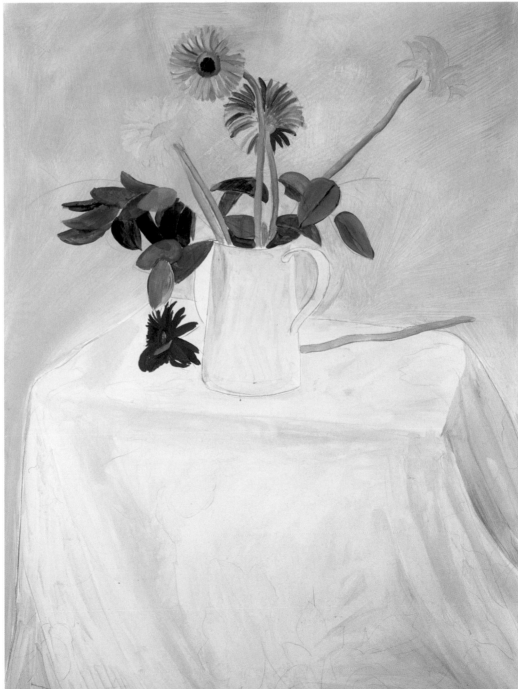

5. The best way to paint a vase
with these characteristics is to treat
it as if it were a cylinder—with
lighter and darker graded areas,
without too much contrast between
them. New grays with violet
undertones are added to the initial
washes, and a few touches of raw
sienna are added to the handle.

THEMES WITH ACRYLICS

6. Two tones of green are used: a bright one mixed with dark green and white for the stems, and olive green for the leaves. The vase is painted with various tones of white and blue-gray.

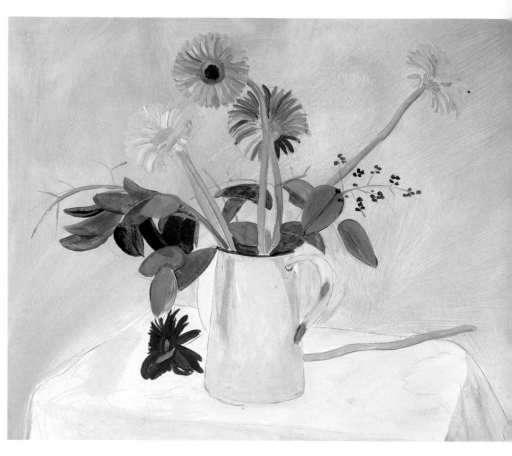

7. The details on the leaves and the small berries are painted with a thin brush. The branches are painted first, then the small berries.

8. The outlines of the design on the tablecloth are painted with very diluted raw sienna. The color used should be almost transparent so the contours are discreet and concealed after the designs are painted.

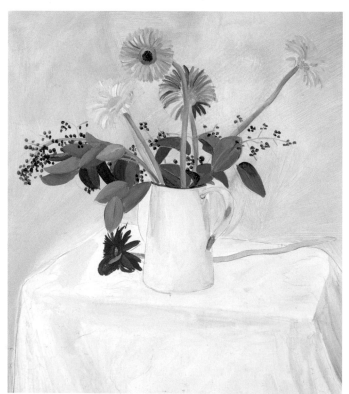

9. *The details of the designs on the tablecloth are painted with tones that are almost transparent. Acrylic paints make it possible to apply large transparencies without loss of color.*

10. *Transparent brushstrokes can be added over the dry, opaque colors, to modify or saturate the initial tone. For example, orange details have been added to the petals of the flower on the right, relating it to the color below. Work by David Sanmiguel.*

THE SENSITIVITY OF THE BRUSHSTROKE

The gesture is very important in painting many floral arrangements. The fluidity of acrylic paints makes it easier to work in a more direct and spontaneous manner, because the paint flows easily on the support, producing a firm and gestural brushstroke. For painting flowers, the sensitivity of the gesture is one of the basic aspects of the work. The interest of many floral paintings resides in the delivery of the paint, in the resolution of the planes, and the spontaneity of the brushstroke, rather than in the theme itself.

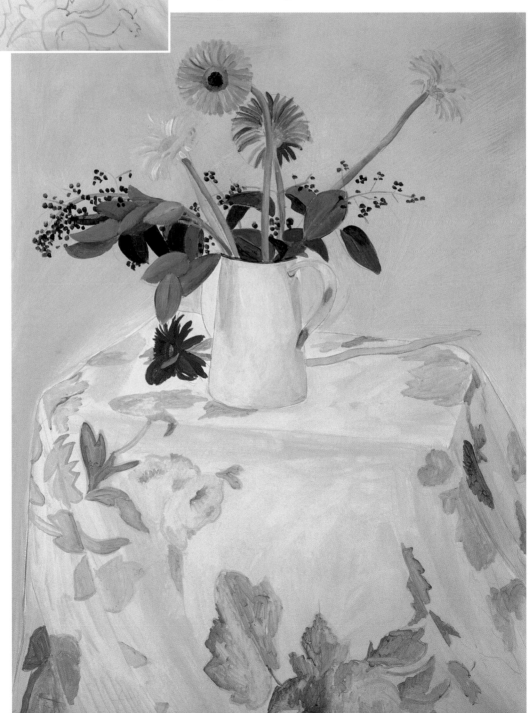

Natural Landscapes

Landscapes offer the artist countless possibilities for creating harmony: the changing seasons, the different tones of light, the time of day, rain, snow. Each of these moments suggests hundreds of color combinations.

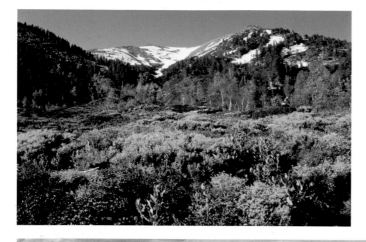

In this mountainous landscape, the strength and the power of the yellow flowers of the foreground guarantees spectacular color.

PAINTING OUTDOORS

Although many artists paint landscapes in the studio from photographs, most prefer to paint them directly from nature. In these cases, the biggest problem of acrylic paints is their quick drying time. The paint left exposed on the palette dries out very fast. The artists who wish to paint outdoors must add a retardant gel to the paint so work can be carried out freely and without fear of paint drying. Painting outdoors presents other problems as well, such as struggling with changes of light, inclement weather, and curious spectators. All this is compensated by the sheer pleasure of being directly in touch with nature.

THE COLOR RANGE OF LANDSCAPES

Warm colors are usually associated with strong sunlight or with vast expanses of land or sand. Cool colors are more common in painting winter or water scenes, in representing some rock textures, and in painting the distant areas of landscape that appear faded by the effect of the atmosphere. Furthermore, intermediate and neutral tones are suitable for painting rainy and foggy days.

EXUBERANT LANDSCAPE

Sometimes nature offers images of incredible beauty that immediately captivate the artist and inspire him or her to capture that moment on canvas. Flowers are always a sure ingredient for beauty and for a variety of color contrasts. Exuberant vegetation is notorious for its varied textural qualities. Besides, if a painting is approached from a close point of view, the landscape provides a fascinating wealth of details and color.

1. The landscape is sketched with charcoal. The lines should be drawn loosely, without too much definition, sketching only the silhouettes of the mountains. Very diluted acrylic paint is used for retracing the lines and for doing the preliminary coloring of the sky.

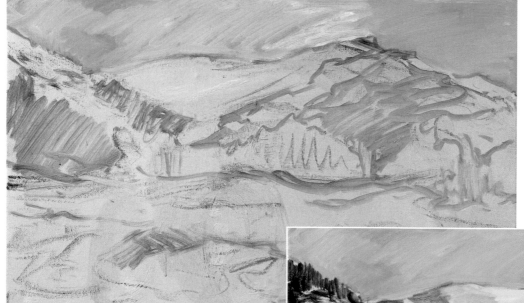

2. The forms are then defined beginning with the background and progressing toward the foreground. Different tones of green and white are alternated for the mountains, to indicate the presence of vegetation or snow, respectively.

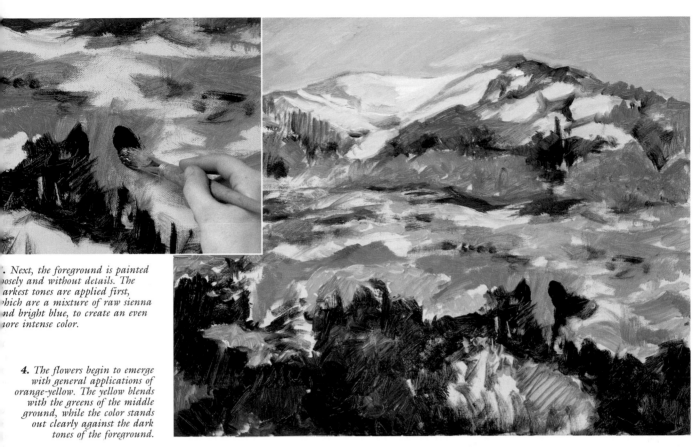

. Next, the foreground is painted
oosely and without details. The
arkest tones are applied first,
ohich are a mixture of raw sienna
nd bright blue, to create an even
tore intense color.

4. The flowers begin to emerge
with general applications of
orange-yellow. The yellow blends
with the greens of the middle
ground, while the color stands
out clearly against the dark
tones of the foreground.

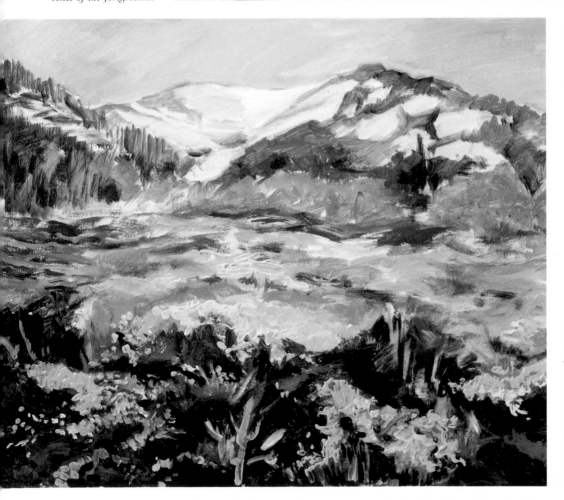

5. Strong areas of
textured yellow color are
incorporated in the
foreground that express
the warm and luminous
character of the
vegetation. The flowers
are formed by a
concentration of small
dashes of color. Although
painting this area in
detail would be a
demanding task, loose,
thick brushstrokes can be
applied to resolve the
subject with relative ease.

6. *The texture of the vegetation is created with a flat brush. The idea is to use short, quick strokes that indicate the direction of the branches and leaves, and the volume of the masses of flowers.*

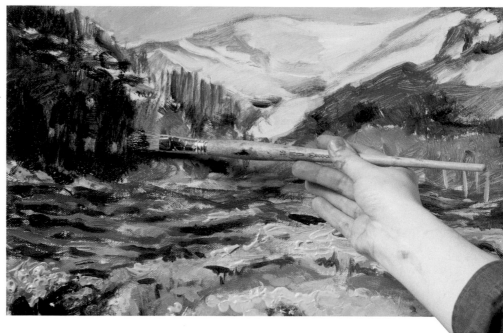

7. *Artist Myriam Ferrón concludes the work after painting the elements of the foreground. The background has not been touched up; there the flowers appear as vague and undefined areas of color. The foreground, on the other hand, is treated in more detail.*

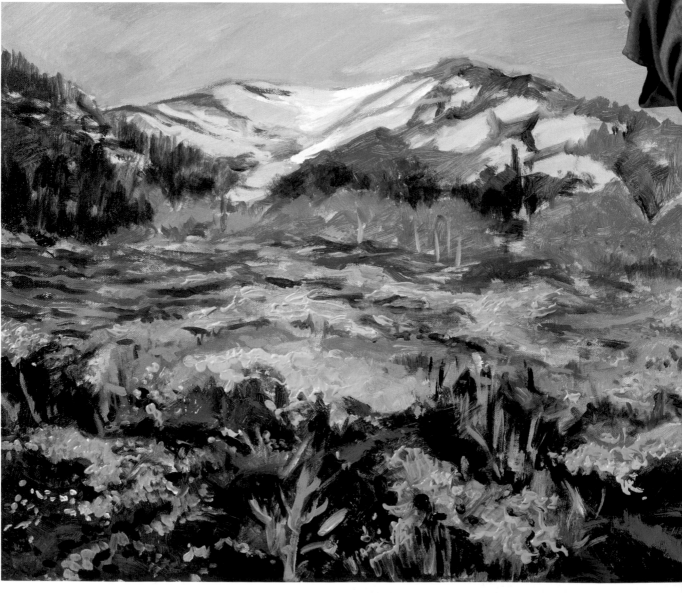

Domestic Landscapes

arden vegetation is interesting because in a way it is seen as a noble landscape, as a rational arrangement of nature. The main difference between painting vegetation in the studio or painting it outdoors is that, in the latter case, the elements are affected by the shapes, sizes, colors, and background that surrounds them. Furthermore, the tree masses appear more compact, and the overall effect has a geometric feeling.

Here is a quaint corner of a whimsically arranged romantic garden, as meticulous and precise in the design of the foliage as in the architecture.

CONTRAST WITH POINTILLISM

Treating color using the pointillist technique is one of the most challenging issues the painter faces. Most of the colors in the painting are created by mixing numerous dots of the primaries on the surface of the work. If the painting is made of complementary colors or a variety of very close colors, the eye will read them as a mixture. Contrasts are created by using darker dots of the same colors in the shaded areas of the subject. Complementary colors are also included in the areas that include shadows.

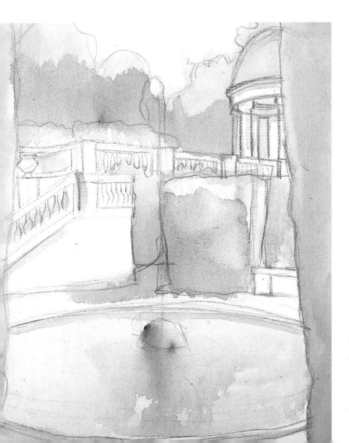

1. The initial sketch is done with a graphite pencil. The drawing should be loose without neglecting a certain accuracy in the representation of the architectural features.

2. Different washes of blue color, which determine the shadows and establish the general mood of the color of the painting, are applied over the sketched elements.

3. *Local colors are added to the previously shaded areas. Greens are incorporated in the vegetation and in the water of the pond. The well-lighted areas are developed using widely spaced dots.*

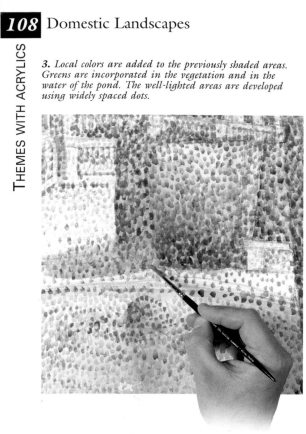

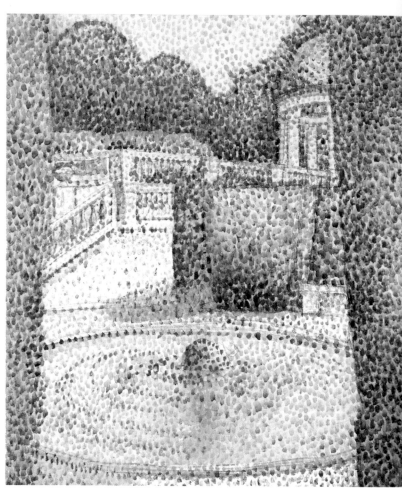

4. *In the areas most affected by direct sunlight, orange and yellow dots are added to the vegetation, and very light ochre and pink to the architectural features.*

5. *The bushes are not composed exclusively of dots, but also of areas of light and shadow that affect their structure in the drawing. The colors, rich and very delicate, of the supple, exuberant, and vibrant bushes give the painting a dignified look.*

6. *The subsequent steps of the painting consist of consolidating the overall forms by establishing the contrasts that define them as such, incorporating blue, carmine, and violet dots in the shaded areas, and yellow, ochre, and pink in the lighted ones.*

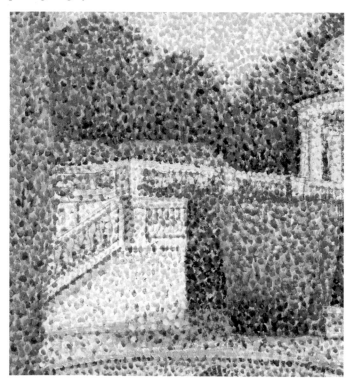

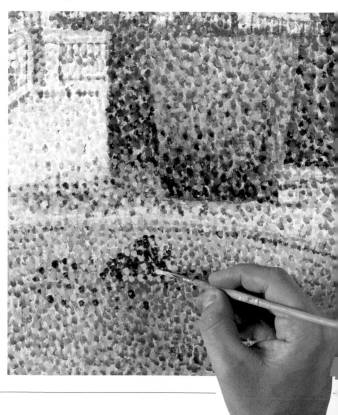

7. When the painting by Gabriel Martín is completed, its surprising effect can be appreciated. The technique of pointillism is ideal for capturing the effect of the sunlight on nature in an atmospheric, vibrant way. If you want to understand how to create the overall tones by accumulating small dots of color, the best idea is to carefully analyze each colored area within the painting.

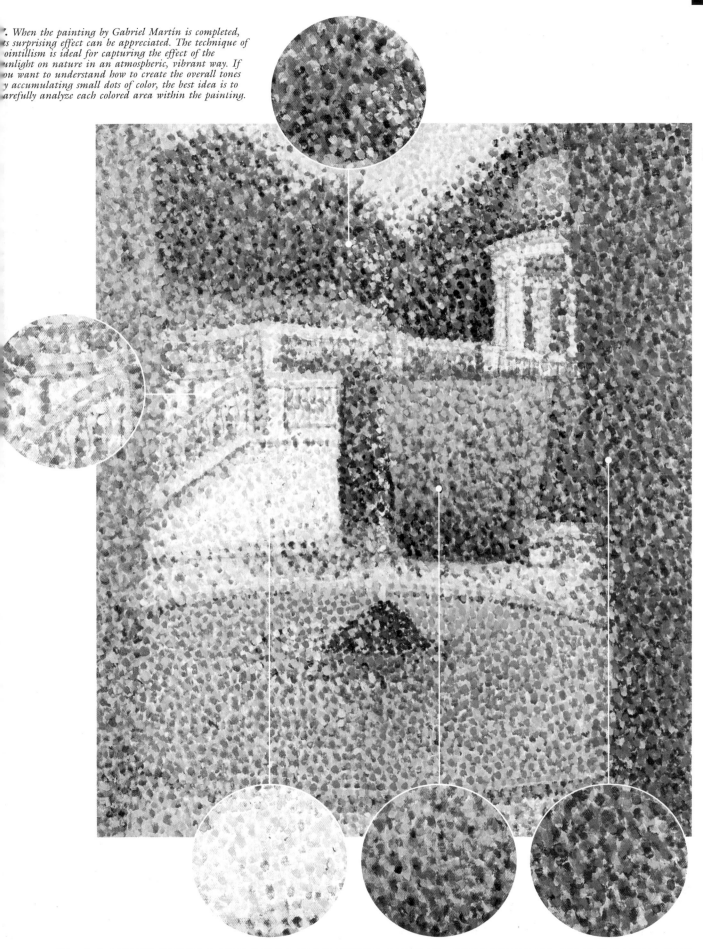

THEMES WITH ACRYLICS

Urban Landscapes

Whereas a rural landscape basically contains natural elements, an urban landscape contains artificial elements, man-made things. The streets, the town square, the large avenues, the views of the rooftops, and the suburbs are all scenes that are available to the artist at all times, because they form part of the daily environment.

CITIES

In a city, everything appears neatly composed, surprisingly organized: the façades with their rows of balconies and windows, the sidewalks, the layout of the streets, the ragged edges of the roofs. The idea of putting the laws of perspective into practice is a thought that discourages some artists who choose to do urban scenes. But they are not complicated if one remembers the basic rule that the extensions of parallel lines converge on the horizon. There is yet another factor that contributes to the three-dimensional effect of architectural elements: the direction of the light. The light in the early morning and late evening hours is the best for highlighting the shape of a building. If the artist knows the basic rules of perspective and is able to control the effect of shadows on the building's front, painting urban landscapes is not difficult.

1. Many artists begin to paint without making a preliminary sketch. But in a structural subject like this one, it is better to have some guiding lines from the beginning. It is not necessary to strictly apply the laws of perspective; simply being a good observer is enough.

PAINTING ROOFTOPS

Elevated points of view are popular among painters of urban landscapes because they show interesting views of rooftops and other elements that are not seen from the ground level. These aerial views are dominated by geometry.

Whereas nature has an endless diversity of sizes and shapes, cities have regularity and precision. The well-defined shapes of the buildings and rooftops allow Almu-dena Careño to show how to construct strong lines and geometric compositions from an aerial view of a group of buildings, creating a fascinating dialogue between lines and flat areas of color.

In an aerial view of a city, the artist must suppress unnecessary details, summarize the architectural shapes, highlight the linear components, and eliminate unwanted mist from the atmosphere.

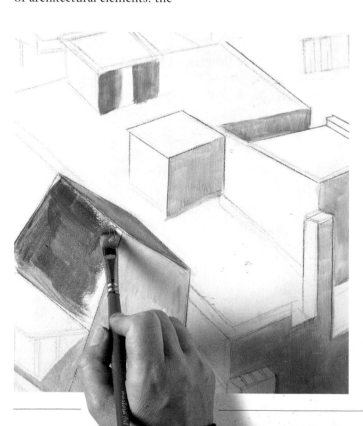

2. The process begins by representing the effect of the light on the façades with colors that are warmer than those used in areas that receive direct sunlight, and the shaded areas with more intense, grayer tones. Ochre washes are applied over some of the lighted façades.

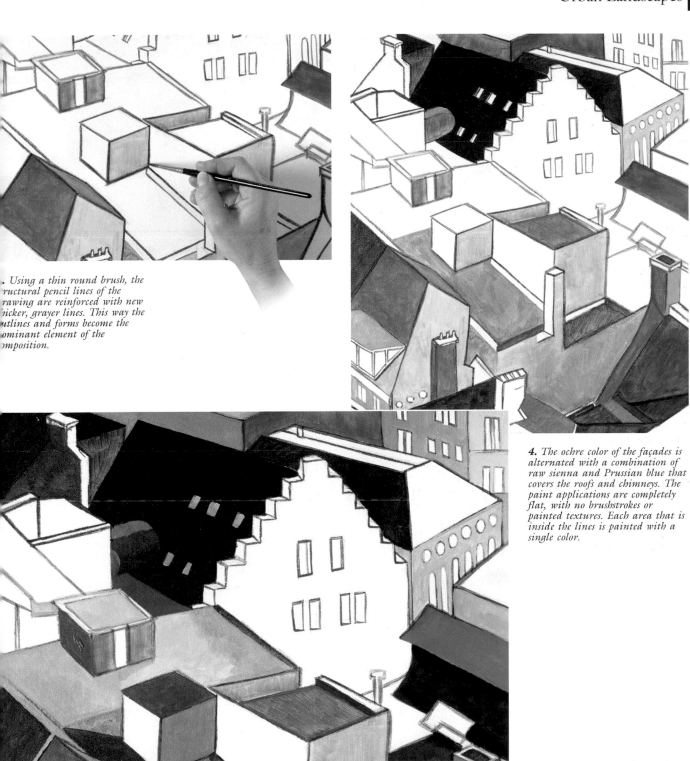

. Using a thin round brush, the tructural pencil lines of the rawing are reinforced with new hicker, grayer lines. This way the utlines and forms become the ominant element of the omposition.

4. The ochre color of the façades is alternated with a combination of raw sienna and Prussian blue that covers the roofs and chimneys. The paint applications are completely flat, with no brushstrokes or painted textures. Each area that is inside the lines is painted with a single color.

5. The intermediate tones are created with touches of gray and natural raw umber. The execution of each plane is deliberate, and in some areas that have a combination of two tones, colors are not mixed to make gradations.

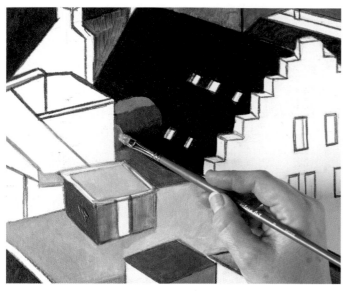

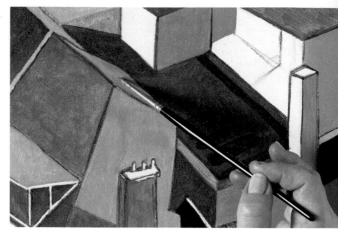

7. *The colors that were already painted can be touched up as much as needed to clean up and correct the tones. If any color needs to be lightened or adjusted, one must wait only until the paint is dry to make the corrections.*

6. *Some areas are painted with a small, flat brush to convey a clear effect of volume. To achieve that, highlights are simply added using the same background color but whiter. As the tones are adjusted, the shapes of the areas of color stand out against each other, defining the limits between them more clearly.*

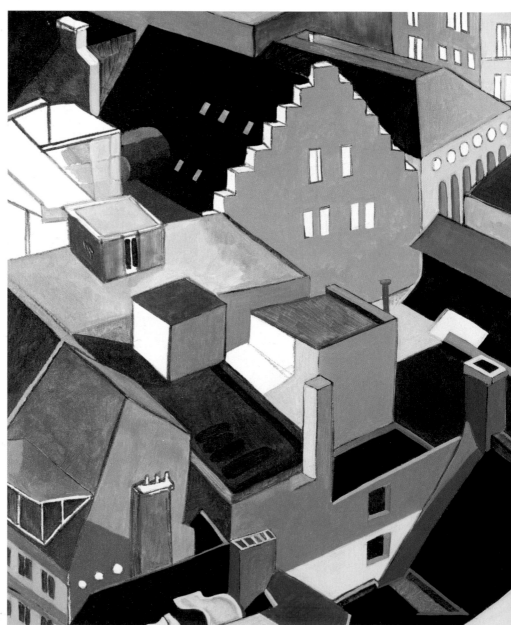

8. *The contrasting light and glossy rooftops have the same compositional effect as the squares in a checkerboard: each shaped by the ones that are adjacent to it.*

9. When the colors of each area have been defined, the small details—such as windows, chimneys, and doors—are painted. Before concluding the composition, the outlines of some of the buildings are redefined.

0. The careful contrast between ght and dark tones and the color alance give the painting a arked abstract quality. It can be read" as a composition of eometric shapes with a finish that obviously flat, but effective in rms of its three-dimensional fect. Contrast is the main tool sed to achieve color balance in his painting.

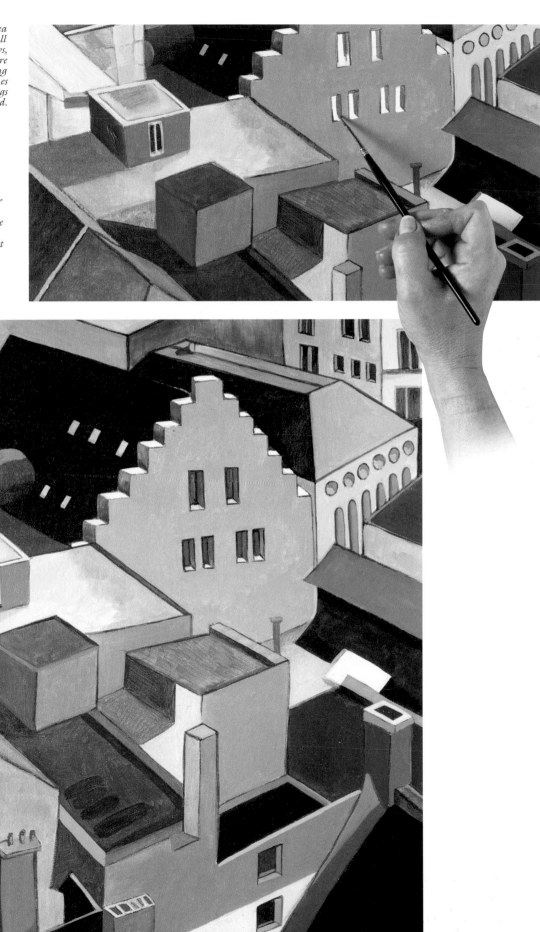

THEMES WITH ACRYLICS

Seascapes

From the dawn of time, humans have been attracted by the vastness, movement, color, and changing aspect of the sea. Through history, seascapes have become one of the classic genres in painting, closely tied to natural painting, although with the added element of the mirrorlike effect of water.

PAINTING THE SEA

The sea is one of the places most frequented by artists, no matter the climate. It has not only a special kind of light but also a variety of themes for painting that are as diverse and fascinating as those that can be found in natural landscapes inland. The activity in the ports, the flow of water, the beach scenes, and the views from cliffs provide a great source of inspiration for artists interested in the play of light on rocks or on wet sand, and in the reflections of the objects on the water.

LIGHT REFLECTIONS ON THE WATER

All bodies of water act as a mirror. However, when water is still, reflections appear all over its surface. When painting the reflection of an object, the vertical edges that determine the height of the object must first be extended downward to locate the upper corners that are reflected on the water. By connecting these two, the upper horizontal edges are created. Reflected images are lighter and more colorful on a sunny day, and less vibrant and diffused when the sky is overcast. Therefore, the intensity of the reflection always depends on the intensity and position of the light source. During a sunset, the reflections of the boats are darker and have a longer-than-normal silhouette.

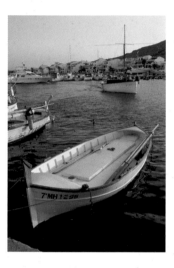

This exercise will demonstrate a harbor scene with small boats where the fresh color will be blended and light tones superimposed onto the dry background.

1. The painting's main element is drawn in complete detail, but without shading. The rest of the boats, as well as the background, are sketched in with lighter lines.

2. The painting of the sea begins with a variety of blue and green tones. The lower parts of the boats are painted with dark violet to represent the shadow.

3. The mountains in the background are painted with soft grays lightened with white, to give the perception of depth and of the atmosphere in front of it.

5. *The dark blue that defines the silhouette of the boat is intensified. The middle ground is painted with cerulean blue mixed with a small amount of green. The deck area is painted with a grayish tone. Overlaying brushstrokes of opaque ultramarine blue creates the texture of the water.*

. It is a good idea to paint the olume of the boats with the arious grays that define their ounded shapes. The bow and the ern are painted with an orange olor, and so are the faint eflections on the water.

A BOAT IN THE HARBOR

In an area of the harbor where the water is still, a boat s a good element to illustrate he importance of the reflec- ions in a seascape composi- ion. The sunlight bathes the cene in such a way that one ide of the boat is in shadow. his creates a clear separation ne with the water. The reflec- ions on the surface of the wa- er correspond to the image of he boat and the surrounding ght.

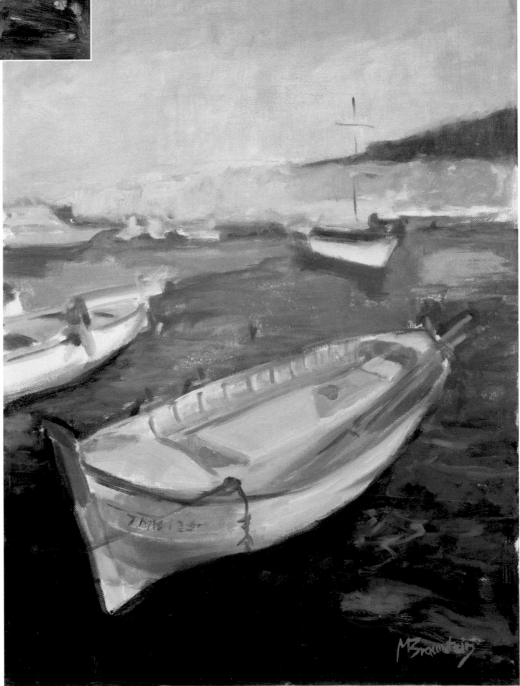

6. *Finally, the contrast that gives the final definition to the form and the outlines of the boat are painted. The blue of the background is also adjusted by applying light and dark blues of various intensities. Painting by M. Braunstein.*

THEMES WITH ACRYLICS

SEA FOAM

Because the surface of the water is constantly moving, it is always changing; therefore, the reflections disappear, the water turns more opaque, and the foamy waves are formed. The most common techniques for painting foam with acrylics are impasto and dry brush, which create a characteristic grainy effect. White foam can almost be painted without seeing it, dragging the brush slowly along the dark edges of the wave or with liquid rubber reserves when working with very diluted acrylic paints

SEASCAPE WITH CLIFFS

When an amateur artist paints the sea, the main problem that he or she encounters is the lack of visible structure. This makes painting the effect of depth difficult, except when there are elements of reference, such as boats, islands, or cliffs in the foreground or near the horizon. In this exercise, Mercedes Gaspar shows how to paint a seascape with cliffs, and uses an alternating effect combined with a free, colorful style.

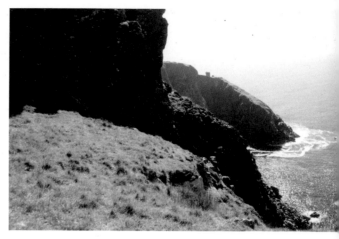

The summer sun floods these cliffs with light and color. On the right, the sea beats on the rocks while the horizon melts away as a result of the intense light.

1. The background is covered with bright pink and orange to create the alternating effect—that is, allowing one of the bright background colors to show through the brushstrokes.

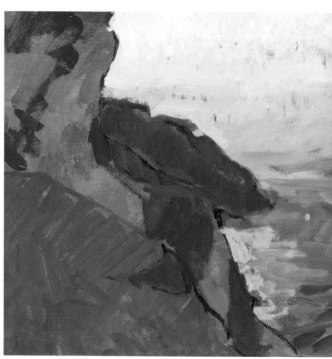

2. The sea should be represented with a series of brushstrokes that create a tonal gradation. In the foreground, the brushstrokes are more defined and blue. On the more distant planes, the colors are whiter and the brushstrokes more diffused. The horizon disappears as the sea blends with the color of the sky.

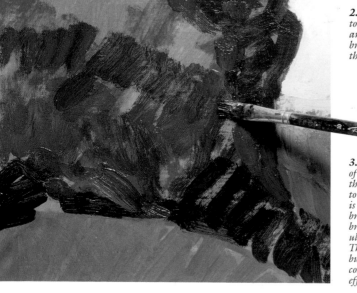

3. The wall of the cliff that is closest to the spectator is covered with brushstrokes of dark brown combined with ultramarine blue and violet. The brushstrokes are juxtaposed, but there is space between them, so the color of the background mimics the textured effect of the rocks.

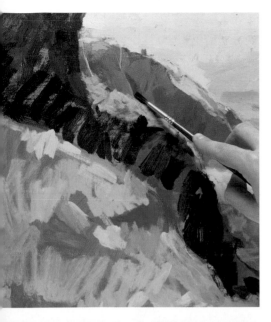

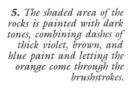

4. *The different areas are resolved. The grass in the foreground is represented quickly with directional brushstrokes that combine permanent green, cadmium yellow, and ochre. They should be painted with an upward motion to reflect its growth. A few more controlled strokes are added on the rocks of the background using a smaller brush.*

5. *The shaded area of the rocks is painted with dark tones, combining dashes of thick violet, brown, and blue paint and letting the orange come through the brushstrokes.*

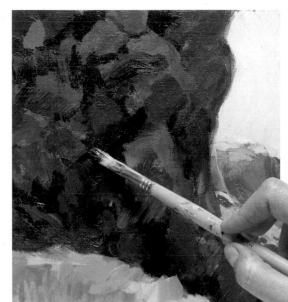

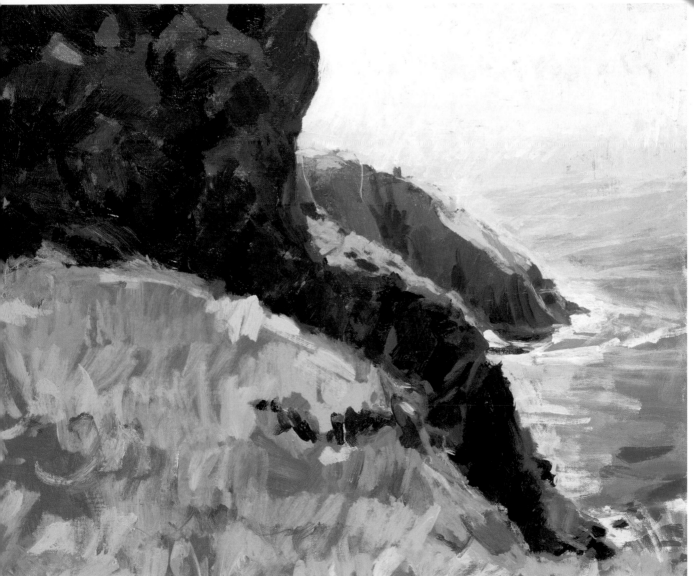

. The contrast between the sea and the rocks is created with different intensities of color and different texture treatments.

Still Life

Still life presents an excellent opportunity to learn how to control the effects of light, to get to know the material, and to practice compositions. Because still life is basically static, it should be composed in a balanced way, but with sufficient variety, energy, and interpretation to maintain the interest of the spectator.

CONTROLLING THE MODEL

When a still life is painted, objects are stationary and can be viewed in the same position for an extended period; therefore, it is possible to work on a large study without interruptions. The artist can control and manipulate at will, selecting and combining the shape and size of the objects, choosing the areas that affect the value and the arrangement of the textures of the materials. Because weather is not a factor—as is the case in landscape painting—still life allows the artist to work at his or her own pace and to experiment with different techniques.

Objects often are arranged in a natural way, creating an attractive scene, as in the case of these metal pots and pans bathed by the light that enters through a window.

INFORMAL STILL LIFE

You do not have to look hard to encounter a still life. There are so many opportunities for this theme that it is difficult to know where to begin: a few objects on a ledge, a writing desk set, a few books on a table, some clothes hang-

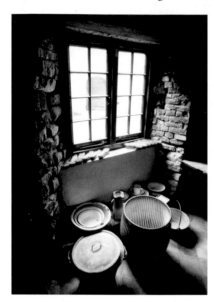

ing on the wall, a group of metal objects under the light coming through a window. We will see how Mercedes Gaspar deals with the latter in the following exercise, parting from a neutral approach. The technical and visual aspects of this type of painting can have the same detail and analytical character as any other, although the painting acquires its special and individual character thanks to the effects of the texture applied by the artist, to the quality of light of the grouping, and to the hidden references found in it.

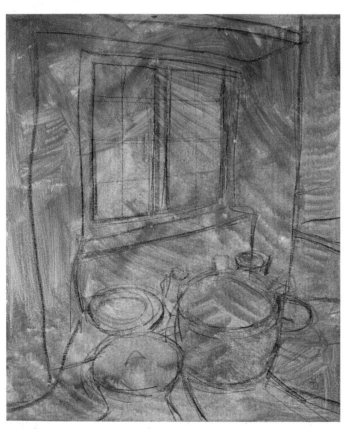

1. The white support is covered with a medium-purple wash. When the foundation is dry, the model is drawn with sketchy lines that are not well defined, using a stick of chalk.

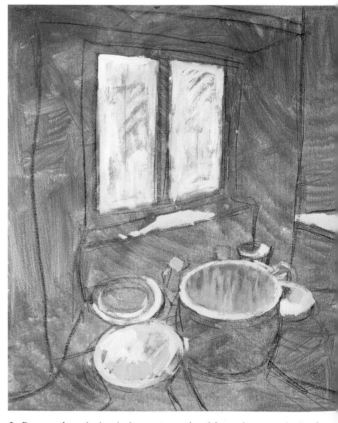

2. Because the painting is done over a colored base, the process begins by painting highlights, using white paint mixed with a small amount of ochre for the windows and the sill, and white with a tint of blue for the metal objects.

PAINTING METAL

There is no specific color for this type of material, because metal color is not found in the palette. Metal objects are painted with a succession of color gradations and the intense reflections that light creates on its surface. Therefore, it is necessary to find the appropriate tone by mixing the different colors and combining them with intense highlights, which are obtained by saturating the chosen tonal range with white. Also, keep in mind that highly polished metal objects reflect other things that are placed nearby, distorting them as a result of the shape of the metal object.

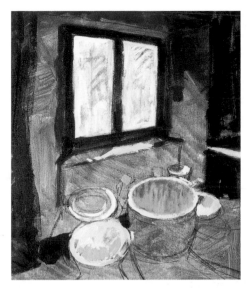

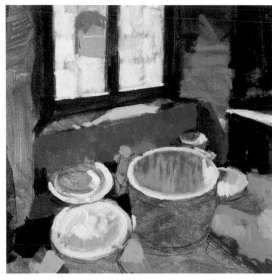

3. *The main areas of shadow are defined with a mixture of burnt umber and violet, and these will create a distinct background for the first applications of light. This way, the two light sources of the painting are identified from the beginning.*

4. *The lower part of the wall and the floor are painted first to bring out the shine of the metal. At this stage of the composition, the broad, opaque applications of color immediately establish the impact of light on the floor, the walls, and the tones that derive from them.*

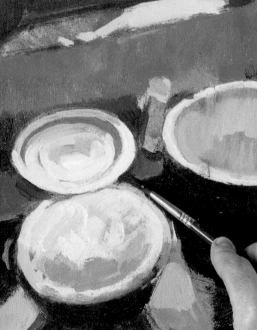

. Every metal object is able to reflect ght, and therefore intense highlight. It is recisely these highlights that are created ith tones that are saturated with white hat help the artist convey the quality of hese materials.

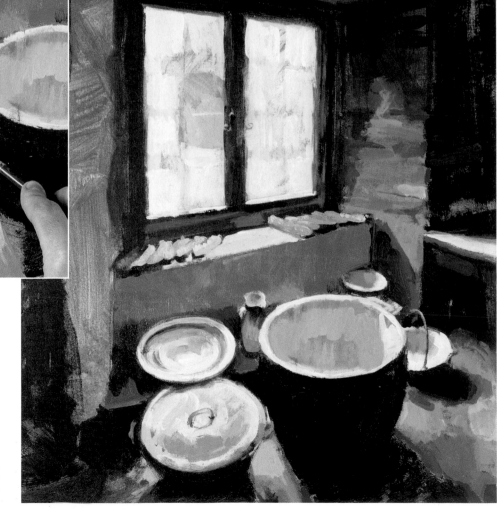

6. *Using a small brush, the details of the metal objects are completed over the gradations, which range from a bluish white for the lightest areas, to a whitish violet for the darkest. The handles and the openings of the pitchers are painted this way.*

7. Notice how the brusquely painted finish on the wall suggests the irregular texture of the stone. Brushstrokes of orange are applied to the areas of the wall with more light, and of brown and violet to the shaded ones. Observe how the blue tones of the metal objects are repeated as accent on some of the stones on the wall.

THE VALUE OF BLACK

If a painting incorporates dark areas, avoid using black in the mixtures. It is extremely important to try to use alternative ways to create different dark tones, such as mixing several complementary colors. Although the resulting tone will not be completely black, it will be a dark color, which, besides fulfilling the same purpose will be in better harmony with the rest of the colors of the painting.

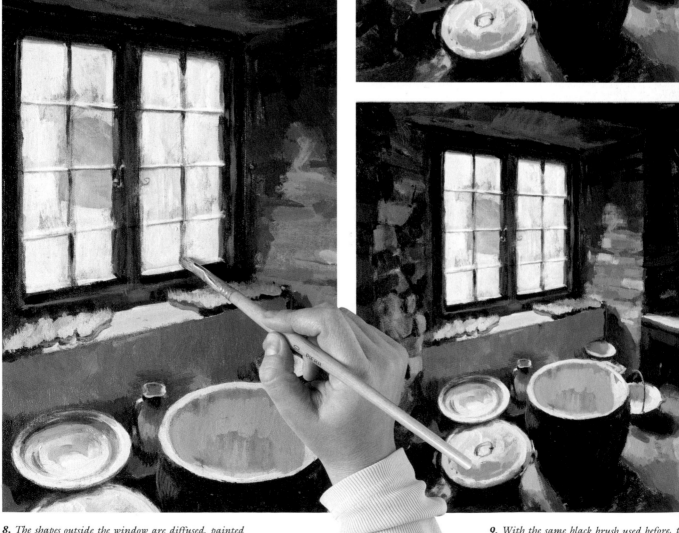

8. The shapes outside the window are diffused, painted simply with abstract strokes. The frames of the window panels are painted with a small amount of black using a worn brush, keeping in mind that the vertical lines should be a little bit thicker and darker than the horizontal ones, which receive some sunlight.

9. With the same black brush used before, th outlines of some of the objects are highlighte and faint lines are added to define the textur of the wall. New touches of dark color and blu reflections are applied in the same area

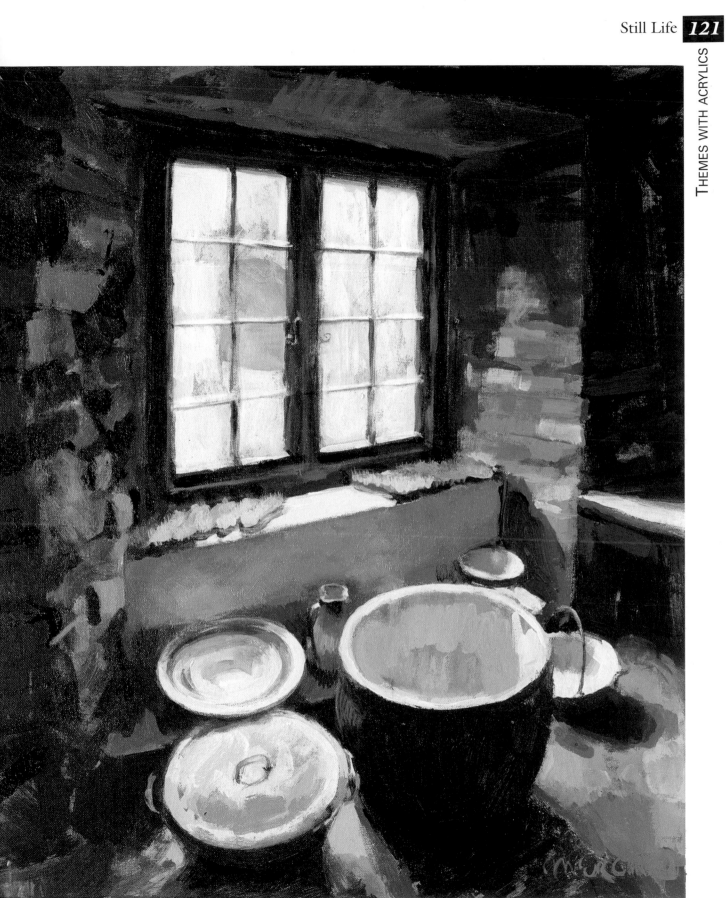

10. In the final image, the way that the light and the objects have been treated in this painting is outstanding. The colors and tones have been carefully studied so that solidity and a spectacular structure of light, shadow, and reflections on the metal are conveyed.

Colorful Still Life

The artist should feel free to interpret still life with a personal approach, even if he or she is not doing a conventional painting or a tonal-value study. One of the most creative ways to interpret still life is by using the theme to express a bright color palette with strong contrasts of almost pure colors. Pure colors possess a power that the artist can use whenever he or she is willing to sacrifice the realism of the representation.

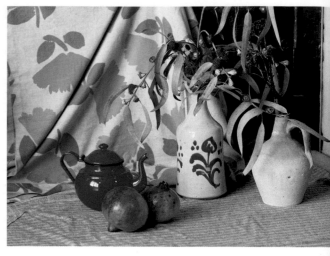

The composition should be composed in a balanced way, because that will be the reference point to follow.

1. The sketch of the still life composition is done directly with paint, using a thin brush with a small charge of paint. The quick drying time of acrylics prevents colors from mixing.

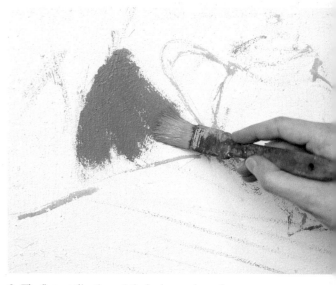

2. The first applications of the background are done with orange, using a wide brush and applying the paint liberally and with a steady hand.

COLOR SYNTHESIS

In the following exercise, Muntsa Calbó has made an effort to synthesize the model—that is, the artist has assimilated the basic shapes before the accessories. When it comes to color, this offers no particular problem, because flowing layers are used in the background and more opaque colors in the main shapes. The effort of synthesizing the model helps develop an understanding of the forms as volumetric studies of the objects painted in the space of the picture.

3. Each object in the composition occupies a space in the painting, and although the shadows and reflections form part of them, they should not be taken into account in the first color applications so the shapes of the still life elements can be correctly defined.

New shape-defining tones are added over the base color. These brushstrokes can be opaque when their purpose is to cover or correct an area, or transparent when their purpose is to define a color or a shape with a glaze of any color.

5. The vases are defined with paint heavily mixed with white. The blue detail that decorates the vase is painted with a brush barely charged with paint.

6. The red berries on the branches are painted directly, without defining the shapes too much. The tabletop is covered with long brushstrokes that define the surface.

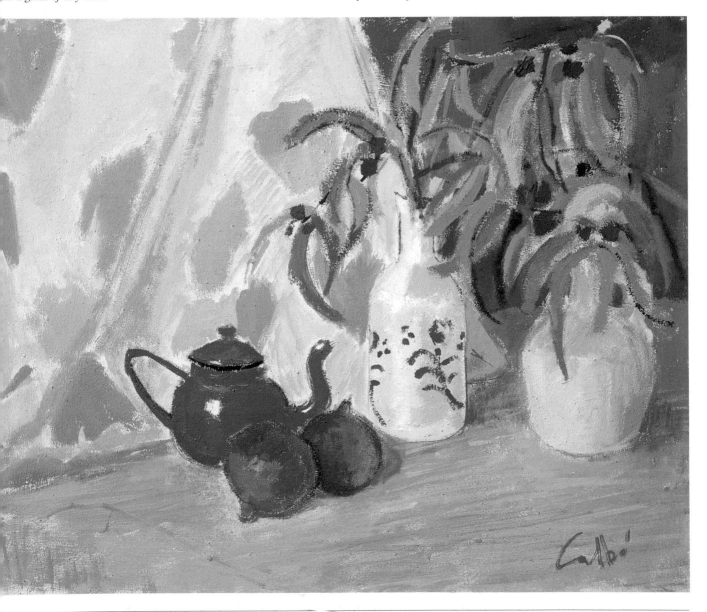

Unusual Motifs

Although simple still life arrangements are rewarding, the artist may prefer to introduce a more personal element in the chosen theme to give the group of objects not only a visual appeal but also a narrative and an associative value as well.

We can set aside the conventions of still life interiors and center our attention on a single object, in an interior or exterior location. The most unusual elements thus acquire a certain interest through the artist's interpretation of them; somehow the setting is captured by the novelty of the theme. In this way the artist can more comfortably concentrate on the forms, the colors, and the textures, creating interesting compositions with seemingly unattractive subjects. The steps painted by Almudena Carreño and reproduced on these two pages demonstrate how efficient this type of treatment can be.

Wood and metal are appealing elements because they represent a specific type of texture and interesting tonal changes from the chromatic point of view.

1. The initial drawing is completely linear and detailed. An appropriate medium-tone background has been used to begin working the texture of the wood and to allow the gray color of the background to breathe through between the lines of the first layer of paint, which was applied with a wide brush.

2. The entire surface of the door is painted. The artist's main task is to define the surface with gray, brown, ochre, yellow, red, and orange, alternating the brushstrokes to show the different intensities of the wood and the way light strikes on it.

3. The metal parts are created. The upper, elongated element of the latch is painted. As far as technique is concerned, the light and straight lines can be drawn with a ruler. Two different types of metal tones are noticeable—one white and colder on the pieces attached to the door, and the other more coppery and red for the movable parts of the latch.

4. The details are finished and some tones are adjusted. The textures of the iron elements are represented according to their condition; they have a reddish tone in some areas, which is characteristic of rusting metal, and they have a muted shine in others, from the light that bathes the parts.

isually, metal is an interesting
ement. Whereas worn-out metal
s muted details that are not very
pealing, new metal acts as a
irror, reflecting everything
round it.

1. The doorknocker is drawn with graphite pencil.
Then, the dark parts are painted black, leaving the
canvas unpainted for the shiny areas. The idea is
to establish a comfortable working method from the
beginning.

2. The background of the image is painted with a dark
tone of raw umber and sepia. Once the background is
established, attention can be shifted to the knob. The
preliminary drawing already shows the correct distribution
of the colors, so the work consists of choosing the accurate
intensity of the tone and filling out the appropriate areas.

3. The areas that are still
unpainted are covered with a
cooler color scheme, like blue-green,
spreading it over the reserved
areas. On the hand and knob,
these colors are mixed with a small
amount of white, because they
belong to areas of light. The colors
are darkened on the top sphere,
which is attached to the door,
because it represents a darker
material.

4. The colors and tones have been
meticulously studied to convey a
solid feeling and a spectacular
display of light and shadow.
Unlike the previous exercise,
polished metals are shinier and
round surfaces distort the images
reflected on it.

Interiors

Sometimes, the artist is not able to paint outdoors because weather is inclement, or no model is available, or because still life themes have become repetitive and boring. In these cases, it is a good idea to use the painter's own studio or a corner of the house as a painting theme.

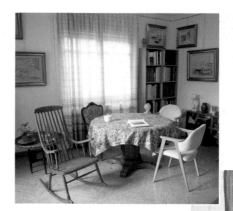

In this scene, the artist has chosen an angle of a room with a strong perspective, which will be emphasized by working with a horizontal format, to which other elements, like a rug and a cat, have been added.

POSSIBILITIES

Interiors offer an array of possibilities, such as painting them in perspective or drawing objects found near a window, bedroom scenes, people in the living room, etc. All require careful control of light and shadow combinations and the texture of materials, such as upholstery, curtains, tablecloths, and rugs. The best way to represent them is to focus the attention on one of the room's angles. Next, a series of diagonal lines are drawn from which the walls of the room are created. Then, the furniture and objects that stand out against the linear structure of the architectural elements, such as doors and windows, are added.

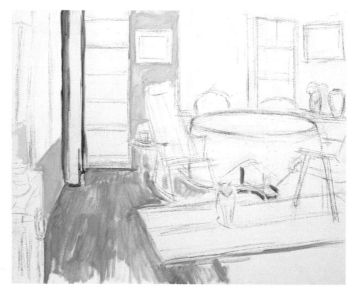

1. Blocking in is done in a concise manner, by indicating each of the different objects and planes. The larger areas of the canvas are painted, beginning with the floor and the background walls.

2. The shelves are painted and the book spines are defined with repeated layers of color. The acrylic paint used up to this point is quite transparent. The painted details need increased opacity.

3. Each area is gradually defined, building up to tones that are more permanent. The tonal contrast of the floor is increased to highlight the colors of the walls and rugs. Notice that the artist, Caritat Gómez, has added the cat to the scene to create a new focal point.

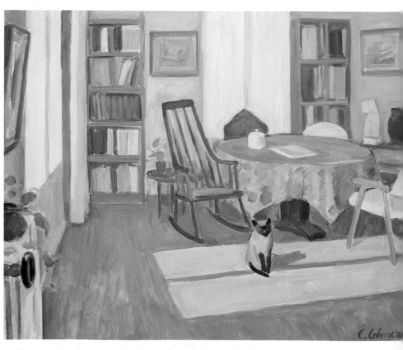

4. The colorful details of the tablecloth are added, and the folds are hinted at with tones that blend areas of light and shadow. Finally, the broad areas of color of the rug are painted, and the spines of the books located in the bookcase on the right are defined.

FIGURES INDOORS

One of the most interesting aspects of drawing interiors is the mixed lighting, when the natural light that enters through a window is combined with the artificial light, creating a peculiar environment where the blue luminosity of outdoor lighting is mixed with the warm and orange color of indoor lighting. If in addition to controlling the environment through light effects the artist wants the spectator to be aware of the spatial dimension of the interior, there is no better method for doing this than by enhancing the effect of per-spective and by introducing a figure on the foreground that will make it possible to compare the scale with that of the human figure. However, one must keep in mind that if figures are incorporated into the interior scene, they should not be treated as separate or superimposed entities on a background, but blended with the elements of the scene. Notice how Josep Torres integrates the figure in this interior.

The interior presents mixed lighting that combines artificial light from fixtures and the natural sunlight that comes into this large space through the windows. The geometric floor and the placement of the figure in the foreground heighten the effect of depth.

1. The angle of the room is established first by drawing the diagonal lines and by placing the figures. All of this is executed tentatively with sketchy lines. The consistency of the lines varies according to the importance of the compositional elements that are blocked in.

3. When painting an interior, it is always best to begin with the background—that is, to work from the most distant planes to the closest ones. The wall in the background is painted using variations of ochre mixed with yellow and red, and using orange tinted with raw sienna for the upper moldings. The purpose of these first applications of color is to enliven the painting.

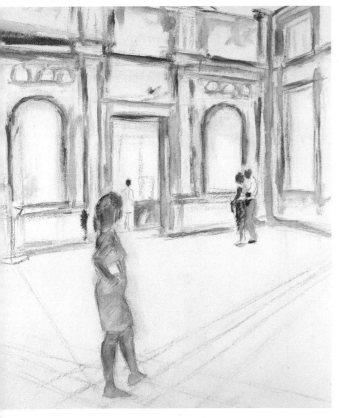

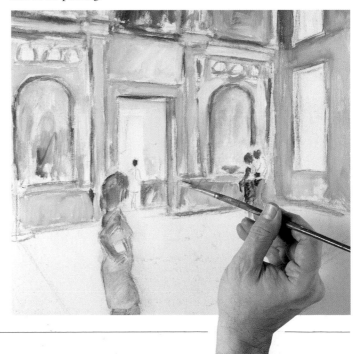

2. The first applications of carmine and ochre appear on the background walls. Because the room includes cornices and other architectural elements, the first brushstrokes serve to establish the architectural design of the space. The figures are painted with transparent washes, with the only purpose being to indicate them.

THEMES WITH ACRYLICS

ATMOSPHERE IN INTERIOR ENVIRONMENTS

One of the most interesting ways of creating an intimate atmosphere is to display most of the colors of a particular chromatic palette almost in a monochromatic way, using only one color and its possible variations. When the need arises for other colors, it is important to make sure that they are saturated with the general tone of the color scheme used.

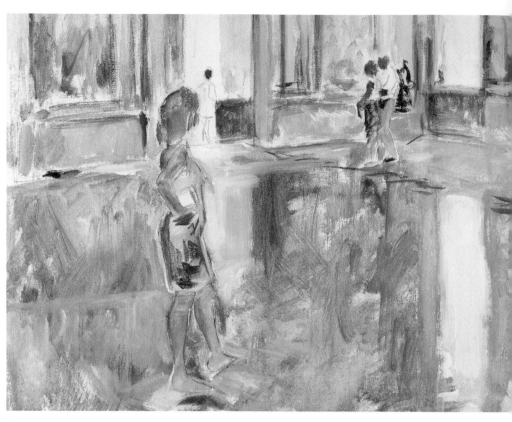

4. One of the main areas of the project is painted, the floor. For this, an uneven combination of raw umber and ochre is used. The brushstrokes are broad, loose, and a little diluted, with special attention given to the reflections of the door and windows, which will be the white color of the support.

5. The overall painting should be guided by a specific color scheme, to create a coherent atmosphere. Once the dominant color that sets the mood of the room has been established, the figures are introduced with new colors that make them stand out.

6. The shapes, which have been sketched out from the start begin to take form with the paint itself, which is used to detail the areas of contrast that allow the differentiation of each plane of the painting. This way, the colors of the figure in the foreground appear darker and more contrasted than those in the background, where the light ochre becomes the dominant color.

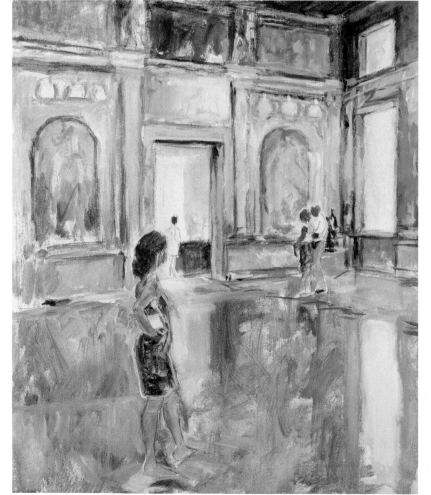

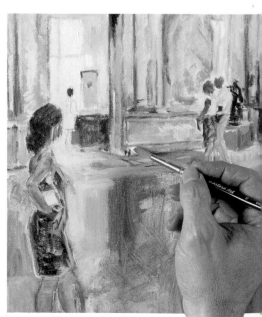

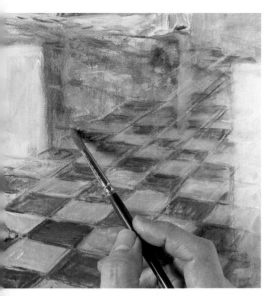

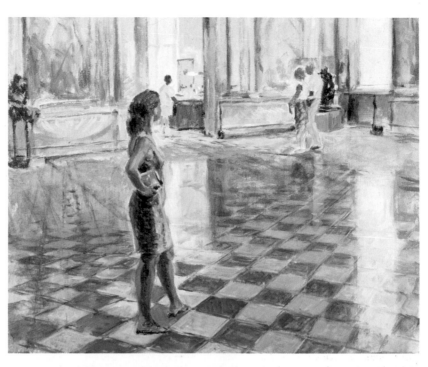

7. The tiled floor increases the effect of perspective of the scene and gives more depth to the painting. The outlines of the tiles fade the farther they go from the spectator, until they blend completely with the ochre color of the reflection of the back wall on the shiny floor.

8. *To paint the geometric design of the floor tile, the artist needs only to draw diagonal perspective lines that frame each one of them. Next, the details of each tile are applied with a raw sienna using a small brush. The first brushstrokes for the foreground are opaque, and the color becomes lighter as they get farther away from the viewer.*

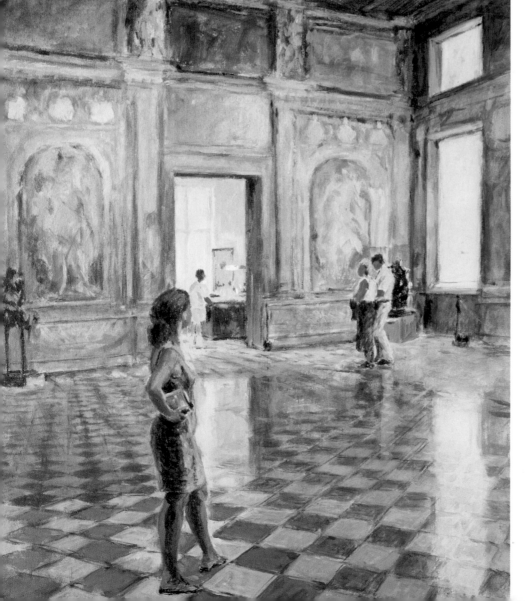

9. *When the paint is dry, a few glazing strokes of burnt sienna and ochre are applied to create the proper atmosphere and to capture the light effects of the model. The details, which are more obvious on the closest figure, do not have to be overly precise, they can just be insinuated.*

Animals

The artistic representation of animals is a subject that has many followers among those interested in painting. The growing interest in ecology and animal rights and the new pronature tendencies in the industrialized countries have led to renewed encounters with nature, making painting animals a popular theme again.

A dog is an animal closely associated with the domestic environment. The best moment to draw a dog is at rest. The hair of the animal presents an array of textures, reflections, and effects that can present a challenge for any artist.

CAPTURING THE ESSENCE

More than with any other type of painting, representing animals requires much observation. Animals are not under the artist's control; they are almost constantly moving. Therefore, the artist has to be able to form a fixed image in his mind to create a sketch. It is a good idea to observe the animal for a long time before drawing it. It is important to capture the essential forms and movements that it makes without being carried away by the details. Controlling the movement and postures of the animal is a major step toward achieving optimum results.

ANIMALS AND HABITAT

If the artist wishes to make the animal the protagonist of a landscape scene, the former should be worked in more detail than the latter so it becomes the focus of the painting. There are several ways to achieve this. The animal can be placed closer to the spectator, the rest of the elements can be painted out of focus and with similar tones so they act as a backdrop to the main theme. Strong tonal contrast can also be created between the model and the background—for example a white horse that stands against a thick, dark brown forest. This example also creates a contrast of forms and highlights the outline of the animal.

DOGS

Dogs are complex animals to paint. However, a dog can be observed and painted without difficulty when it does not move. Resolving the hair can be easy if the artist adopts a shading approach. The secret resides in determining the areas of light and shadow from the beginning, taking advantage later of the intermediate tones to describe the effect of volume and highlights of the skin.

This exercise, done by Esther Rodríguez, is somewhat more difficult than the previous ones because of the great variety of textures of the vegetation and the animal's hair. However, it should not present a problem if the following advice is observed.

1. The first color areas on the dog are applied by covering the preliminary sketch with burnt umber and raw sienna. The sun-washed grass is painted with slightly whitened ochre, and emerald green is mixed with gray for the background vegetation.

2. It is important to paint the background at the same time as the figure of the animal. The colors of the background highlight the tonal contrast of the dog's hair and help define its profile, given that the hair is dark and the background is predominantly lighter.

3. *The thick brushes of the initial work are replaced with a round, thinner brush. More brushstrokes that are opaque are applied over the previous paint to define in more detail the main tonal areas of the animal. At the same time, transparent white washes are applied to the dog's back to introduce the first indications of light.*

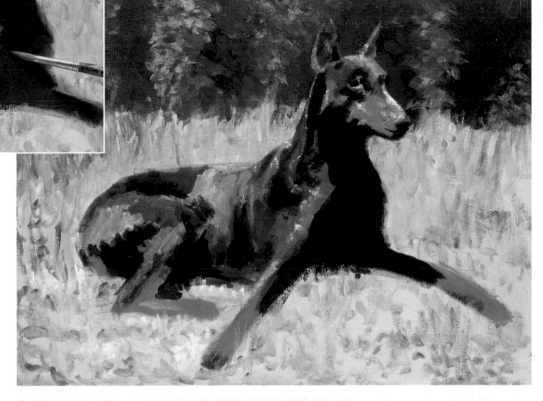

4. *Darker, more contrasted tones are gradually applied around the dog's head and neck, and a white glaze covers the back. To prevent the colors from mixing accidentally on the paper, several areas should be worked at the same time—in other words, one side should be painted first and while this dries the other side is started, alternating shapes and colors.*

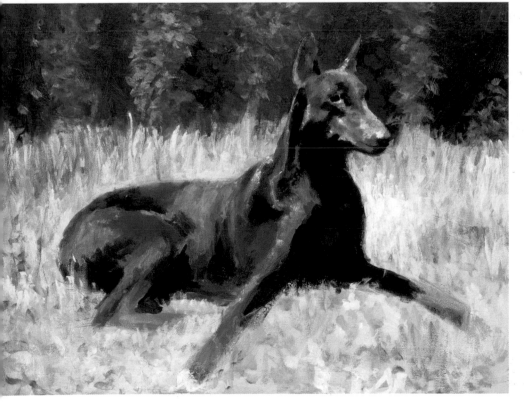

5. *The bright yellow vegetation of the background is subdued with additional brushstrokes of lightened ochre, to make it more compatible with the effect of the sunlight on the golden grass. The eyes, nose, and volume of the animal's head are defined with a small amount of black and white washes applied with a small brush.*

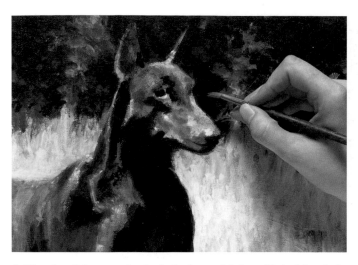

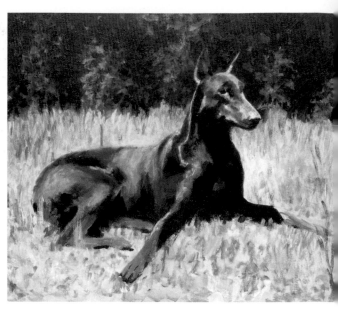

6. *The color of the vegetation in the background is intensified with a dark green and brown. Texture is modeled with these colors applied with short and superimposed brushstrokes and the paint diluted in some areas to create gradations.*

7. *The [color] of the dog's short hair depends on its position and muscle mass. Notice how the soft, smooth surface of the animal's back and hind leg appear as a layered mass of dark and light tones that range from a washed white to the darkest black, with a series of intermediate gray tones in between.*

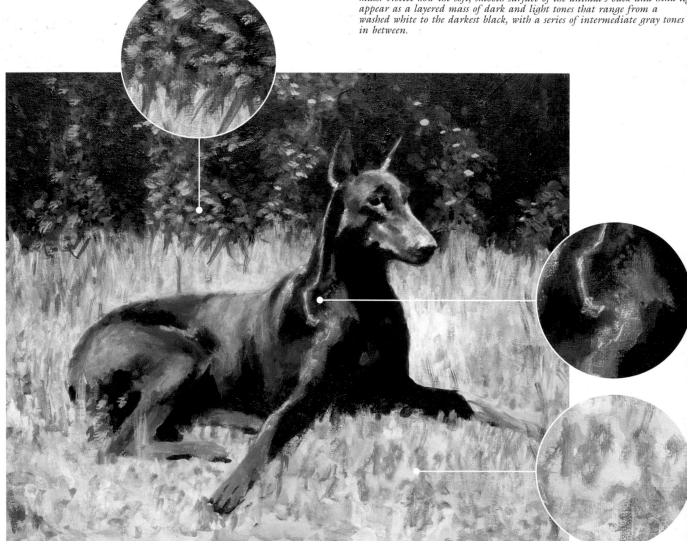

8. *A few dabs of green are applied over the vegetation of the background to highlight the textural effect of the leaves. All over the dog's body the paint has been applied by using a glaze or by lightly touching up with the brush, instead of the conventional rubbing, to avoid brush marks.*

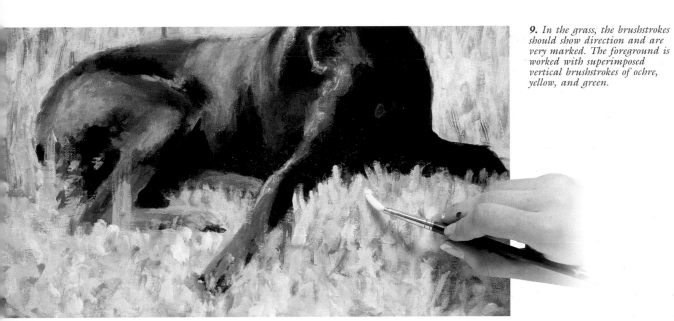

9. *In the grass, the brushstrokes should show direction and are very marked. The foreground is worked with superimposed vertical brushstrokes of ochre, yellow, and green.*

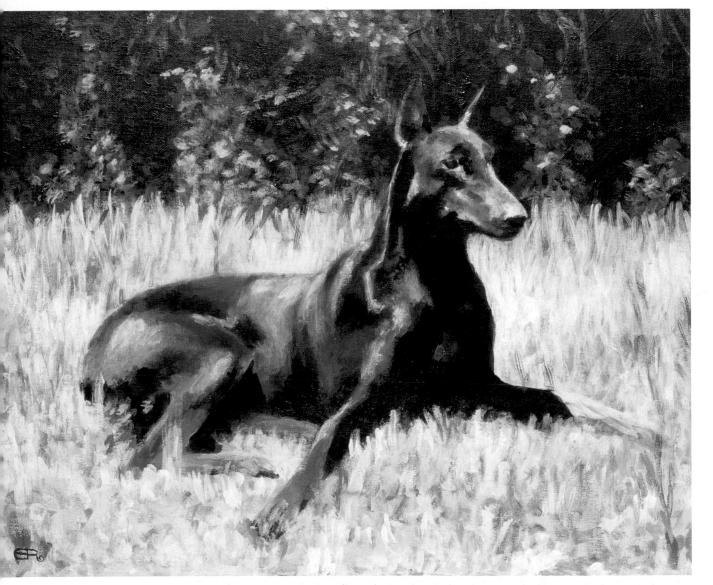

10. *The painting has not changed much from the previous step. Following the exercise from the beginning confirms that this is a simple theme that does not require too much involvement other than a conscious attempt to convey the freshness of the life model that is established at the beginning.*

Nude Figure

D rawing nude figures requires visual perception and provides practice in the ability to represent the figure. The human figure provides a rich subject matter, whose artistic representation can be approached from many different angles and personal styles without altering its essence.

The tone and nuances of the skin make this an appropriate subject matter to paint with acrylics because they represent the firmness, quality, and volume of the skin with a value study of light and shadow.

PAINTING THE SKIN

The color, softness, firmness, etc. of the skin constitute the visual elements that make one person different from another and give personality to the figure. This is why it is important to treat each type of skin properly, reflecting in each case what the eye sees. When the artist comes face to face with the task of painting the skin, he or she must keep the following aspects in mind: the undulating profiles of the muscles, the folds around the articulations of the limbs, as well as the age and race of the figure being painted. It is not the same to paint the saggy and wrinkled skin of an older person as the soft and firm epidermis of a child. In the same way, the skin of a black person presents different tonal variations than that of a white person.

The volume of the different parts of the body mainly depends on the muscles, tissue, texture, and firmness of the skin. As a general, more obvious rule, it is important to mention that, with age, wrinkles make their appearance, the skin becomes flaccid in certain areas, and bags form, especially on the cheeks and in the neck. The following exercise by Josep Torres shows how to paint the skin with a light-and-shadow approach.

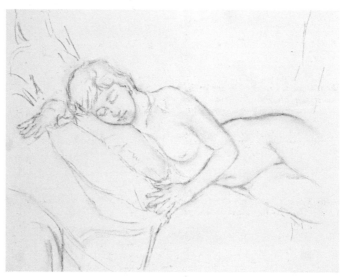

1. In the preliminary stage, it is important to establish the composition and every aspect of the drawing correctly. The first step must be conscious and precise, and should be corrected as many times as needed until the result is proportionate and harmonious.

2. The contours of the figure are redrawn with magenta acrylic paint using a thin brush. The idea is to reinforce the previously drawn pencil lines so they remain visible all the way to the advanced stage of the painting, to serve as guidelines when applying the color.

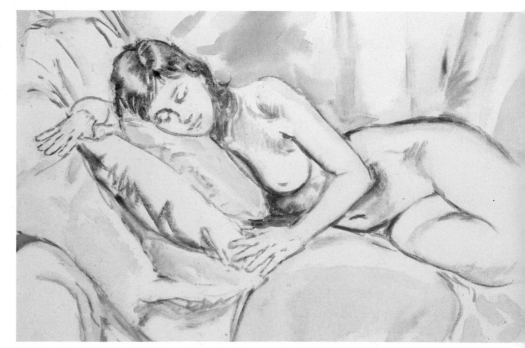

3. The initial approach can be done with paint that is quite diluted. The areas of shadow in the model are identified with raw sienna, and the background is established. The figure cannot be painted as an isolated element without taking into account the surrounding colors.

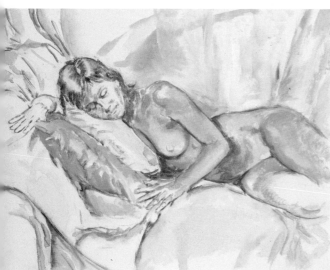

. The paint has been applied in
in layers, going over it several
mes and dragging the brush on
e canvas to create intermediate
nes with the color of the
ckground. The lighted areas of
e body are created with a whitish
ixture of carmine and ochre.

5. The combination of light and
shadow is the tool used by the artist
to suggest the body's volumes. It is
important not to forget the
relevance of the direction and
quality of the brushstroke when
applying and suggesting facial
details and textures.

. To finish, white paint tinted with ochre and a small amount of carmine has been used to apply the touches that create the soft highlights on the skin, by
ushing the color and blending tones together to avoid a brusque transition.

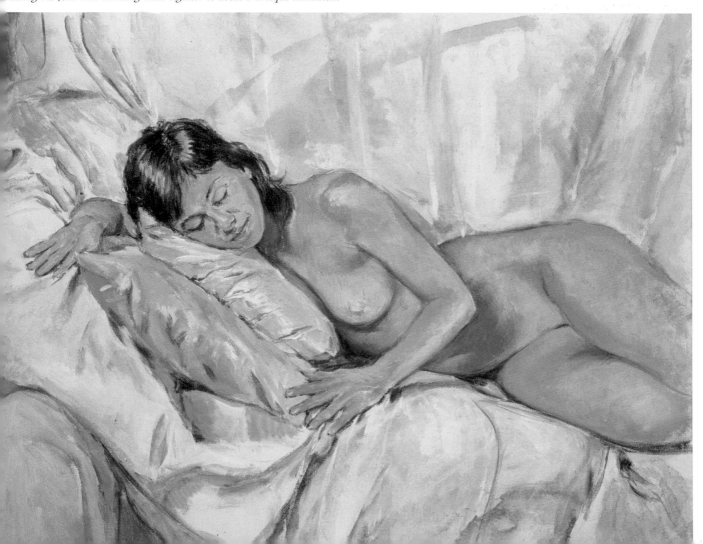

EXPRESSIVENESS IN FIGURES

Interpreting the model with expressive lines emphasizes the formal aspects of the painting and gives character to the drawing. Drawings not only make reference to physical representations and structures but also express certain personal and unique aspects of the person who executes them, including emotion, imagination, perception, and personality. The abstract qualities of the shape, rhythm, colors, and the relationships among them always prompt an emotive response in the receptive artist.

Expression is a difficult concept to define directly without ambiguity. In figure drawing, one can say that a work of art is expressive when it is "alive," when it has internal vitality, when the model appears as a living creature rather than part of a pure and cold representation. If the artist succeeds at capturing the life of the figure, he or she will produce an expressive drawing. Expressiveness can be achieved through various means: by using saturated color, by using intense and spontaneous lines, and by distorting the forms.

BRIGHT COLORS

Bright colors have an inherent visual power that the artist painting nude forms can take advantage of as long as he or she is willing to sacrifice the pure realism of the painting. Working with contrasting colors, combining cool and warm and light and dark tones, is one possibility available to the artist. In such circumstances, realism becomes less important, although this does not mean that certain aspects of the composition or the proportions of the figure should be ignored.

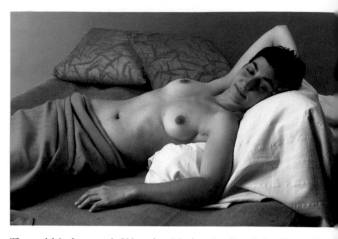

The model is shown at half-length, with the soft colors of the skin combined with bright objects. The bed and the sheets act as compositional elements that frame the figure.

1. The free interpretation of color requires a sketch whose lines are not too defined. A few lines executed with a thin round brush and burnt umber paint are sufficient. It is easy to see that the artist, Esther Olivé, has modified the pose to make the painting more expressive.

2. The paint used should be dense and thick, and applied in generous amounts. The painting is executed with brushstrokes that convey an immediate feeling of vitality.

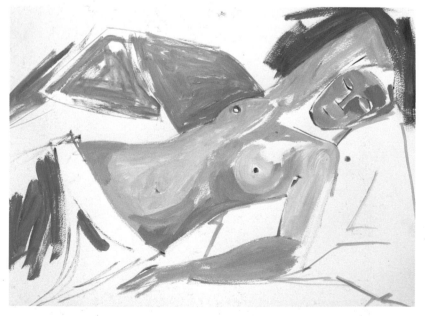

3. While the skin is being painted, the background is blocked in with rough, quick brushstrokes that allow the white of the support to show through. The colors of the background interact with the nude, and they become a valuable compositional element for the diagonal line of the figure.

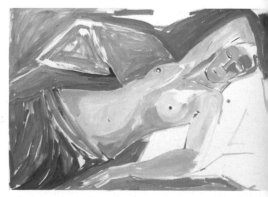

4. The artist is more interested in the interaction of the colors, which have been carefully orchestrated, and the shape, rather than space and modeling. The volume of the figure represents a very small part of the painting.

5. The brushstrokes are heavy, directional, and charged with paint. The brush moves very fast on the canvas, covering several areas at the same time, applying new strokes over the previous ones, which provide more definition to the volume and tonal details.

6. Although the artist will still make modifications to the colors and tones, they already constitute a good base of bright tones and powerful expression. The vibrant colors of the background are the perfect contrast to the warm tones of the skin and the subtle colors of the drapery.

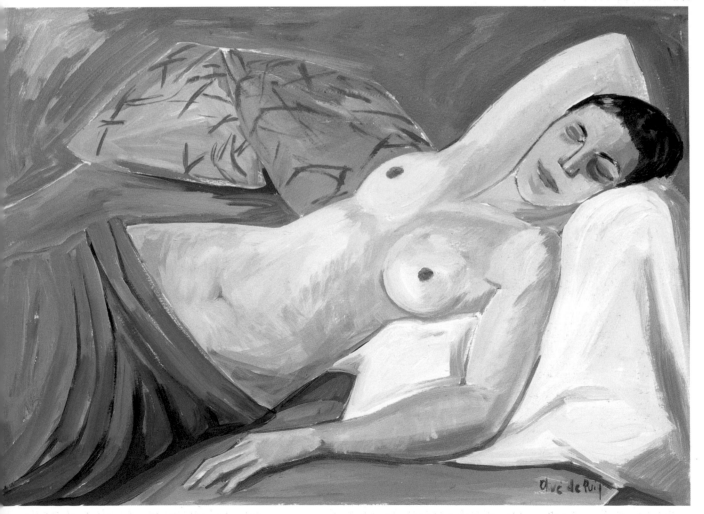

7. The completed work shows that the artist has continued touching up the areas of shadows and creating the texture of the pillows. Artistic license is acceptable as long as the structure of the figure is firmly rooted in the basic principles of human anatomy.

Clothed Figure

Painting a clothed figure is not easy, in part because of the complexity of the clothing and in part because of the descriptive ability required, where the shortcuts that are sometimes used in landscape painting are no longer applicable here. Mistakes like figures out of proportion or facial features out of balance become obvious.

CLOTHED FIGURE

For the beginner, a clothed figure presents, at first, less of a challenge than the nude figure in terms of setting up the composition, thanks to the clothes that conceal the anatomical features and the muscular shapes. However, it is not only a matter of drawing a well-proportioned body and its posture but also the way the clothes hang, with their folds and wrinkles. Drawing clothing, fabric, and adornments of any kind is a challenge worth exploring. The folds that drape the body can convey the feeling of heavy and stiff or soft and volatile volumes, hinting at the shapes of the body underneath. Lighter fabrics, such as silk and cotton, tend to form a lot of small wrinkles, so their color values are mostly soft. Heavy velvet and wool fabrics, on the other hand, present stiffer and more defined wrinkles.

HIGHLIGHTS

Highlighting is nothing more than adding a color that is much brighter than the background of the painting. When the drawing is made over a colored background, the contrast is so strong that the painting acquires a new dimension. Figure painting can be executed with lines, thick blocks of light applied broadly or by dragging the tip of the brush over a specific area, making it appear lighter overall. Highlights produce no effect when they are applied indiscriminately all over the painting, only the ones that are reserved for the specific areas that add to the contrast and emphasize the volumetric effect of the figure.

PAINTING TWO FIGURES

When painting a huma figure bathed by artifici lighting, the artist must kee in mind that this type of lig tends to intensify the colo by creating marked contras between the lighted an shaded areas. The final co trasts should be left for th end of the process; in th meantime, other nuances th enrich the overall tone can added. The outlines of th lighted areas have to b sharp, and they have to defi each plane that is affected direct lighting with touche of light color. The author this painting, Óscar Sanchí shows in this exercise how execute this type of paintin with highlights.

The painting consists of two clothed female figures, one standing and the other seated next to a small table. The artificial light from a small lamp creates interesting contrasts and highlights the volumetric effect on the bodies of the models.

1. The background is first painted with a flat brush. Prussian blue is used for this, mixed with ultramarine blue and a little bit of violet. The brushstrokes should not be flat, but should make a gradation from left to right, with the left side being lighter as a result of the light from the lamp that dominates the scene.

2. The artist begins the work wit a sketch painted over the blu background. The selection of dar ultramarine blue is not accidental This method involves a beginning with dark colors that becom lighter as the work progresse

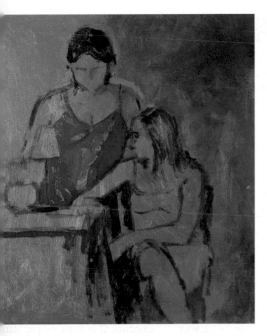

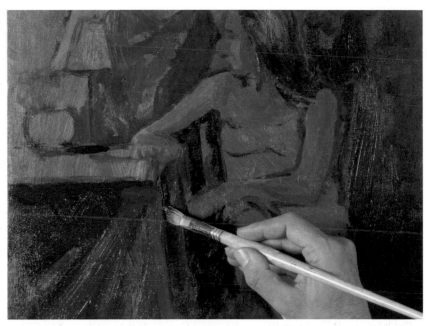

. The first areas of color are applied over the dark
ackground, starting with burnt umber mixed with raw
enna for the hair, and violet with a few carmine touches
r the dress of the figure that is standing. It is a good
ea to begin by applying dark medium tones with flat,
rge brushstrokes that conceal the details.

4. The less lighted areas are painted with very dark
earth tones, establishing the intensity of some shaded
areas, like the tablecloth. The flesh is painted the
same way, with coarse strokes for the shaded areas
using a mixture of ochre, orange, red, and brown.

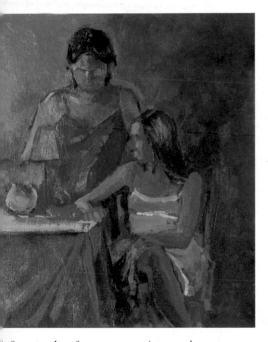

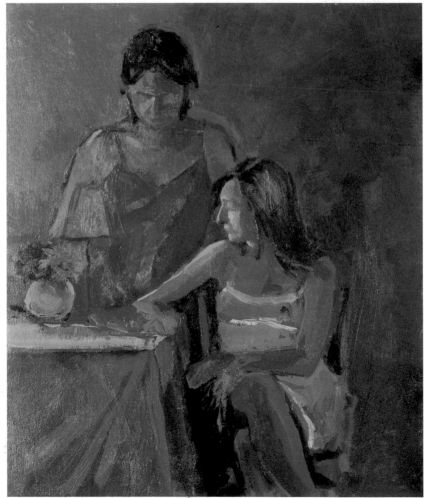

. Some touches of warmer, more intense colors are
dded over the previous layers of color for the flesh
nes of the figures. The brushes used are still large,
uppressing the need for details. The dark background
mphasizes the saturated red of the scarf and the
ntense coloration of the dresses.

6. The first lighter facial tones of the seated figure are
applied with a small, round brush. Even though the
number of colors added is beginning to be noticeable,
none of the layers is opaque. Hints of the original blue
color can be seen on the bodies of the figures. The lamp is
painted with pure white mixed with a small amount of
dense, opaque violet and yellow paint.

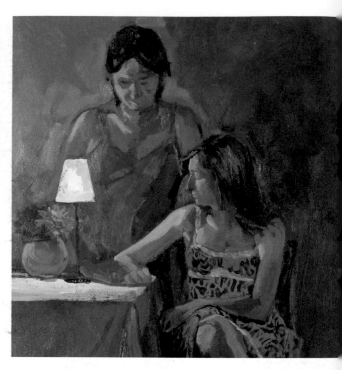

7. The faces of both women are painted with ochre and orange mixed with white in certain parts, adding more highlights in the areas of the face and arms that stand out the most. The details of the designs on the dress are simply spontaneous forms without any particular detail.

8. The light areas of the flesh are painted with a combination of ochre and white mixed with a small amount of carmine. If the colors are worked gradually—that is, by applying new washes that progressively intensify the tones—they will not stand out too much against the background. A few touches of dark cyan blue for the figure that is standing allows the integration of this volume in the composition without clashing with the darker background.

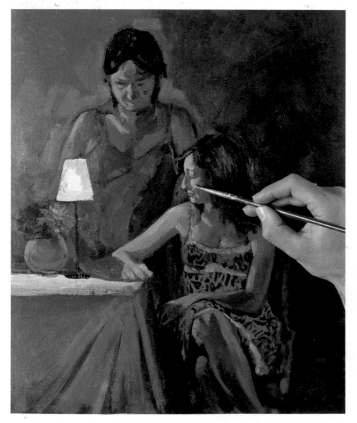

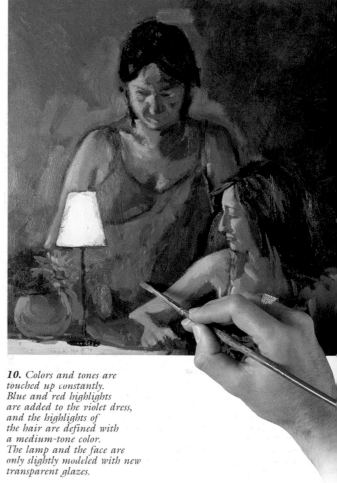

9. Opaque paint is used to suggest the volume of the nose and cheeks. The shape of the dresses and the flesh tones continue to be retouched with light colors, developing the figure by using the light. The medium tones of the tablecloth's folds are also added. The arms and legs are painted broadly with touches of light and shadow.

10. Colors and tones are touched up constantly. Blue and red highlights are added to the violet dress, and the highlights of the hair are defined with a medium-tone color. The lamp and the face are only slightly modeled with new transparent glazes.

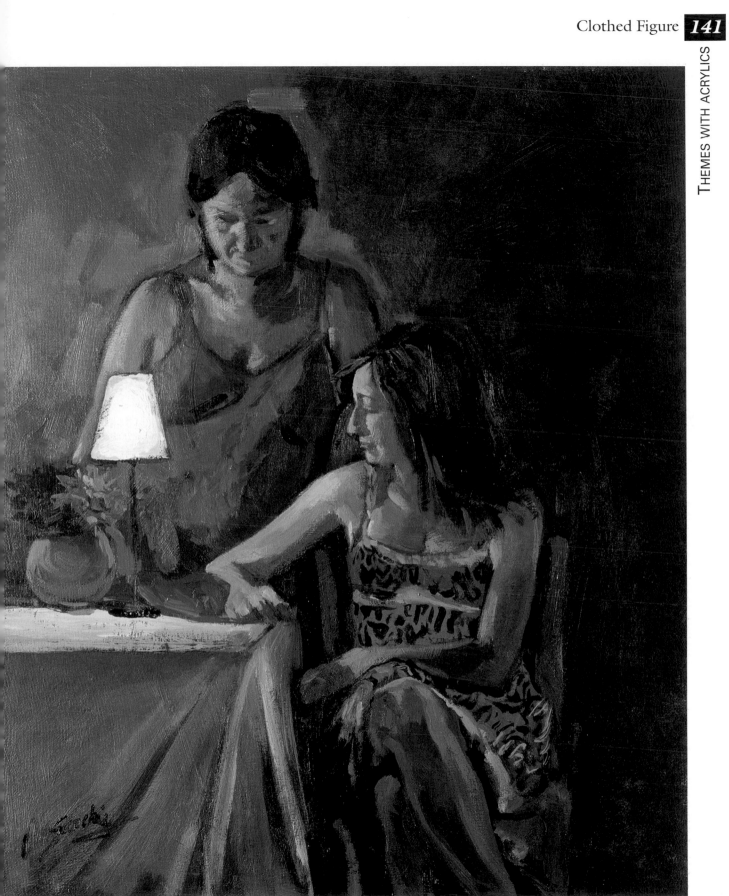

1. *The completed exercise shows the vibrant character of the painting
and the way the shapes have been constructed using light and shadow.
It is important to mention that if the goal is to create a portrait, one
must keep in mind that it is one of the most difficult genres in
painting and that it requires a lengthy period of observation and a
considerable amount of work.*

Topic Finder

ALL ABOUT TECHNIQUES IN ACRYLICS

Editor in chief: María Fernanda Canal
Editor: Tomàs Ubach
Text and Coordination: Gabriel Martín Roig
Exercises: Marta Bru, Carlant, Almudena Carreño, Mercedes Gaspar, Gabriel Martín,
Esther Olivé de Puig, Esther Rodríguez, Óscar Sanchís, Josep Torres
Series Graphic Design: Toni Inglès
Book Graphic Design: Estudi Toni Inglès (Alba Marco)
Photography: Studio Nos & Soto, Gabriel Martín, Marta Bru, Esther Rodríguez, Óscar Sanchís
Illustration Archivist: Mª Carmen Ramos
Production Director: Rafael Marfil
Production: Manel Sánchez

Original title of the book in Spanish: Todo sobre la técnica del acrílico

© Copyright Parramón Ediciones, S.A., World Rights
Published by Parramón Ediciones, S.A.
Empresa del Grupo Editorial Norma de América Latina
www.parramon.com

Translated by Michael Brunelle and Beatriz Costabarria

© Copyright of English language translation by Barron's Educational Series, Inc.

ISBN: 978-84-342-2976-1

Printed in Spain

Acknowledgments:
Parramon Ediciones, S.A. wants to express their gratitude to Ana and Ofelia Amor
for their collaboration in this book.